Art Restoration

Other books by James Beck

Mariano di Jacopo detto il Taccola, 'Liber tertius de ingeneis
 ac edifitiis non usitatis'
Jacopo della Quercia e il portale di San Petronio a Bologna
Michelangelo: A Lessen in Anatomy
Raphael
Masaccio: The Documents
Leonardo's Rules of Painting: An Unconventional Approach
 to Modern Art
Italian Renaissance Painting
The Doors of the Florentine Baptistry
The Sepulcral Monument for Ilaria del Carretto by Jacopo
 della Quercia
Jacopo della Quercia
The Tyranny of the Detail: Contemporary Art in an Urban
 Context
Stanza della Segnatura

Art Restoration

The Culture, the Business and the Scandal

JAMES BECK

with

MICHAEL DALEY

W.W. NORTON & COMPANY
New York London

First published in 1993 in Great Britain
by John Murray (Publishers) Ltd.

First American edition 1994

ISBN 0–393–03670–7

Printed in Great Britain

W.W. Norton & Company, Inc., 500 Fifth Avenue, New York, NY 10110
W.W. Norton & Company, Ltd., 10 Coptic Street, London WC1A 1PU
1 2 3 4 5 6 7 8 9 0

Contents

Illustrations

(*between pages 82 and 83*)

1. Jacopo della Quercia, *Ilaria del Carretto*, San Martino, Lucca, *c.* 1406–8
2. Della Quercia, head of *Ilaria*
3. Della Quercia, *Creation of Eve* (detail), San Petronio, Bologna, *c.* 1425–38
4. Masaccio, *The Tribute Money*, Brancacci Chapel, Santa Maria del Carmine, Florence, *c.* 1427–8
5. Masaccio, *The Expulsion of Adam and Eve*, Brancacci Chapel
6. Michelangelo, *The Creation of Adam*, Sistine Chapel ceiling, 1508–12
7. Michelangelo, Sistine Chapel ceiling. The head of the *Erithraean Sibyl* and the foot of the *Libyan Sibyl* (details)
8. Michelangelo, *The Prophet Jonah*, Sistine Chapel ceiling
9. Four copies of *Jonah*: Clovio's wash drawing, between 1524 and 1534; Piccinni's drawing, 1886; Rados' engraving, 1805–10; and Conca's drawing, 1823–9
10. Bramantino, *Adoration of the Kings*, National Gallery, late 1490s (detail)
11. Uccello, *The Battle of San Romano*, National Gallery, *c.* 1450 (detail)
12. Masaccio, *Holy Trinity*, Santa Maria Novella, Florence, *c.* 1425, detail of the Virgin; Michelangelo, *The Last Judgement*, Sistine Chapel ceiling, 1534–41

The author and publishers would like to thank the following for permission to reproduce illustrations: Aurelio Amendola – Nos. 1–4; NTV, Tokyo – Sistine Chapel ceiling, post restoration; Scala, Florence – *The Tribute Money*, Masaccio, and No. 6; National Gallery – Nos. 10 and 11

Preface

Veritatem dies aperit.
(Time unveils the truth.)

Seneca

Over the past decade, my energies have been galvanized by issues concerning the stewardship of cultural treasures and, in particular, the restoration and conservation of prominent sculptures and paintings in the Western tradition. This turn of interests was totally unplanned and, in retrospect, is something of a surprise. I had been a student and professor of Italian Renaissance art and a constant observer of contemporary art for nearly thirty years before any concern about restoration entered my head. I now consider my previous neglect as a flaw, but it does, for the most part, characterize the state of affairs among art scholars. Under the instruction of the German refugee generation which had migrated to the United States immediately before the Second World War, I became an art historian of a fairly traditional bent. With this orientation, I was engaged in understanding the historical context out of which emerged the Renaissance artists and their works of art. Hundreds if not thousands of hours in the archives and in the manuscript rooms of libraries puzzling over fifteenth- and sixteenth-century documents constituted a substantial portion of my annual routine. Furthermore, I have long been devoted to a formal reading of paintings and sculptures, my interest growing

from a truncated stint as an aspiring painter.

In about 1983, having seen the restoration and cleaning of the façade of the Basilica of San Petronio in Bologna, and especially the Porta Magna, I became alarmed. The transformation of the reliefs and the in-the-round sculptures of the portal by Jacopo della Quercia (which incidentally had been the subject of my Ph.D. dissertation) was bewildering. I felt a moral obligation to put my reactions on paper. The article on their restoration, which was published by an Italian scholarly art journal, represented my first entry into the arena of restoration.[1] I had noticed most of all that, following the intervention, the sculpture had lost something of its monumentality, and that the reliefs, with their massive forms, appeared flatter, more akin to graphic renderings than three-dimensional carving. (This issue is discussed further in Chapter I.) Out of innocence or ignorance rather than caution, I failed to question the technical assumptions that rested behind the extensive restoration project on Bologna's main civic square. It never occurred to me, even for a single moment, to challenge the ability or the integrity of those who had conducted the operation. With Twainian naïvety I thought that everyone contentedly fulfilled their roles like noble medieval craftsmen. Indeed, I perceived restoration as a near magical craft which could bring the dead back to life.

Nevertheless, scratching only a few millimetres beneath the surface, I soon came to realize that there were a variety of approaches, techniques and methodologies that vied with one another for acceptance, and that considerable sums of money were involved in the business of art restoration. And as well as material gain, reputations were at risk, not just those of the restorers but also those of the directors of works, often prestigious superintendents, as well as their art historian advisers.

To take the medical field as an analogy, one might easily assume that doctors are singlemindedly devoted to healing the sick. It is only as one becomes familiar with the profession that one sees that internal differences of opinion and interpretation, jealousies,

in-fighting and hierarchies are also part of the healing business. When sick, we tend to head straight for the 'doctor' – not usually Doctor so-and-so, but a nameless person who will take care of things. And if we have a problem of a spiritual nature we might call upon a priest, not Father so-and-so, or a pastor, not Pastor blank. We seek the aid of someone from the *métier*, from the calling, as if any one of them will do, as if any one of them can be substituted for another. Yet approaches may indeed be very different, advice diverse and even contradictory. So too it is with restorers. We may call upon a faceless specialist in the favoured white coat, but we are really dealing with a field that has divergent philosophical positions and approaches. This realization became strikingly clear to me when pondering the two most influential fresco restorations of the 1980s, which are both subjects for discussion in the coming chapters: the Sistine Chapel ceiling and the Brancacci Chapel. While the problems with each have been described and are very similar – dirt, candle wax, pollution, water damage, old and ill-conceived restorations, and layers of varnish or glue – the treatments they received were radically different. Yet they were both hailed by experts as exemplary, pioneering restorations that brought back much of the original appearance to the frescoes and, in the bargain, brought new 'insights' into the history of Italian Renaissance painting. Could they both be 'right', and yet be so differently treated in methodology, I wondered? Or, I thought with increasing insistence, could they both be wrong, as my eyes were telling me from the start?

Indeed, my true baptism was the restoration not of Jacopo della Quercia's portal at San Petronio, but of the work of his greatest admirer from a later generation, Michelangelo Buonarroti; not his sculpture but his painted ceiling in the Vatican. Once I began to become acquainted with some of the issues involved in that restoration, other, related situations seemed to demand greater attention, especially the Brancacci Chapel.

It should also, however, be made quite clear at the very outset of this book that restoration, *per se*, is sometimes not merely

desirable, but actually essential; nothing said in the following pages should be understood as a rejection of necessary conservation. But I categorically reject the dangerous rhetoric current in some restoration circles and many museums, not to mention amongst some sponsors, that a fresco, picture or sculpture which is four or five hundred years old can be brought back to 'its original beauty'. Such a claim was made after the Louvre's restoration of Veronese's *Marriage at Cana*, completed in 1992. Likewise, it was stated by many, including an influential curator at New York's Metropolitan Museum, that the newly cleaned frescoes in the Brancacci Chapel had been restored to their 'original' condition. Vatican officials have sung the same tune over the Sistine Chapel ceiling. Not only is such an achievement impossible, but the claim also lulls people into thinking that they are indeed seeing what previous generations, and foolish romantics like Ruskin and Berenson, did not have the honour or good fortune to see. This goal is crude and arrogant, and can lead to calamities such as the removal of a strong red-coloured robe on a central figure in Veronese's *Marriage*, upsetting the harmony of that gigantic picture, or the other serious disasters discussed in this book.

We need some sort of consensus among experts and other representatives of the art world, drawn from beyond the limits of the present restoration establishment, before we entertain work being carried out on masterpieces such as the Veronese painting, the Brancacci Chapel, the *Ilaria del Carretto* statue, the Sistine Chapel ceiling or the Barnes Foundation pictures. We need much more discussion and a much more secure system of controls before embarking upon severe and irrevocable treatments. No one is likely to object to light and rigorously self-controlled cleaning, like that conducted on Michelangelo's Medici tombs, or the one now promised for Piero della Francesca's True Cross cycle in Arezzo. But equally no rational person would assert that these are being made like new. None should entertain such a goal; that is simply impossible and, in the balance, more likely to produce serious damage than anything else.

Since restoration is still a very imperfect craft, without effective national or international controls, we must be on the alert and lobby for a system of checks and balances. A small group of individuals, even with the best of intentions, should no longer be left to make decisions about the custody of our culture's most profound statements in isolation. I am convinced that restorers on the whole would welcome such a system.

In what I frequently view as a continuing battle, I have often felt isolated, although I actually came rather late to the controversy over the Sistine restoration. I became involved in 1986 when I was encouraged by Alexander Eliot and Professor Alessandro Conti who had sounded the alarm almost a year before. Earlier still, artists such as Frank Mason, Toti Scialoja, Venanzio Crocetti and Pietro Annigoni had warned those who would listen of the possible damaging effects of restoration as they were revealed. So too did a passionate Italian journalist, Lucio Manisco, who took up the cause in the press, despite overwhelming support for the official Vatican position. Nevertheless, as an American art historian, I remained pretty much alone, undergoing rather ugly attacks and ridicule from colleagues and former friends, all of which tended to harden my resolve to get at the truth.

Among my good fortunes was my meeting with Michael Daley. A brilliant draughtsman and illustrator, a trained artist and an expert at rendering the human figure with pencil, brush or chisel, Mike is also an unrelenting researcher, a skilled writer and a clear thinker. As we joined forces in a united effort to uncover the real story, our particular abilities began to support and reinforce one another. In this book, Chapters I, II, VI and VII are my work, closely scrutinized by him. Chapter V is his, equally scrutinized by me, and Chapters III and IV represent a collaboration. Even before we began writing, in the course of my trial (of which more below), he provided a wealth of information. He has remained a steadfast co-conspirator – or really anti-conspirator – and the results of our exchanges have influenced every phase of this book.

Out of the adversity of my legal adventures in the Italian courts, I had the good fortune to meet a number of people who stepped forward to volunteer support. I must mention Agnese Parronchi and Francesco Pannichi who followed my evaluation of the *Ilaria del Carretto* cleaning. Their dedication to the conservation and restoration of stone sculpture is virtually without equal. Indeed, Agnese conducted the exemplary cleaning of Michelangelo's sculpture in the Medici Chapel. Francesco, who is wise in the ways of the modern world, was a source for direction in my own conduct on a public level in Italy during those difficult months, and was instrumental in my appointing Avv. Antonino Filastò, the lawyer who saw me through the various venues in my defence.

Filastò, a remarkable and energetic man in his fifties, is a criminal lawyer of extraordinary intelligence, an articulate spokesman of just causes, and a man of unflappable determination. He very quickly appreciated the central issues in the case, perhaps all the more rapidly because he had spent some time in art school himself and is constantly in the company of artists in his native Florence. Furthermore, he has a second career as a writer, having produced five well-crafted novels which use his legal background to the fullest. Because Filastò is at heart an artist himself, he fully understood the issues surrounding the *Ilaria* case.

Another who deserves special mention is my civil lawyer, Carlo Querci, known as 'Lalo' and, like Filastò, the son of a lawyer. He was the stabilizing force on the little team which also included Cosimo Mazzoni, a law professor. Querci was always prepared to balance all the elements, but at the same time he shared my concern for the morality of my position, and saw that the issues went far beyond one, however beautiful, Renaissance sculpture.

I must also mention my friend Jan Sawka, painter, graphic artist and theatrical designer, who was constantly by my side, if not physically then in spirit, during the entire episode, and who offered not only valuable artistic insights, but also much-appreciated encouragement. Several other artist friends were constant supporters, including Milo Lazarevic, a Montenegran transplanted to

New York, Laura Ziegler, an American sculptor who lives in Lucca, and Roberto Barni, a Pistoese painter and sculptor living in Florence. The brilliant photographer Aurelio Amendola, a longtime friend, was also prepared to go to bat for me, notwithstanding the possible negative effects on his career. I must mention too the loyal and dogged support offered me by Richard Fremantle, art historian, free-lance writer, journalist and art expert, who has been living atop a tower that looms over Piazza San Pier Maggiore in Florence, only a few blocks from the courthouse. Richard took up the issues and passionately explained my position to the outside world. Another friend, Gabriel Blumenthal, stood by my side in the long months of the court battle, and supplied impeccable advice and interpretation of events as they unfolded. Gabriel, who lives in the same nondescript Tuscan village of Lamporecchio as I do, at least some of the time, has also been a source of inspiration in the larger ecological-cum-cultural battle out of which the *Ilaria* case arose.

Some valuable last-minute observations were offered by Jodi Cranston, as well as by Gordon Bloom and Donald M. Reynolds, my collaborators at ArtWatch International, and Richard Fremantle, Director of ArtWatch Italia. My thanks also go to Matthew Dontzin and Harold Ruvolt, Jr., for specialized advice.

In the course of events my path crossed with that of Mirella Simonetti, a devoted and honourable restorer as well as one of the most informed persons I have ever met on the physical structure of Renaissance painting. Painstakingly she filled me in on the details and nuances of the issues that I had missed and she unhesitatingly shared her enormous experience with me on many occasions. Mirella realized that I was not an enemy of restorers but really a friend, and she has always treated me like one, thereby enriching my knowledge of art and of restoration.

Finally, it is worth asking whether, given the terrible problems that exist in the world, we can legitimately syphon off valuable time and resources to consider the guardianship of mere paintings, sculptures and buildings. Frequently I have asked myself whether

my efforts are well directed. Would it not be more appropriate to work towards alleviating poverty, preventing famine, halting pollution? Yet, can any of us live on bread and air alone? Art has from the start been a part of man's existence, and may well be its distinguishing feature: art and religion have been virtually inseparable since men dwelt in caves. The bombing of the Uffizi Gallery in Florence has shocked the world because it illustrates how absolutely defenceless art really is. The attack could serve to lull us into thinking that the situation is hopeless, but we cannot permit ourselves the luxury of inaction, whatever the odds. Think for a moment of a society without music, of a society without the plastic and the visual arts. On reflection, efforts to maintain and perpetuate the art of the distant and the near past do represent a truly essential activity. And conversely, the destruction or degradation of art, with whatever good intentions, is a process that must be halted, for otherwise we are all the losers.

New York
May 1993

PROLOGUE:

Serious Business

THE FLORENTINE *MAGISTRATURA* is located in the heart of the old city on Piazza San Firenze, which is shaped like a narrow football field. Down a slight incline, behind and off to the side of the Palazzo Vecchio, the building is actually a converted church dedicated to S. Apollinare. Part of a vast incomplete Baroque complex that includes another still functioning church, that of S. Filippo Neri, the structure appears out of tune with the predominantly medieval and Renaissance inner city. The shabby, ill-lit entrance hall and chaotic internal corridors of the court-house give no clear indication as to the function of the building or its different rooms, imparting an uneasy, Kafkaesque air. Amidst the universal informality, the presence of uniformed *carabinieri* clutching automatic weapons introduces a note of gravity.

I was not quite sure why I was there at all that first time. In the inner entrance hall, Giovanni (or usually Gianni) Caponi, my adversary, who was about ten years my junior and consequently not all that young himself, intercepted me. A large man with a finely chiselled head held high, back straight, he suggested confidence as he greeted me with unexpected, almost cordial civility. To be sure, we had met once before, at a symposium in Pisa a

1

few months earlier, when fresco restorations he had conducted at the Camposanto were unveiled along with cleaned marble monuments in the same space. I had introduced myself on that occasion, seeking to instil in him the perception that I was not at all apprehensive over our scheduled encounter in court. But I am running ahead of the story.

The lives of the Italian art restorer Gianni Caponi and an American university professor of the history of art, James Beck, an Italian painting and sculpture specialist, converged without premeditation on 24 July 1990. Having acquired a reputation as an outspoken critic of restorations of Renaissance works of art, I had been sought out in New York City the previous April by Laura Zeigler. A sculptor born in Ohio who had settled in Lucca three decades before, she was distressed by the restoration of a statue there. The spring semester at Columbia University was winding down and I was preparing for my annual trip to Tuscany and for some research. Laura knew that I had written on the Sienese sculptor Jacopo della Quercia, including a recently published monograph on his funerary monument celebrating Ilaria del Carretto, carved from Carrara marble and located in Lucca's cathedral, San Martino.

'They' had restored the *Ilaria* and, in the process, had seriously diminished the beauty of the sculpture, Laura argued. In the course of previous years I had studied this tomb, that of the second wife of Paolo Guinigi, Lord of Lucca, who died during childbirth in 1405. With its unrivalled sarcophagus showing, besides Ilaria and her dog, five garland-laden putti on each of the two long sides, it is the earliest known monument of its type since Antiquity. Beloved by travellers over the centuries, it was prized by Ruskin as the finest tomb statue of its period.

Knowing the monument to be in excellent condition I paid little attention and quickly forgot my promise to go and see it when in Italy. I do recall being convinced that Laura must have got it all wrong, that 'they,' whoever they had been, could not possibly have touched the *Ilaria*. But Laura persisted, intercepting me

at my farmhouse on the west flank of Montalbano. After several procrastinations, I yielded and we met on 24 July 1990 in the north transept of the Cathedral on what turned out to be a fateful morning. Laura must have sized me up well, because she had two Lucchese journalists on hand, each with a photographer, and she had brought along my monograph so we could make the 'before' and 'after' comparisons.

Alas, she was right. 'They' had indeed 'cleaned' the statue. I was not sure precisely what had been done but the intervention must have been drastic, for the appearance of the monument as a whole and of the individual figurative elements looked noticeably different from what I remembered and from what was recorded in the photographs. I answered the journalists' provocative questions angrily, offering sharply phrased criticism about the effects of the restoration. The local reporters from *Il Tirreno*, published in Livorno, and Florence's *La Nazione* were delighted by my polemical reaction and in the days that followed an outburst of exchanges appeared in the press and even on Tuscan television. In fact, I later learned that Signor Caponi was particularly annoyed over the television account, perhaps because it reached him most directly. The next day a reporter from Turin's *La Stampa* came to my house for an interview.

The *Ilaria* tomb is arguably Lucca's finest monument and perhaps even contains the most beautiful effigy of a woman in all Italy. From an art historical perspective, not only does the monument present the precocious use of the putto, which was soon to become virtually a symbol of Renaissance figuration, it is also a distinctive example of the free-standing tomb type which has its culmination in Michelangelo's first project for the tomb of Pope Julius II. The *Ilaria* also represents Lucca, as it were, as well as being the trademark image of the bank, the Monte di Lucca, which actually and with public fanfare paid for the restoration. In other words, it is a local icon as well as a work of grand distinction.

I never suspected for a single moment that I would be brought to court for my remarks. After all I had spent most of my scholarly

life studying Jacopo della Quercia and writing extensively about both the artist and the monument itself. Rightly or wrongly, I must be regarded as the world expert on della Quercia and I never considered for a moment concealing my disappointment and rage. During the original interview and in several that followed, I insisted upon a debate or open discussion among the interested parties. In view of what followed, I should point out that I did not then know the identity of the person or persons who had conducted the restoration. I actually asked the reporter from *La Nazione* if he did, but he answered in the negative.

My remarks must have displeased several lobbies, including the powerful institutional sponsor and the regional superintendent of art in charge of the project, whose headquarters are in Pisa and whose hegemony includes Lucca, Carrara and Volterra. Lucchese cultural luminaries who had failed to speak out earlier must have been offended too. But the most concerned of all was, of course, the restorer himself. In lieu of the academic exchange I expected, I was cited for criminal defamation by Signor Caponi under a law that provides for a penalty of up to three years in prison. Hence my appearance in court at Piazza San Firenze in Florence on 18 January 1991 at 9 a.m.

In the articles printed in *La Nazione*, which were at the heart of Signor Caponi's case in Florence, the headline in the national edition was '*Ilaria* appears to be plastic', while the Lucchese edition of the same paper ran '*Ilaria* "ruined" by the restoration'. These articles, both written by the same reporter, Oriano de' Ranieri, must have hit home because when Caponi submitted his marked-up copy of the two articles as part of the formal accusations I saw that he had furiously underlined many passages himself. I was quoted as saying that the *Ilaria* appeared as if washed and consumed by bleach, that the restoration was 'completely incorrect', 'a disgrace'. I was also quoted to the effect that the '*Ilaria* has been well preserved for 600 years and in a single day it has been ruined'. And, 'the *Ilaria* has been overcleaned. The play of chiaroscuro has been lost, the figure now seems "mummified".' These and similar

remarks obviously and understandably raised Signor Caponi's temperature. In retrospect, however, I am reminded of the street adage, 'If you can't take the heat, stay out of the kitchen.' The basic issue for me was whether or not a then nameless restorer had irrevocably altered a world-renowned work of art. If his feelings or his pride had been bruised, too bad.

I did not learn about the legal actions taken against me for several months. Weeks before I was officially notified by the court, a news item appeared in the Communist daily, *L'Unità*, reporting that Caponi had cited me for aggravated slander. Even then I was incredulous, because it appeared to me unimaginable that he had a viable case. I calculated he was bluffing with the objective of inducing me to retract my criticism so that he could save face, especially with the officials of the superintendency in Pisa who were his patrons. He would never bring me to court.

Even on the rainy January morning when I entered the court-house, I was convinced that at the last moment Caponi would withdraw the charges. But no conversations between our respective lawyers took place so we ended up in the chamber where, as planned, a delay was obtained to allow my lawyers time to prepare the case. Despite the fact that the case was tried on the fast track, *direttissima*, denoting the utmost priority and gravity and generally reserved for drug dealers, rapists and anarchists, there was no apparent urgency. The court was to meet again in four months. In Italy, my defence lawyer took care to explain, the express train is really a local. What did strike me vividly, aside from the eighteenth-century ceiling frescoes (ironically, in rather good condition, having been spared, at least for now, a radical cleaning), was the presence of a gigantic cage off to the left. The robed president of the tribunal sat with two other judges in what had been the raised altar area, in lieu of the priest and his acolytes. As I entered with my two defence lawyers, four unhappy handcuffed men were being led out of the cage. My turn had come.

Caponi's rhetorical statement of accusations (*querela per diffamazione*) charged that I had violently attacked the conduct of

5

the restoration of the *Ilaria del Carretto* as well as having offered a series of critical judgements on the effects of the restoration. My statements were described as 'heavy' with regard to the work of the restorer, his ability and, in general, his competence. Taken together, Caponi had understood them to be 'a succession of invasions of his personality, his professionalism and his seriousness as a restorer of works of art'. Caponi's decision to instigate criminal rather than civil proceedings was revealing. In a criminal case, he could hope for a more rapid resolution of the case, *per direttissima* as indicated. A civil action could take years. If found guilty under criminal proceedings I would face prison and some sort of a fine, and would still be open to a civil suit later on, which could be particularly costly. I did not know then that Caponi could also have been awarded substantial damages.

The proceedings in Florence were the first but not the only ones that Caponi had instituted. According to Italian law covering such matters, the crucial element was where the offending interviews were printed, not given, so that in addition to that in Florence, three analogous suits were brought against me: one in Livorno where *Il Tirreno* is published; another in Turin because *La Stampa*, which ran a long hard-hitting interview on the same subject, has its home there; and the third in Alessandria where the influential monthly *Il Giornale dell'arte* is published. Later, the cases in Turin and Alessandria were combined and hearings were held concurrently in Turin. But the fact remained that, rather than a single case, I was at risk in four. This could have been part of a plan to encourage me to recant. Not only the physical difficulties of defending myself in four cases, but also the potential costs were thought likely to discourage me from carrying on. After all I live in New York although as chance would have it, during the academic year 1990–1 I was on sabbatical in Italy doing research and correcting proofs of my Jacopo della Quercia monograph.

To my utter dismay, the charges in the three venues, Florence, Livorno and Turin, were accorded three different treatments.

As a further complication for the defence, besides the different centres for the same alleged crime, the regulations covering the handling of the defamation charges varied. In Turin, the *magistratura* dropped the *direttissima* aspect. They opted to follow a new procedure which required a preliminary hearing before a judge. The charges were to be evaluated with all the parties present and a determination reached as to whether the case should, in fact, be brought to trial. As things turned out, the preliminary hearing in Turin was initiated and a decision reached before the final session in Florence. In the latter city the tribunal was unwilling to change course and insisted on carrying on under the old procedure, as it had begun.

Another significant factor distinguished the conduct of the case in Turin from that in Florence. Under Italian law in cases of defamation, the charges are brought by the Public Minister – a district attorney or crown prosecutor of sorts – in conjunction with the lawyer for the offended individual. In each of the four cases, Caponi's lawyer, Dr Ugolini, sought to isolate me by failing to implicate the journalists who wrote the articles, not to mention the publishers of the newspapers who after all are responsible for what gets printed in their periodicals. I did not wish to buck my responsibility but obviously I did not control every word that was written. Equally obviously, one would assume the newspapers had, in effect, approved the stories and were aware of the law. The Florentine court, in the person of the Public Minister, accepted Ugolini's notion of my sole responsibility, but in Turin the court stipulated that the charges be extended to include journalists together with their editors. Such a signal from the Florentine *magistratura* should have alerted my lawyers from the start, or rather even before the start, but neither my two criminal lawyers, 'Nino' Filastò and Ferruccio Fortini, nor the civil lawyer I had also engaged, Carlo Querci, nor a professor of law, a friend and informal adviser, made particular note of the odd omission.

Following the postponement in January, the trial recommenced in Florence on 17 May, ten tense months after the interviews. In

7

the meantime, we learned that the Public Minister from the court in Livorno was entertaining doubts about the validity of Caponi's charges. Adhering to the new procedure he requested a statement from us before he was prepared to decide whether to prosecute the case at all. Our spirits were lifted by this, the first positive signal we had received during the entire affair.

My lawyers elaborated a ten-page presentation indicating our line of defence which, in substance, was based upon the right to freedom of criticism and on the reasonableness of that criticism in light of the importance of the *Ilaria* as a work of art. We were able to supply photographs of the statue taken before and after the intervention, although the 'after' photographs were unofficial and homemade since we received no reply to our registered letter to the Superintendent of Pisa, architect Giovanna Piancastelli, asking permission for a professional to produce new photographs. (As of 1993 a full set of carefully prepared illustrations showing the restoration is still not available.)

The Florentine proceedings took place this time in a small, dingy courtroom upstairs where observers had no place to sit, nor frescoes to muse over, nor even a decent cage for especially dangerous defendants. Members of the press turned up and followed the entire session which lasted until well after 1 p.m. I was particularly anxious to have English-language journalists present. The publicity surrounding the possible crucifixion of an American professor might give the court pause in adopting an arbitrary stance. I managed to get representatives of the *New York Times*, whose reporter came down from Paris for the occasion, and of the *International Herald Tribune*, in the person of their stringer in Florence. There was a reporter from the London *Guardian* present as well. A host of Italian journalists were also in attendance. After all, an art critic had never before been dragged into court in Italy for speaking negatively about a restoration. To my knowledge, it had never happened in any country.

Several friends from Florence attended the session, notwithstanding the cramped conditions. In particular, the distinguished

Italian art historian Alessandro Parronchi, who is also a highly regarded and prize-winning poet, conspicuously stood up throughout the session despite his age.

The presiding judge, Dr Bellagamba, laid out the case of *diffamazione aggravata* based upon two articles printed in *La Nazione*. By omitting the name of the journalist who had written both pieces he implied that I had somehow written them myself, although naturally they were essentially summaries and snippets of an interview lasting an hour or more. Prior to introducing the Public Minister, the judge called attention to the titles of the two incriminating articles, '*Ilaria* "ruined" by restoration', and '*Ilaria* appears to be plastic'. Although, obviously, I had no control over the headlines that the editors of *La Nazione* gave the stories, the insinuation in court was otherwise. The Public Minister also referred to me as the 'author', saying that I was responsible for the interview and, consequently, for the articles.

The session moved right along since Dr Bellagamba was obviously anxious to get on with it, but we soon suffered an unexpected setback. My side had prepared a set of exhibits including my three books on della Quercia – two of them already printed and the third, a thorough monograph on the artist that represented the fruit of nearly three decades of study, still in proof. Naturally my *curriculum vitae* was submitted, along with letters from Italian scholars, including Professors Alessandro Conti, Alessandro Parronchi, Gianlorenzo Mellini and Carlo Bertelli. I submitted as well a letter from the Roman sculptor and Academician Venanzo Crocetti, who created one set of bronze doors for St Peter's and was for many years a restorer of paintings.

We had also assembled eight witnesses to testify on my behalf. Among them were Laura Zeigler; Contessa Stefania Barsotti of Lucca, the last heir of the Guinigi family and of Ilaria del Carretto; Professor Mina Gregori, Chairholder in Art History at the University of Florence as well as a national adviser of Italia Nostra, and President of the prestigious Roberto Longhi Foundation; Dr Giorgio Bonsanti, Director of the Opificio delle Pietre Dure,

which is the national restoration institute in Florence; Aurelio Amendola, an expert photographer of sculpture who collaborated with me on my monograph on the *Ilaria*, and Oriano de' Ranieri, the journalist who conducted the incriminating interview for *La Nazione*.

According to Caponi's lawyer, an argumentative and rhetorical representative of the old school named Ermanno Ugolini, the issue was not whether the restoration has been conducted well or badly, which he asserted was of no interest to the court. Even my *curriculum vitae* was not pertinent, although Caponi's was referred to frequently. Ugolini's main point, ostensibly, was that I had exceeded the right of criticism by violating the professional status of the restorer. The issue, he claimed, was one of 'self-restraint'. The defence countered that, on the basis of jurisprudence, in cases where the public interest was at stake, the public aspect takes precedence over private interests, and that the *Ilaria* was unquestionably a landmark in the history of art and culture.

The President announced that the tribunal would admit only two of our eight witnesses: Dr Bonsanti and the Lucchese journalist de' Ranieri. Bonsanti had a direct interest in the case, because Caponi, at least according to his *curriculum vitae*, submitted to the court, claimed to be a collaborator of the Opificio, the institution which Bonsanti supervised. As it happened Dr Bonsanti, who claimed a medical indisposition, did not show up, and in his place the somewhat embarrassed President allowed Professor Gregori to testify, having at first rejected her.

Of twenty-four written pieces of evidence, only two, my monograph on the *Ilaria del Carretto* and the report on the restoration prepared by Caponi, were allowed. Noteworthy is the fact that we, not the claimant, asked to have this report placed on the record. None of the other materials, not even the letters of support from Italian colleagues, were admitted. Hence the range of our defence was severely restricted from the very start. Somewhat innocently however, we persisted in our assumption that there was nothing untoward, that the judge merely wanted to expedite

10

things. We did not realize that the rug had effectively been pulled from under our case.

Caponi was the first to take the stand. It emerged that although he is often referred to as Professor, and attended the Accademia delle Belle Arti in Florence, he does not claim to be a graduate of that or any other institution. This revelation, in itself, was not damaging since much of the instruction of restoration, at least in the past, was passed on from master to apprentice in the work-shops. Caponi conducted himself confidently throughout the questioning and, on the whole, managed to restrain his temper. Perhaps the strangest admission to come from his testimony was a refinement he volunteered. He said that the treatment of the *Ilaria* really 'was not a "restoration" but a normal extraordinary [*sic*] maintenance . . . a washing'.

Professor Mina Gregori was called to the stand next. The first of our two witnesses, a sensitive and spirited art historian, she testified to my expertise in the study of Italian Renaissance sculpture and then went on to explain that 'we are in a dilemma with regard to the methodology of the restoration of sculpture'. Eloquently, she pointed out that some critics have called for a suppression of restorations of sculpture until an international conference can be held to discuss all aspects of the problem, simply because current operative techniques are not convincing.

Oriano de' Ranieri, the only other witness permitted us, was then called. A passionate admirer of the *Ilaria* before the intervention, his sympathy for my position was transparent. He confirmed that I had asked him to supply the name of the restorer of the *Ilaria* since I had not known it. He testified that he had not remembered the man's name either. My lawyer also asked him if any of my remarks were directed as an attack upon Caponi. Before he could answer, Caponi's lawyer demanded that the question be struck from the record, and the motion was sustained by the President. For the most part, de' Ranieri was questioned about the content and duration of the interview, and the accuracy of the quotations in the two articles derived from it.

11

Finally, as lunchtime approached, I was called to the stand. In the face of continual signals from the presiding judge to move swiftly, I felt pressured and tended to rush my answers. I spoke without an interpreter, which may not have been as good an idea as I had thought. My comprehension of Italian is reasonably good but my spoken Italian, even if one ignores an unpleasant American accent, does not permit me the same flexibility of expression as my native English. My explanations were thus somewhat primitive in terms of nuance.

Unlike all the other witnesses, I was not required to take an oath. I nonetheless volunteered that I would tell the truth, the whole truth, anyway. The President responded that in Italy they are not as ingenuous as they are 'in some other countries' and do not require the accused to take a useless oath. I began to fear that national pride might be involved. Innocently I had never contemplated that, though perhaps I should have. To be sure, in the accusation, this point had come up. The attacks that I made on the *Ilaria* 'are not new for Professor Beck, who habitually attacks at once whatever restoration is effected in Italy . . . therefore [Caponi] is also intent upon defending the grand Italian school of restoration, to which it is his honour to pertain . . .'

I reviewed the circumstances surrounding my examination of the restored monument with the journalists present, after relating Laura Zeigler's initial role. I recalled my reaction upon seeing the radically altered monument. I had hardly been able to believe my eyes, and had been deeply saddened by what I saw. In my testimony, I suggested that the restorers had removed the aura of history from the work. I also described how I had gone to Pietrasanta, where Michelangelo had collected marble and still an active centre for sculpture, to talk to artists, copyists and foundry technicians. An old carver demonstrated to me how sculptors of the past would leave certain grooves very roughly chiselled, thus providing places where the 'dirt' would collect, to give the effect of light and shade. Sculptors were thus well aware that their works would age, and provided for that inevitable process in their

planning. By recess time and after more than thirty minutes on the stand, I felt sure that my points had made an impression upon the panel. At the least, the three judges seemed attentive to my answers.

Following my testimony the case was adjourned until 3 July, when all that was scheduled were the summaries of the Public Prosecutor, the lawyer for the plaintiff and that for the defence. Ingenuously, I was convinced that the trial was going well for us and that my own testimony had been effective. I hoped my presentation had reinforced the impression that I was not an individual who had acted out of a wish to embarrass Italy, Italian restoration methods or a particular restorer; and that furthermore, since I was an expert on della Quercia, I had spoken within my rights. As the first session ended, I was confident that I had won the day and would quite soon win the case.

We had a celebratory luncheon at Professor Parronchi's apartment together with several friends. Our optimistic mood was interrupted by a worried telephone call from Alessandro Conti, a Professor then teaching at the University of Milan and an outspoken critic of the Sistine Chapel restoration as well as other interventions. Conti, arguably the best-informed individual on the history of restoration of Italian art, was concerned about the issue of freedom of criticism, and I noticed his disappointment that the trial had not been concluded (in my favour, it goes without saying).

After lunch and still in high spirits, my wife and I, accompanied by a couple from Chicago who happened to be in Florence for the day, walked around the city. At about 5 o'clock I decided to telephone my lawyer Filastò to hear his interpretation of the day's events. He was uncharacteristically grave on the 'phone. Without the slightest hint of an explanation, he ordered me to go immediately to the other lawyer's, Fortini's, office where he would meet me within the hour. Something had come up of extreme importance concerning the case, he said, but he could not tell me anything more on the telephone.

What I learned was truly a shock. As the court session had

ended, an intern-lawyer attached to Filastò had followed the President out of the courtroom – whether by chance, instinct or on orders, I never learned. On his way out of the building, he had overheard an exchange between Dr Bellagamba and Ugolini, Caponi's lawyer. Since the young man, whose name is Luca Cianferoni, had previously been a member of the *carabinieri*, Italy's efficient national police force, he had been trained to be attentive, and sought to report to Filastò precisely the conversation he had overheard, recognizing the gravity of our situation.

The translated text of his courageous declaration, which was subsequently submitted to the Court of Appeals as part of our effort to recuse Bellagamba, reads:

> At about 1.20 p.m., I left the courtroom, since the session had terminated a few moments before. The gentlemen, the lawyer Ermanno Ugolini and Doctor Giovanni Bellagamba, President of the second section of the tribunal, preceeded me by a couple of metres in the corridor. Walking side by side they discussed Beck's case . . . More precisely the lawyer Ugolini was saying, I am giving his exact words more or less, 'the lawyers of the defence had intended to raise a big noise but they should have discussed the article from the newspaper'. Doctor Bellagamba nodded in agreement, then opening the glass door [leading out of the building] he uttered the following phrase which I heard distinctly: 'Eh, but I shall convict him'.[1]

Whatever his motivation, it appeared that Dr Bellagamba had decided to declare me guilty without listening to the rest of the case, and had probably made up his mind even before it started.

That the lawyer representing the prosecution should be discussing an on-going case with the presiding judge outside the courtroom would, at the very least, be irregular. We concluded that the severe and unexpected limitation of witnesses, the elimination

of the greater portion of our evidence and the judge's impatience with the defence were all of a piece. Crucial decisions had to be made: how should we react?

My wife and our friends waited anxiously in an outer room while we held tense discussions, punctuated by loud outbursts. Our friend from Chicago was a lawyer himself and soon became involved in the conversations, despite barriers of language and culture. Two options were open to us. We could seek an out-of-court settlement, which meant I would sign a statement about Caponi's professional ability and the restoration of the *Ilaria del Carretto* that would, in effect, vindicate him. In addition, I would have to accept his legal fees and the court costs, which could amount to £20,000 or more. This is precisely what my lawyer friend from Chicago vigorously urged me to do: cut my losses, keep out of jail and stay out of the courts. He suggested that I had made my point in public anyway and the best, cheapest and safest course now was to step aside. This was by and large also the view of my second lawyer, Fortini, who had always been gloomy about the outcome of the trial. He had my interests at heart, but he was less in touch than Filastò with my own resolve concerning the restoration issue in general and in particular the treatment of the *Ilaria*, which I found especially odious as a result of my long intimacy, so to speak, with Jacopo della Quercia.

Our second option, an extremely serious step, was to seek from the Court of Appeal the recusance of Dr Bellagamba. If our request was denied, we would be back in court on 3 July facing the very same Dr Bellagamba, who would of course know of our efforts to have him removed. It was only after the appeal that I learned I could also have been liable for a substantial fine if the action taken on my behalf were considered frivolous or unfounded. There was no time to shilly-shally over a decision, however. The law provides that action must be taken within three calendar days after the alleged misconduct, including Saturdays and Sundays. To complicate the matter further, Filastò was due in court in Naples on Monday, so if we were to proceed the decision had to be made

there and then. The papers had to be drawn up over the weekend.

Basically I put my trust in Filastò who, without pushing, made it clear that I must either settle the case at this stage out of court or move against the judge. Being by nature a battler and believing deeply in the justice of my position and its future importance, he hoped that I would act against Dr Bellagamba. We ended up doing exactly that. In the process, I lost my other lawyer, Ferruccio Fortini, who perceived that he was being short-circuited. And naturally I was disappointed that our energies were being deflected from the case itself and also from the larger issue, namely the plague of uncontrolled restorations all over the world.

We lost the appeal. The court concluded, on the basis of denials from the judge and Ugolini, that the overheard conversation had been misunderstood. Bellagamba claimed that the conversation was brief and touched only generically upon crimes relating to the press, and not the specific case in question. Yet Filastò was content, even euphoric, because the lengthy declaration by the court, he assured me, contained a veiled threat to the judge to the effect that the case must be prosecuted fairly or the Court of Appeals would take up the matter again.

Here it is worth considering posssible ramifications of the case. Would the conviction of James Beck be seen as a justification of 'the Italian School' of restoration, or at least a vindication of Italy? Was the case understood by the presiding judge as a national face-saving issue in a country where outward appearances mean a great deal? Could reasoning of this substance be behind the Florentine *magistratura*'s determination to prosecute such a thin case in the first place, and their reluctance to bring in the Italian journalists and the newspapers? Or, I wondered, framing the question more paranoically, was this a chance, finally, to shut me up altogether? I had certainly offended a good many people over the Brancacci Chapel and the Sistine Chapel restorations (both of which are discussed, in Chapters II and III respectively) and the charges may have been a vendetta of sorts by the faceless establishment. After all, Caponi specifically mentioned my disapproval of the results

16

obtained in both the Florentine and the Roman restorations. Indeed, I had learned that some people in the art field were gleeful at the prospect of that sonofabitch Beck losing the court battle in Florence and even ending up for a time in the clink.

Perhaps most persuasively, the catalytic force in the move to convict me may well have been the desire to avoid any possible domino effect on other restorations. In Florence, billions of lire are spent annually on the restoration of buildings – churches, palaces, squares, fountains, outdoor statuary and loggias. The 16 million lire that were paid to Signor Caponi as a fee for undertaking the *Ilaria* restoration is infinitesimal in relation to the total, but if reservations about these mainly unnecessary and often damaging restorations are permitted, then the construction companies, their suppliers, government officials at various levels and also those who might benefit from kickbacks risk losing substantial amounts of money. The economic importance of restoration in Italy has been confirmed in recent revelations. It now appears that during the 1980s nearly a half a billion dollars allocated to restoration through a fund (FIO, Fondi di investimento per l'occupazione) were distributed to refurbish masterpieces in Italy, but there is little trace of any work actually having been done. Twenty-seven firms were involved in the operations, and an investigation is now underway. The point here is that none of the individuals directly or indirectly involved could be expected to speak out about unnecessary restorations.

Obviously my analysis is pure conjecture, but the fact remains that restoration is undoubtedly a major activity in Florence and Pisa, and any threat to its profitability would be unwelcome, all the more so since scandals have broken out. The Fountain of Neptune with its famous statue, the *Biancone* (that is 'the big white thing'), has after three different cleaning campaigns become in part a greenish yellow. In the same Piazza Signoria, the eighteenth-century paving stones disappeared during an archaeological campaign, and in their place unbecoming, flat, machine-cut ones were laid down. The patchwork result angered the citizenry, and the

courts convicted a number of those responsible.

Whether or not secret forces were operating against me I shall never know, but as 3 July approached I became increasingly apprehensive at the prospect of facing Dr Bellagamba again in the courtroom. As it was, the pre-trial hearings in Turin were held before the scheduled session in Florence, so my lawyer and I concentrated on that appearance. At the start of the hearing, Filastò asked to have the twenty-four pieces of documentation entered as evidence as before, in Florence. Ugolini objected, but this time our side prevailed.

During the Turin hearing we had good news from the outside, too. The court in Livorno had dropped the charges, or rather they had decided not to bring them at all. This was, in fact, the first verdict we had, and our hopes soared. It certainly struck me as odd, though, that for one court there was no crime while for another there still might be. After all, the interview given to *Il Tirreno* (Livorno) was simultaneous to the one given to *La Nazione* (Florence), the only difference lying in the interpretations of the journalists.

We hoped that the outcome in Turin would influence the tribunal in Florence. And there I was not alone; the testimony of the journalist who wrote the article for *La Stampa* was authoritative and convincing, I thought, and of course he was able to express himself much more accurately than I could. I was quoted as saying that after the intervention on the *Ilaria* it appeared as if cleaned with Spic 'n Span and shined with Johnson's Wax. I also had an opportunity to testify and, although apprehensive, I gave a professorial plea for freedom of speech and freedom of criticism. The Court President in Turin conducted the proceedings with the utmost seriousness, and did not show any desire to rush the hearing. He too found in our favour. Returning to Florence and to Dr Bellagamba, therefore, we were armed with two victories (or really three, since in Turin two cases had been handled together). Given the background as we knew it, though, anything could happen.

As I walked alone from the Santa Maria Novella train station early on the morning of 3 July, the eve of Independence Day in the United States, I hardly knew what to expect. I remembered that as a boy I had lived a few hundred yards from Thomas Paine's house and mulled over his words about liberty and freedom. I hummed patriotic songs to myself. Arriving at the now all too familiar court-house, I looked around for Filastò, but to no avail. Ugolini was there. So was Caponi and apparently some of his relatives, including perhaps his mother. Everyone was confused, not quite sure where to go while waiting for the courtroom to clear for our case. In the absence of my lawyer I thought I would defend myself, and actually said so to someone, but was quickly told that that is not possible under the Italian system.

Struggling with a battered satchel full of books and documents, Filastò came racing in from the station at the last minute. His train had been late. When we entered the courtroom Ugolini was visibly upset. In a short time we realized why: no Bellagamba. A new tribunal had been appointed because, we were told by the new presiding judge, Dr Bellagamba had stepped down from the case. The other two judges were also new. Filastò's enthusiasm over the result of the appeal had proved justified. Perhaps some sort of deal had been hammered out in which the court would uphold its judge, but on the understanding that he would not try the case.

The 3 July session was another anticlimax of sorts, as the case was postponed until 7 November. But the conditions were now quite different. My sabbatical had by then ended and I was back teaching in New York. Thus in November I had to make a special trip to appear in court. This time I was relatively free of anxiety but Ugolino had one final card which he played skilfully. He claimed, with some justification I thought, that the case had to start again from scratch, given the new circumstances. During the subsequent debate there was talk of a compromise between the parties to avoid further lengthy and expensive litigation. That would, in effect, have been a victory for Caponi, whose legal position had become most precarious.

19

On grounds that I entirely failed to understand, the court accepted the validity of the earlier testimony taken under the previous President. No new witnesses were therefore called, although I was given another opportunity to speak on my own behalf. This time I had prepared a statement. Delivered in Italian, the text, which I sometimes persuade myself influenced the court, read:

During the past three decades I have pondered the art of Jacopo della Quercia and have studied his sculptures together with those of his contemporaries, including Donatello and Ghiberti, and those of his followers, chief among them being Michelangelo. I have sought to extract from the documents related to his life and works insights in order to elucidate the art of this Tuscan master. I suggest that I have earned the right to speak in a public forum about his art. In fact, after a dreadfully long space of time, my third book dealing with the artist, a monograph in two volumes, has finally appeared.

I believe that not only do I have the right to defend his magnificent statues and reliefs against what I believe to be mistreatment, I also have the obligation to do so: if I declined to speak out, it would be I who were negligent. I would have failed in my duty as an academic, as an art historian and as an art critic to express an expert opinion in the market-place of ideas. This does not suggest that there are not other expert opinions which might not agree with mine, nor do I claim special privilege. Yet following a scholarly prepara-tion and long experience with the material, and, I might add, a period when I was a student at the Scuola del Nudo at the Accademia delle Belle Arti in Florence, not to have spoken out would have been not merely cowardly, but a dereliction of duty.

The possibility that the considered observations of art critics and art scholars should not be aired, or that their

judgements need to be cloaked in palliative euphemisms if they are expressed at all, is a dangerous precedent for the principle of free speech and free criticism. If such rights, which are guaranteed by the world charter of the United Nations and by the constitutions of both the United States and Italy, among others, were qualified, the effect would be chilling, and certainly the true losers would be the art objects of the past and future generations who have every right to expect to enjoy and learn from treasures of the culture, conserved and preserved in the best manner possible.

I actually felt rather good about my performance, although by that stage the case had probably already been decided in the minds of everyone present. Yet there is always a wild card, and this time as things happened the court clerks went on strike. When the final session was held a week later I was back in the United States teaching. Caponi's lawyer asked not only that I should be convicted of the crime of aggravated defamation as charged, with a fair penalty, but also that I should pay his client for material and moral damages to the tune of 60 million lire.

Shortly after the trial was concluded, I received a euphoric telephone call from a Florentine painter friend who had followed the trial and who was standing with my lawyer. Then Filastò took the 'phone, and in his heavy Tuscan accent spelled out the results. He was justifiably contented.

I too was delighted and not just for personal reasons. The point had been legally established in Italy that to criticize a restoration, even severely, is acceptable.

Coda

On 30 March 1992, I learned from an article in Milan's *Corriere della Sera* that there were plans afoot in Lucca to move the *Ilaria* out of the church to a museum space created within the Oratorio di San Giuseppe, a few hundred yards away. Another savings bank,

not the Monte di Lucca which had paid for the restoration but the Cassa di Risparmio di Lucca, is the sponsor of the new museum. The issue of whether or not to move the monument from its long-time abode, which is readily available to the public, into a museum space with an admission fee, has caused something of a rumpus in the city. The article's final paragraph was a perplexing *non sequitur*: 'Now, an American expert, Professor James Beck of Columbia University, has sharply criticized the work of the restorer, maintaining that with the cleaning of the marble, the light and shade that exalted the work were removed. For this, Beck was cited in court, brought before a tribunal and then convicted for slander. The *Ilaria*, the judge recognized, has come back as beautiful as it was made by Jacopo della Quercia.' I immediately contacted the journalist whose byline appeared beneath the story: he apologized and said he would rectify the matter. He also said that though he accepted responsibility he had not written those lines. They were put together by the editorial staff of the newspaper back in Milan. I was reminded that the Director of the Vatican Museums repeatedly said that I had never been on the scaffolding during the restoration of the Sistine Chapel ceiling, although privately he acknowledged that I had been there twice.

Am I paranoid about some powerful group or lobby bent on diffusing my criticism? Maybe.

I

The *Ilaria del Carretto*

WHAT HAPPENED IN the course of that restoration which was in my view unnecessary in the first place? Has the work come down to us the poorer, after that 'normal extraordinary maintenance'? What was really done during that August of 1989 in the name of artistic restoration in the Cathedral of Lucca that was so vigorously supported by the Superintendency of Pisa, the Opificio and various art critics? The court did not evaluate or pronounce on the restoration as such, although it did have available the photographic evidence from before and after the intervention and some critical material, which we supplied. And while my point of view was not specifically supported by the judgement, it was determined to be legitimate and sustainable. Make no mistake about it, if my claims had not been sustainable, I would have lost straight away. Nevertheless, no serious, disinterested investigation by the authorities has ever taken place before or since, or probably ever will, which is the norm with restorations anyway. For that reason, I shall do my best to present one here.

An effective starting point is the technical report which Caponi submitted to the Superintendent of Pisa just before work began. It was based upon an on-site examination of the monument

conducted towards the end of July 1989. Under the rubric, 'the state of conservation', the *Ilaria* was described as covered by a thin veil of dust and fats which had turned black in the depressed zones and in small abrasions and cracks. 'The resulting strong blackening makes the contours appear stiffer and the volumes of the sculpture heavier.' This of course was largely an aesthetic observation, as were Caponi's additional comments about the 'readability' of the long sides of the sarcophagus containing the putti. In fact, the main thrust of his report on the appearance of the work did not seem to be scientific by any stretch of the imagination, although in the rhetoric of modern restoration 'science' was accorded exaggerated respect. Judgements about the artistic appearance of the sculpture, or any work of art for that matter, are by their very nature subjective and dependent on an individual's beliefs and expectations. These, in turn, are built upon the broader cultural environment of the age. What might have seemed harsh lines to Signor Caponi did not seem harsh to John Ruskin, nor to James Beck, and nor possibly to future generations whose taste will not necessarily be that of the 1980s.

According to Caponi's report the head of the woman revealed an abrasion, the nose was discoloured and a measurable loss of relief could seen both in the nose and in the eyes. As for the putti, the one under the dog's head was worn to the point that its face and hair were hardly legible. Since Amendola's excellent photographs had been taken only the year before, Caponi's observations may be checked with reasonable accuracy and, in all fairness, discrepancies between the photographic evidence and his statement cannot be pinpointed. Where it is strictly objective, his presentation appears to be a fair description of the *Ilaria* before the restoration. The head of the winged boy mentioned is indeed worn. On the other hand, a restoration cannot in any reasonable way bring back portions of the marble surface that have been lost except by replacement with modern insertions. Intervention can alter the colour to some extent, however. Caponi also noted graffiti in pencil, some tentative incisions poorly corrected and a spot of green from a flow

pen which after an inept effort to remove it had penetrated the stone.

The report concluded that, on the whole, the monument was in a good state of conservation and that almost all of the original polish had been preserved. (This is a remarkable assertion because the history of the work indicates several important moves, including instances of physical separation of portions of the tomb from the rest, beginning as early as the mid-fifteenth century.) The report went on to maintain that there was no original patina at all. (Patinas are surface appearances acquired through time and are distinctive to materials – those of marble, for example, differ from those of bone or ivory. Artists have often 'patinated' their own new works in imitation of time's beneficial effects. Sculptors like Canova and Nollekens are known to have toned down the whiteness of their marbles but because the practice imitates the effects of ageing, it is difficult to identify in old work.)

Keeping in mind the preliminary assessment, let us now turn to the reports compiled upon completion of the restoration.[1] There are in fact troubling discrepancies between Caponi's own final report, another one prepared by the Superintendency of Pisa in September 1989 in conjunction with the public unveiling of the cleaned monument, and still another communication, issued by the Superintendent herself on official stationery (of the Ministero di Beni Culturali e Ambientali), which was released to the newspapers on 27 July 1990 in response to my criticism. Furthermore, Caponi made occasional statements and gave interviews which also constitute evidence as to what really ensued in the north transept of Lucca's Cathedral in August 1989. The inconsistencies among the various documents tend to impair confidence.

We are informed by Caponi that the first phase of the treatment included the application of a thin layer of an anionic resin manufactured by Syremont, a Milanese company that belongs to the chemical giant, Montedison. A vigorous agent, it is costly and its use relatively experimental in that possible side effects have not been exhaustively explored. Caponi was ostensibly proud of the

fact that the same cleaner had been employed on portions of the surface of the Brancacci Chapel frescoes to dissolve the layer of dirt and varnish. He stated in an interview that 'the restoration of fresco and of stone are similar in many ways, because fresco is, after all, made with stone and water. When the water has evaporated fresco is technically a kind of stone.'[2]

The length of time that such products are allowed to work on a surface varies and is essentially problematic. In the case of the *Ilaria* the resin was left on for between five and fifteen minutes. As with an analogous product used on the Sistine Chapel ceiling, the number of minutes for which the chemicals were allowed to work was empirically decided, not based on extensive scientific testing. Such matters can be subject to changes of mind. An analogy may be drawn between the recommended dosage of medicines.

An advantage of the resin would have been that it allowed the work to go ahead with all due speed. After all, the restoration would have disturbed the church's functions especially when machines were used; and besides, the famous monument was covered up with an unsightly nylon tent, and was hidden from the flow of summer visitors who wished to see it. It is not clear how long Caponi took to complete his restoration, for which he was paid a fixed sum regardless of the time taken. Church officials thought it a matter of days, and while Caponi was generally vague, he apparently claimed it took about three times that long, up to about three weeks.

If we are concerned with establishing certain guidelines for the future, if we can learn lessons from past experience, including the *Ilaria*, one result seems more than obvious. Notwithstanding good intentions (is not the road to Hell paved with them?), we should avoid giving an award for speed in restorations where there is no emergency.

In addition to the issue of speed, the choice of a synthetic resin ought to have rung alarm bells because such chemicals can, many believe, provoke molecular changes on the surface of stone. Once

the surface of the *Ilaria* had been softened up, the deposits on it and presumably a part of the surface itself were removed with the aid of a 'pistol' or *microdropulitrice*, as Caponi testified in court. A mixture of de-ionized water and plastic pellets (20 per cent) was fired on to the marble, especially into the more inaccessible fissures. At the core of this aspect of the cleaning, as in nearly every case with both painting and sculpture, is the question of whether the physical surface of the monument itself, not merely dirt or fatty deposits like candle wax, was removed. Caponi has consistently denied sanding, filing or mechanical smoothing out, but his statement offered in *La Nazione* on 27 July 1990, shortly after the public controversy exploded in the press, seems to speak for itself. There he explains, 'To remove the abrasions [scratches and marks that were on the surface of the *Ilaria*] we [then] made use of a machine similar to a small pistol, that fired air, water and a percentage of microspheres of plastic which upon impact with the surface, did not produce other scratches . . .' This statement is for me a drastic admission. There are, after all, only two ways of eliminating abrasions: either they can be filled in, or they can be smoothed away. Since Caponi used the second approach, it appears that he must have removed some of the surface adjacent to the abrasions, to make the indentations level with the surface. From his own explanation, Caponi's technique seems to be a modified form of sandblasting, using pellets of plastic rather than grains of sand. On reading the profile of the *Ilaria* one can indeed see a change from the pre-restored condition that is best explained by a process involving smoothing of the surfaces. And how else could the losses in the mouth and in the nose which were described in the condition report have been corrected except by adjusting the surface? Obviously the best way to determine the actual situation would be to institute an open discussion among the parties concerned with ample photographic evidence as well as a first-hand examination of the monument under proper visual conditions. This has yet to occur.

Caponi emphatically defended his treatment of the *Ilaria*: 'I am

proud of the work undertaken and am certain that not even minimal damage to the monument has occurred as a result: I continue to consider this restoration as an achievement for me as well as for my company . . .' Yet when asked whether he had destroyed the image of the *Ilaria*, the restorer offered a rather odd though revealing answer: 'Perhaps, but I am merely a technician, I am a restorer who seeks authenticity of the object [*manufatto*], bringing it back to its original state.'

If the methodology of 'cleaning' leaves something to be desired, Caponi's modification of the surface after the cleaning is also highly problematic. As revealed in his post-operative statement, a layer was applied of a modern synthetic oil which happens to be extremely costly. This application was described by the director of the works for the Superintendency who, in a press release (September 1989), explained that the product, Fomblin Y Met, was also employed to try, in so far as was possible, to diminish the discrepancies between the zones that had retained their original polish and those that had not. Fomblin is normally used only for works located out of doors, so that its application for aesthetic as well as protective reasons is probably unique to this case. Fomblin is not highly regarded by everyone in the restoration field, in Italy or elsewhere. As far as I know it is not used at all, for instance, in Rome or Venice, for interior or exterior sculpture, or at museums like the Victoria & Albert in London because it has negative side-effects. Since Fomblin penetrates deeply into the stone it can change the colour and appearance, bringing out imperfections deep in the block. The product attracts dust and furthermore can cause spotting, as happened on the façade of the Cathedral of Lucca, especially around the main portal.

After the Fomblin, beeswax was also applied. This seems harmless enough although in modern restoration practice it is now widely frowned upon. The 'plastic' appearance that some notice when viewing the sculpture now may, in fact, be the result of these applications of Fomblin and beeswax to a squeaky clean surface. Despite the method of cleaning and the subsequent applications,

Caponi asserted in court that 'the patina and the original polish of the *Ilaria del Carretto* are still there'. This was a departure from his report, which stated that there was no patina present when he started work.

From these reports I form the following conclusions. First, the cleaning was not required for anything other than cosmetic purposes. The monument was in good condition before the cleaning and was not subject to any foreseen threat. Second, the present surface, free of chips and abrasions, cannot have been achieved without affecting the surface of the work carved by Jacopo della Quercia. Third, no analysis was made of the material removed from the monument, so we cannot now know how much marble was removed, if indeed some was; and the opportunity is now lost for ever of discovering whether della Quercia applied any pigment, gilding or other substance to any part of the monument, though historical precedent suggests he may have. Fourth, a chemical, Fomblin, has been introduced into the marble though no one can be sure what its long-term effects will be. Fifth, what has been done cannot be undone. The reversibility of intervention is a fundamental ideal in discussions of modern restoration but Caponi himself avowed that an 'intervention cannot be reversible'.[3]

What are the corresponding gains? It is no surprise that Caponi's first report leans so heavily towards the aesthetic, because the *Ilaria* now looks as we in the twentieth century are supposed to prefer it to look: white, waxy and all-over clean. I cannot change my view that it looks as if it has been cleaned with Spic 'n Span and shined with Johnson's Wax. Even if we are sure that this is how our generation wants it to look, rather than letting it bear the signs of its half millennium of dignified existence, can we be sure that future generations will share our taste? Is it likely that della Quercia himself expected it to look this way? He knew it would age, and in carving it he almost certainly planned the places where dirt would collect, creating an effect of chiaroscuro which has now been removed.

While on the subject of della Quercia and the gains and losses

involved in the restoration of sculpture, it is interesting to compare the fate of some other works of his, the reliefs and the in-the-round sculptures for the façade of San Petronio in Bologna. These certainly needed attention for they were suffering from the villainous deposits of a modern industrial city, besides the unaesthetic menace of pigeon droppings. And certainly positive, if transitory, aesthetic gains have resulted from their restoration. Liberated from a sooty blackish crust Jacopo della Quercia's reliefs at first appeared fresh and lively. On the portal, the play of colour between the whiteish stone or marble and the Veronese red can be appreciated as it was conceived, a vibrant and rewarding juxtaposition which is accentuated by the strong light of the piazza.

But the restoration also has its drawbacks. Parts of the stone were so friable that the restorers had to leave them untouched. Had they been cleaned there was a distinct danger that they might crumble into powder. The net effect is very noticeable in *Cain Slaying Abel*. Cain's face, neck, right arm and shoulder, and also the finished drapery around his waist, have been severely damaged over the years. Abel's face has disappeared. In order not to incur further risk, blackish layers have had to be left over much of the relief. Since part is bright and clean and part not, a sensible reading of the whole is now virtually impossible. The contrast between black and white creates other problems too. The surface is pockmarked in many places, leaving flecks of black in the stone. The *Madonna and Child* is the worst case, the Madonna's face looking as if it is suffering from a severe case of eczema.

A still more serious defect, from the visual point of view, is the deceptive outlining now apparent in some of the reliefs. This effect is seen most graphically in the *Creation of Eve*. Eve's left leg looks as if it were an outline drawing by Matisse rather than an undulating relief sculpture. There was difficulty or danger in deep-cleaning the contours, especially those places where the bodies of the figures are connected to the ground plane as in the right side and leg of Adam, and the right side of Eve's body. In some

places the darks that have had to remain appear in a reading of the relief as shadow, which is of course deceptive. So in 'saving' these works the artist's intentions have been seriously distorted, just as I argued they have been with the *Ilaria*.

And have the works in fact been saved? They are still exposed to the pollution and the pigeons. The earlier coats of grime, which offered some protection against later and more sinister pollutants, have now gone. So too has the protective, wax-based coating the restorers discovered had been applied when the sculpture was made. In their place we are offered 'scientific monitoring', in which I at any rate do not have complete faith.

A recent visual examination has revealed to me that even a relatively few years after the radical 'cleaning' (which employed, it might be added, the same solvent that was used on Michelangelo's Sistine Chapel ceiling) the sculptures are now a uniform pallid grey punctuated by some black spots from the pre-restorative state. The entire surface is covered with a faint coating of new pollutants. The pigeons, too, continue to create their special havoc, passing through the wire nets, now broken, that were installed to impede them.

Would it not have been better for all of Jacopo della Quercia's sculptures at San Petronio to have been removed from the portal and brought indoors, leaving faithful copies in their place? That would have provided a far more certain solution to the problem of their conservation.

Caponi's report on the state of the *Ilaria* never mentioned that its illumination was inadequate, even when the yellowish artificial light was activated briefly by coins. The side door leading into the north transept, which could produce considerable light, was and continues to be draped with a heavy curtain. A decent system of illumination which would not have been physically damaging in any way, might, if combined with a superficial dusting, have achieved much of the effect the restoration seems to have aimed for, and at considerably less expense. Ironically, even after the restoration and the controversy, the light is provided by the same

inadequate source. As in Bologna, less glamorous and less risky possibilities were left unexplored.

Simple solutions which do not involve 'scientific' interventions and miraculous transformations have very little appeal for restorers, sponsors or the rest of the restoration establishment. I shall return to this issue in a later chapter.

II

Masaccio, the Brancacci Chapel and the *Trinity*

IF THE *ILARIA del Carretto* is a monument of high distinction in the firmament of European art, the frescoes in the Brancacci Chapel in Florence, and in particular Masaccio's *Tribute Money* and his *Expulsion of Adam and Eve from Paradise*, are arguably of even greater power. They are located in the Church of Santa Maria del Carmine on the 'other' side of the Arno, that is, on the Pitti Palace side rather than the Uffizi Gallery side.

Felice Brancacci, a prominent merchant of some political note, had his family chapel decorated with murals after returning from Egypt, where he had been sent on an ambassadorial mission. They were undoubtedly initiated around 1424 by the gifted late Gothic painter Masolino. After executing the vaults, probably showing the four Evangelists and lunette scenes directly beneath, Masolino left Florence for greener pastures in Hungary. Fresco, unlike, panel painting, can be produced with surprising rapidity, and the work on the entire chapel could comfortably have been executed in a year or so of steady work. With two masters working side by side, the time presumably would be reduced proportionally. It appears that at the beginning of 1427, give or take a year or two, a younger painter from the region, Masaccio, was brought in to

execute the rest of the cycle, which deals with episodes in the life of St Peter. Masaccio had only recently produced an important altarpiece in Pisa, the central panel of which now adorns a wall of London's National Gallery. Soon after Masaccio had taken over at the Brancacci Chapel, Masolino appears to have come back from Hungary and participated again in the project. Thus three phases may be reconstructed: one all Masolino, one all Masaccio, and then a collaboration between the two. Soon, however, for unknown reasons, both artists abandoned their Florentine activities, leaving the Chapel unfinished.

Only in the early 1480s, when both painters were long dead, did the cycle receive its final scenes, from the hand of Filippino Lippi, the son of Fra Filippo. The attributional problems surrounding the frescoes of the Chapel have long occupied connoisseurs, who delight in sifting out the portions of the frescoes among the three artists, and perhaps even a helper or two, including Fra Filippo. For centuries, separating Masaccio from Masolino, in particular, has been a favourite challenge for art historians.

Study and analysis of the frescoes have been hampered by alterations that were made in the seventeenth and eighteenth centuries. A new marble altar was positioned around 1650, partially overlapping some of the fifteenth-century passages located on the altar wall; and some frescoes in the vault were replaced, along with those in the lunettes, by 'modern' depictions. As if these losses and alterations were not enough, a fire swept through the vast Carmelite church in 1771, destroying most of the building. Miraculously, the Brancacci Chapel was saved, but apparently the frescoes were damaged by smoke and heat, and some of the colours may have been affected.

For better or worse, the frescoes were cleaned and revived at different times both before and after the fire. At some undetermined point the genitals of Adam and Eve, in the *Expulsion from Paradise* and the *Fall*, were given new leaf-covers. The frescoes in recent memory appeared to have a warm, orange filter in front of them. The appearance in several scenes on the altar wall of a

hazy, whiteish mould on the undulating surface, whose presence seemed to challenge the future integrity of these scenes, was visually troubling. Despite all the difficulties, the Brancacci Chapel, until the early 1980s when it was closed off to the public, was a sacred shrine for art, and from the very beginning the frescoes have had an impact on both artists and the public that far outdistances their scale.

The revolutionary impact of Masaccio's contribution – his inventiveness, the strength of his figures, their dignity, and the harmony between them and the landscape, as well as the remarkable atmospheric effects – was enormous. And this before Masaccio reached his twenty-seventh birthday. The *Tribute Money* signifies a breakthrough in narrative painting that has no equal. Nor should it come as a surprise that Florentine artists over the years paid homage to Masaccio and his fresco scenes at the Brancacci, as well as to the lost monochrome fresco in the cloister attached to the same church. These paintings were copied and studied by the finest masters of the time, headed by Michelangelo, and were thought of as an unofficial school for artists. To some extent Masaccio was always a painter's painter, an artist's artist, and when he died still in extreme youth, Brunelleschi in particular is said to have lamented.

For decades Florentine Superintendents of Fine Art were keen to restore the Brancacci Chapel but not until 1981, under the administration of the then Director of the Opificio delle Pietre Dure, Professor Umberto Baldini, did the project get off the ground. The moisture that was seeping into the walls as well as the mould seemed clear warning signals of increasing trouble. Unlike the Sistine Chapel, where a thorough restoration appeared to many observers to be totally unnecessary, the apparent threat to the Brancacci frescoes was readily visible

The preliminary phases of the Brancacci restoration unfolded almost simultaneously with the restoration of the Sistine Chapel ceiling, which began in 1980, and together they must be thought of as the most prestigious and influential restorations of the decade,

if not the century. The actual work of cleaning and subsequently integrating the Brancacci frescoes was undertaken from 1984 to 1988. As we shall see, the conduct of the Brancacci Chapel restorations *vis-à-vis* the general public could not have been more dissimilar to that of its much vaster Roman counterpart. In the Vatican, the cleaning advanced section by section with great fanfare. Publicity was focused on the 'splendid' discoveries, the 'new' Michelangelo, and since the restorative activities were conducted while the Sistine Chapel was still open (and while tourists were paying their entrance fees), most of the ceiling was constantly visible.

Not so with the Brancacci. Had the Chapel been open to the public it would have been physically impossible to attend properly to the work, simply because the scaffolding filled the entire space. The restoration was thus much more secret than that in the Sistine Chapel, with only a few specialists authorized from time to time to observe the progress of work, not counting, of course, well-connected clients and friends of the sponsor, Olivetti Corporation. Olivetti's funding for the Brancacci arrived after restoration had begun. By restricting publicity, the directors of the restoration were able virtually to control potential criticism. Indeed, in contrast to the insistent opposition heard during the course of the restoration of Michelangelo's ceiling, hardly anyone complained about the Brancacci Chapel restoration, at least while it was being carried out.

Only one minor scandal occurred. A local photojournalist disguised in the characteristic white coat of restorers entered the closed-off Chapel, went straight up the scaffolding and photographed the Adam, now fully naked, even before total defoliation had been accomplished. Baldini was livid; the journalist was brought to court but eventually carried the day. One might be puzzled by the anger surrounding the leak, unless it were interpreted as having disrupted the publicity plans to unveil the results of this rather sensational aspect of the restoration in such a manner that credits and honours could be harvested to greatest effect.

Indeed, illustrations, not to mention technical data, were not made readily available during the restoration itself. They had to await the publication of rehashed monographs on Masaccio and inconclusive summaries of the restoration process. In general, there was in fact very little discussion about the details of the restoration and virtually no opportunity for debate. The crucial decisions were made by the tiny circle specifically charged with undertaking the work. Occasionally, unofficial consultations, or rather explanations, took place in public, usually with exclusive slides of the bright and striking results.

No thorough and disinterested book or article on the subject has yet appeared although an admirably researched book, and one basically sympathetic to the restoration, was published in 1991, not by an art scholar but by an American journalist living in Florence, Ken Shulman. His presentation is based largely upon interviews of the principal personalities connected with the restoration, and provides eminently illuminating raw material on the subject.

When the frescoes had finally been restored, the public and experts alike were handed the finished product on a take-it-or-leave-it basis. On the whole, they took it joyfully, although muffled displeasure from artists and art scholars was expressed here and there.

Early on, a discovery was triumphantly announced. Sections of a decorative frieze and two small roundels with heads in them, located in the Gothic window embrasure that had subsequently been filled in, had been found. To the glee of the sponsors, not to mention the restoration team, Baldini pronounced one of the heads to be by Masolino and the other by Masaccio – no innocuous 'School of' for these finds. This art historical claim based upon arguments concerning the assumed collaboration or rivalry between the older and younger master was echoed widely in the daily press, the weeklies and specialized journals, including Baldini's own *Critica d'arte*. But it found only feeble scholarly support. Few believe that what was uncovered has anything to do with Masaccio. Personally, I doubt that Masolino himself was

37

responsible either, for heads or frieze. For that matter I question whether this decoration was even part of the Masolino-Masaccio programme. Indeed, the window decoration could have been done at a slightly earlier moment, before the more ambitious mural project was undertaken. Of course, as always with attributions, the existence or absence of a consensus proves very little in itself, simply because there are fashions and currents in connoisseurship as there are in art and in restoration.

The issue of whether or not to bare Adam's sexual organ (Eve's was mostly hidden by her hand in Masaccio's *Expulsion* but not in Masolino's *Fall*) was something of a national dilemma. Eve's total nudity in the *Fall* did not attract the same attention, either because of Masolino's lesser critical reputation or because complete male nudity is somehow more sensational than complete female nudity. The question which launched the only public outcry concerning the restoration was whether to remove the leaves painted over the genitals or to let them stand as they appeared before the restoration began. The art historians in charge of the restoration petitioned the authorities in Rome to permit their removal because, they confidently asserted, the leaves had been painted in the seventeenth or eighteenth century (specifically between 1652 and 1798): the leaves were not by any stretch of the imagination original. Adam's sexual organ is certainly among the major 'discoveries' of the restoration, but whether or not the leaves should have been removed is an interesting issue. From the infamous, illicitly taken photograph it appears that the restorers, evidently anxious to get to the 'heart' of the matter, removed the crucial foliage that covered the genitals *before* attacking the other leaves dispersed more casually around and on the side of the figure. Apparently the urge to see the crucial member got the better of a more patient, methodological approach.

What the restorers found was a robust member, alleged in Florence with characteristic local pride, at least around the Ponte Vecchio, to be the finest example ever painted.

Should the leaves have been taken off? In the name of getting

back to the original, I suppose, one could present a case for stripping them. Yet we do not know what Masaccio's intention was. It is possible, if only remotely so, that in a later *a secco* adjustment he painted leaves over the genitals himself. This suggestion is certainly compatible with what is known of fresco technique, as the following explanation will show.

On a rough plaster base, the *arriccio*, the artist would outline his painting in red earth, perhaps using a cartoon. That outline is called the *sinopia* or underdrawing. On top, a coating of fine lime plaster was spread, a *giornata* or day's worth at a time. This was the *intonaco* to which pigment was applied. After *c.* 1430 the use of *sinopie* declined as artists took to transferring designs made full size on paper directly on to the *intonaco* by tracing or by pricking and dusting (*spolvero*).

Fresco painting is much more complex technically than is popularly thought. In its theoretically 'purest' form – so-called *buon fresco* – colours mixed only with water are applied to the still wet surface. By a miracle of chemistry (to which we will have to return in more detail in Chapter IV) these colours are 'locked' into the surface of the plaster and become, thereby, part of the building itself and not a coating or film on the surface. The aesthetic effects attainable with this technique are highly prized and the finished *buon fresco* surface (whose crystalline surface mimics marble) is hard, washable and, given an unpolluted dry environment, extremely durable.

Historically, the goal of producing such pure fresco has rarely been achieved. Most *buon fresco* was 'finished off' to a greater or lesser extent with additional painting applied when the surface was partially or totally dry. This latter technique – known as painting *a secco* – was used for a variety of reasons. First, to extend the range of colours: in *buon fresco*, only mineral colours can be used because the caustic properties of lime damage others. Second, to make adjustments for the uneven and unpredictable effects on the colours and tones produced by the drying of the plaster. Third, to make the kind of leisurely embellishments or revisions that

are impossible in the swiftly executed *buon fresco* where the artist races against time as the plaster dries and begins to acquire its crystalline surface.

In *secco* painting, the colours are *not* incorporated into the fabric of the plaster and must, therefore, be 'bound' or 'tempered' by a material (glue, size, egg or oil) that will adhere to the surface. Some 'frescoes' have been carried out entirely *a secco* on dry walls which have been primed or sealed with one or two coats of glue or size.

To complicate matters further, the distinction between 'in the wet' or 'on the dry' painting is not absolute: hybrid methods exist which combine features of *buon fresco* and *secco* painting. In *fresco secco*, a dry plaster surface is saturated with lime water (the active ingredient in *buon fresco*) and mineral colours bound in water are applied to it. Just as in *buon fresco,* a crystallization of the surface occurs, fixing the colours but to a reduced extent and more vulnerably. In compensation, the process was commonly strengthened by applying the colours with a watery solution of casein (a milk-derived adhesive). This technique is described as 'lime-wash' or 'lime-milk'.

Thus, an artist might paint a whole mural in *buon fresco* on the still wet, fresh plaster, or *a secco* in tempera on a completely dry plaster; or in *fresco secco* on a wetted, once dry plaster. A painting might be begun as *buon fresco*, continued as *fresco secco* and completed *a secco*; or begun as *fresco secco* and completed *a secco*; or begun as *buon fresco* and completed *a secco*.

Whatever the method or combination of methods used, all parts, whether mineral or organic, are vulnerable to attack when pollution levels are high or conditions poor. *Secco* work, which lies on the surface, is particularly prone to injury by harsh cleaning, fungal growth and internal decomposition. It can harden, darken and crack, or flake from the plaster surface. *Buon fresco* is very much prey to air-borne pollution and to the migration of water-borne salts within the fabric of the building. Traditionally, such frescoes have been left untreated but in modern times, with rising levels

of pollution, restorers have taken to 'varnishing' them with glues or resins, natural or synthetic.

Because old frescoes are so often composed of accumulated and interlocking layers which defy scientific analysis – no means exists, for example, of separating or dating glue layers – it is impossible to clean them with complete safety and without controversy. In the face of this impenetrably complex material restorers have often elected to remove all organic material from the surface of the plaster, even in the knowledge that it contains or is likely to contain original work.

It is possible, therefore, that Masaccio himself added leaves to his *Expulsion* in the Brancacci Chapel although not the actual leaves that survived until 1984. There can, at all events, be no certainty that he did not. Surface adjustments made by the original artist are usually less long-lived than the portions painted in *buon fresco*. If Masaccio had added leaves, they could have been lost, perhaps in earlier restorations. I first noticed long ago that the added leaves on Masolino's *Fall* were different from those in Masaccio's *Expulsion*, both in style and in the way they are disposed in the scenes. Is it then not possible that they reflected in each case a previous tradition? A drawing in the Louvre attributed to Michelangelo, which copies quite faithfully the Adam (and Eve) from Masaccio's *Expulsion*, offers another bit of puzzling but fascinating information. Michelangelo (if the drawing is his) shows the male organ with much less prominence, in a markedly different appearance from what has been uncovered. The genitalia in the drawing are close in interpretation to Michelangelo's painted treatments found on the Sistine Chapel ceiling. It is thus possible that Michelangelo found Masaccio's Adam covered and unveiled it in his own style.

In summary, I am suggesting that the leaves proudly removed could have been a repainting, freshening up or reconstruction of earlier leaves, which originally might have been painted by Masolino and Masaccio themselves.

The removal of the leaves by modern restoration will not have wiped away these painters' own paint, but it may have wiped away

41

their intentions for the frescoes. Furthermore, even if the scenario I have sketched is only remotely possible, what harm would there have been in retaining these innocuous leaves until they had been researched more thoroughly? At the least, they were part of a historic situation of two hundred years' duration. Given the level of technical sophistication now available, facsimiles could have been constructed to show the figures both ways, without actually touching the surface. The sacred computers could have been put to solid use.

Professor Baldini asserts that with the aid of reflectography (a technique which allows the reading of underdrawing in panel pictures as well as in frescoes), it was determined that 'neither Masaccio nor Masolino had planned to cover his figure's genitals . . . there was no hint of the branches in the underlying drawings [that is in the *sinopie*] . . . the leaves were strictly a superficial phenomenon, and that as such they could be removed without modifying the whole work'. He maintains that cancelling the leaves was 'an act of total and absolute respect for the original work'. Such an assertion should not go unchallenged. There is no reason whatsoever to expect that the underpainting would reveal what the painters decided at a later stage in the pictorial process, especially where *secco* applications are concerned. In this respect reflectographs have little relevance, but by bringing to the discussion the mystique of scientific corroboration with modern technology, as has often been the habit in recent discussions dealing with restoration, a title of validity had been co-opted.

Apart from the issue of the artists' intentions, there are other, more worrying consequences of the restoration in the Brancacci Chapel. It is in the overall appearance of Masaccio's *Expulsion* that these consequences perhaps reveal themselves at their worst. Created on a strip more than twice as high as wide, though appearing less narrow due to its high placement, the scene of the *Expulsion* stands among the most successful figural inventions in the history of art. Masaccio's conception of the figures is largely empirical and even slightly deficient by later standards: the proportions of

Adam, when measured, reveal a short torso, a somewhat awkward right leg, truncated arms and enormous feet. 'Errors' abound, yet the overall effect is visually impeccable. The *Expulsion* is also distinguished for its psychological insights. Eve reacts to being driven from Eden with a shriek that pierces the stark landscape; Adam, teeth nearly clenched, buries his face in his hands, despairing. The colour was held to a restricted range and generally acted to maintain a clarity of reading and purpose. This was the *Expulsion* I remember from before restoration.

Today the effect is distinctly altered. Besides the brittle-seeming surface of the figures, the awkward and harsh shadows cast on the ground and the elimination of atmospheric effects, a general ambiguity between background and figures now persists. We are not sure spatially where things are or should be. Such a disruption of the operation of planes often occurs with drastic, and even with more moderate, restorations. For example, the sky between Adam and Eve, near the newly exposed genitals, now appears to jump out in front of both figures. The deep blue patch around the upper portion of Adam's body is more like a modern-day abstraction than the background of an early Renaissance painting. Perhaps most disconcerting of all the new effects that the restoration has brought to this scene is the accentuated separation between the *giornate*, or days' work, in the fresco. They are so sharply revealed as to become an unpleasant distraction to the reading of the scene. For instance, the earth beneath Adam's feet is a different colour from that beneath Eve's. Masaccio's intention cannot have been to deflect the spectator's attention from the dramatic figurative representations. Who could doubt that he unified his scene and modulated or totally hid the separations between one *giornata* and another? There are but four in this earth-shaking subject.

The question of leaves, which at the time were often added over the *buon fresco*, and were here perhaps added *a secco* by Masaccio, must also be faced with regard to the landscape elements in the *Tribute Money*. In the course of the restoration, leaves on some of the trees in the middle ground towards the centre of the pic-

ture and the foliage on the extreme left side of the composition were all but entirely wiped away. We now have oddly barren rows of trees that appear ungainly in the landscape. While quite possibly a tree or two could have been painted leafless, as a naturalistic interpretation of the landscape, to have nearly all of them so is quite unexpected, so much so as to require an iconographic interpretation. There can be no certainty therefore that what we see now is what Masaccio intended. Indeed, the contrary seems much more likely.

Three different episodes from Matthew 17 are encapsulated within the same fresco of the *Tribute Money*: the central scene, by far the largest, shows Capernaum, where Christ and the Apostles are approached by a tax collector who asks Peter whether his master will pay tribute. Christ instructs Peter to go to the sea, catch a fish, and open its mouth in which he will find a coin. This episode is depicted on the left, where Peter appears in the distance opening the fish's mouth. The third episode ensues on the right, and it represents Peter, still following Christ's instructions, presenting the piece of money to the tax collector, 'for me and thee'. Here is a reiteration of the 'render unto Caesar' theme that occurs elsewhere in the New Testament, signifying the Church's willingness to concede civil hegemony over political matters.

Peter struggling to keep the fish's mouth open is now framed by a leafless bush, quite unlike his setting before the intervention and unlike that in early engraved copies. Quite possibly, as the restorers claim, the green foliage they removed in this area was nothing but marks of a previous ('inept', they always are) restoration, and not Masaccio's own paint. Yet the scene is now so bizarre that it seems to me unthinkable that Masaccio himself did not paint leaves for the thicket, just as he must surely have painted leaves on the trees in the distance directly to the right of Peter and the fish. Of course, other art historians may take a different view. But while the truth is unknown it is surely wrong to present us with a revision that is iconographically and pictorially so improbable.

Whatever one's view of the likely authenticity of the image we

44

now see, one can accept that when the restorers removed the leaves historical authenticity was at any rate their goal. By detaching the leaves they sought to remove emendations that were not the handiwork of the original artist. But in exchange they have left us awkward and unconvincing barrenness, a condition parallel to the efforts undertaken during the past decade on Leonardo's *Last Supper* in Milan, where old restorations were systematically removed right down to the naked wall. The monumental draperies of some of Masaccio's figures have undergone restorations in the past and this time repaintings were extensively removed because, in the words of the Director, 'they are falsifying and do not comprise a part of the chapel's history'. But what has now been left is just unmodulated areas which produce an uncharacteristic, un-Masaccian flattening of the figures in a total rejection of the three-dimensionality which is his hallmark.

The insistence upon purism for certain portions of the fresco is in any case nullified by disregard for authenticity in other areas of the same fresco. For example, the restored edition of the *Tribute Money* has seen a good deal of so-called 'pictorial intervention' or new painting. At the extreme right, behind the messenger who receives the coin from Peter, we now discover a vividly painted stone bridge which was not there before. The area had been damaged in the past and was totally unreadable prior to the restoration. Some lines of *sinopia* may have turned up while the surface was being excavated. When asked, one of the young restorers working on the Chapel confided to me rather ingenuously that they had indeed painted that bridge, but that it was done in a manner that accurately reflected how Masaccio himself would have painted it!

Even if there had indeed been viable guidelines for a convincing recovery of the bridge, which cannot be confirmed from the available evidence, nonetheless the precedent for reconstructing paintings from *sinopie* is revolutionary. If followed, the restoration of frescoes would be turned on its head. Think of all the lost paintings by Uccello, Castagno or Mantegna that could be

reconstructed from the red-earth strokes still preserved on the *arriccio*.

The new paint, to be sure, though it runs contrary to the goal of fidelity, is bestowed in such a way that upon close examination it can be distinguished from the original, or at least older portions. This practice gives assurance that there can be no confusion between what is real and what is fake. On the other hand, the general public and even the reasonably aware read the entire cycle as given to them and consequently both in fact and in theory the present version represents, in my view, a serious manipulation.

In defence of this kind of repainting and a host of others, including the Sistine Chapel ceiling, a common argument has been that the repainted segments are reversible since they are, after all, in water-colour and can be readily removed with a damp cloth. It is of course excellent that they are reversible, yet despite the rhetoric I doubt that their removal would be an easy matter, partly because visual rapport with surrounding areas would then have to be achieved afresh. In all likelihood, we shall have that new bridge before our eyes for the next few decades. Consequently, the fact that it is removable is really only a matter of theory. Is it likely that a sponsor benevolent and enlightened enough to spend significant sums of money in this way will be found? I contend that the representation of Masaccio's *Tribute Money* has been for all practical purposes altered by a 1980s assumption about how Masaccio might have painted a bridge.

Newly painted golden halos are similar additions. Instead of simulating fragile, diaphanous confluences of rays, they now appear like heavy plates weighing on the heads of the sacred figures. The gold work found on the fresco before the restoration seems itself to have been a replacement of the original gold leaf and was probably applied some time during the nineteenth century. The modern restorers were able to determine the outlines of Masaccio's original halos which they employed as a guide for painting in new ones. In this case, then, the tradition of an old restoration, that is the

repainted haloes, was retained and somewhat heavyhandedly reiterated, while in the case of the leaves exactly the opposite occurred.

Broadly speaking, there are three options in handling those sections that have lost all tangible articulation. First, they can be left that way. Second, they can be repainted to harmonize as closely as possible with what surrounds them. Third, they can be given a neutral tonality that interferes as little as possible with remaining original passages but is readily and even disturbingly distinguishable. The last-mentioned approach had a certain currency about a generation ago, reflecting a particularly purist point of view which is now out of favour.

The specific solution reached for the Brancacci is something of a compromise between the second and third options. The result is an awkward patchwork, in which we have fully repainted segments alongside cleaned or skinned areas which function like unmodulated flat planes unconnected with the forms to which they are supposed to relate. Bits of original fifteenth-century tones now abut sections where they have been removed or zones repainted neutrally to reintegrate architectural elements, and whatever else is left of the undisturbed original surface. It is like a collage of fragments unified by a rather brittle-seeming, intentionally keyed surface. As one painter described it to me, here we now have the metaphysical Masaccio, that is, Masaccio in the style of de Chirico.

Underlying the exposition offered thus far is the realization that the choices in a restoration, especially such a thorough and all encompassing one, are virtually infinite. And every decision affects all the other elements or aspects, a lesson every art student learns during his or her first year of study. Certainly there is nothing easy about any phase, and whatever solution the restorers and their directors took, criticism could, would, and perhaps should have been levelled. When done acceptably, restoration and conservation require immense skill, good judgement, patience and a heavy dose of humility, due on the one hand to the complexities involved at

every step of the way and, on the other, to the potential physical and aesthetic harm that can result. Like the mistakes made by medical doctors, those of restorers are often irremediable.

In the final analysis, responsibility (and credit) must rest squarely at the feet of the chief restorer in tandem with the director of works, in recent times usually an art historian. Parameters are imposed by physical conditions as well as external factors including the extent of funding, time restrictions, and the availability of skilled assistants and collaborators. The key, however, remains the sensitivity, skill, knowledge, insight, orientation and intuition of the executor of the work together with his or her assumptions of what can and should be gained from any intervention, and what cannot or should not be.

The root of the problem with the Brancacci restoration, it seems to me, lies in the response at the start to one question: how encompassing should the intervention be, how clean is 'clean'? In defining the extent of a restoration certain flexibility is needed, since unexpected conditions will arise in the course of the work. What is essential, though, is the institution of a system of controls, of checks and balances, necessarily from outside the limited circle of the restorers. For an intervention such as that in the Brancacci Chapel or, as will be discussed, in the Sistine Chapel constitutes a massive recasting of Western civilization's sacred texts.

The restorers in the Brancacci Chapel particularly disliked a layer of gummy, translucent material that covered the frescoes. It was unscientifically but commonly called the *beverone* and it included in effect all the substances that had been applied on the surface during the various restorations, especially those of the eighteenth and nineteenth centuries, plus dirt and dust. It was assumed that these substances, which in large measure appear to have consisted of egg, should be removed. It was thought that they had been applied in the past to brighten the colours, somewhat like varnish. (The same general assumptions were reached about the glue layers on the surface of the Sistine Chapel ceiling and these, too, were removed.) In the Brancacci, the layer also contained carbons which

compounded the darkening of the images. These were thought to have come from the parking lot in the vast piazza facing the church. The frescoes were diagnosed as difficult to read and the future, according to the restorers, promised further deterioration.

The fire of 1771 was also assumed to have had a negative effect upon the appearance of the frescoes, even after diverse cleanings and adjustments. If the heat of the fire was so great that it actually altered the colours of the paint, as has been regularly asserted, could the present restoration reverse the process, bringing the colours back to their original vibrancy? Fifty years before this latest restoration, in 1932, a portion of a baroque marble altar was temporarily removed revealing several turbaned heads from the scene of the *Baptism of the Neophytes*, painted by Masaccio. They appeared remarkably fresh because they had been spared past restorations and exposure to the fire, and the overall original colour of the frescoes seemed to have been preserved. I understand that these colours were the ones used by the restoration team as the model for their chromatic reintegration once the cleaning phase was completed. But are they a fair standard upon which to standardize the reintegration?

Two objections may be raised. First, by the time that section of the frescoes had been covered, over two hundred years had elapsed, so that the heads really represent the state of the cycle at that point, not when it was originally painted. We must assume that air pollution was much less of a problem in the period from 1427 until the late 1600s than in the period that followed, and especially in the past hundred years. Yet candles were burned in the Chapel and cleanings took place. Thus the goal of the most recent restoration turns out to have been to revert to the appearance of the frescoes immediately before the baroque altar was set in place in the late seventeenth century. The cleaning in effect maintained the ageing and intervening treatments that the frescoes had undergone between 1427 and the time the turbaned heads were covered. What about the ageing since that period, the aura of history, the patina or whatever one might wish to call it, that

evolved between 1650 and 1984? The decision to work from the bits that had come down to us in their seventeenth-century state seemed to me an arbitrary one. In the light of these reservations it is surprising that Dr Ornella Casazza, the supervisor of the restoration, should assure us 'of the *certainty* [my italics] of a total rediscovery of the chromatics, even in the portions not protected'.

Did the fire really change the colours, as is claimed? The Director of the works, Professor Baldini, is forthright on the question: 'the frescoes . . . were damaged by the intense heat and flames'. If this is so, how was the restoration able to change them back, to achieve 'the recovery of the original shades of colour', except in those extensive areas that were repainted during the restoration?

Doubts also arise over the perpetuation of the artists' aesthetic intentions. How is it possible that the work of the three artists who were responsible for coherent portions of the decoration appear so similar today? Has the restoration tended to homogenize the entire ensemble? This apparent unity, which seems to be more the result of the restoration than a reflection of the appearance of the cycle after Filippino Lippi completed it around 1482, is certainly troubling. We now find that the differences between Masaccio and Masolino are not vast, contrary to the opinion of Masaccio's contemporaries, nor is it confirmed by Masolino's frescoes in Empoli and Castiglione Olona. Still more disconcerting is the perception that Filippino Lippi is not sharply distinguished from the two artists who flourished fifty years before him. In other words, the restoration has had a drastic effect on the appearance of the Chapel decoration as a whole, just as past restorations probably had, those past restorations unhesitatingly condemned as inept and even damaging. Will the essentially irreversible Brancacci restoration become yet another episode in the drama of questionable treatments of the 1980s?

Coverage of the Brancacci Chapel restorations in both the popular press and more specialized publications has emphasized the revelations made as a consequence of the intervention. Our know-

ledge of the frescoes has expanded, images entirely unknown have been exposed, bits of *sinopia* that had been buried in the wall for nearly six hundred years have been unearthed. Here, it is proclaimed, is justification for all the effort and cost involved – a new Masaccio, a new Masolino, a new Filippino Lippi. The conservation aspects, perhaps because they neither make headlines nor sway sponsors, are at the bottom of the publicity agenda. Is preservation the by-product of discovery, rather than the reverse?

As the restoration progressed we learnt of the discovered frieze and heads in *tondi*, the discovered penis, traces of *sinopie*, and so forth. Once the restoration was complete, the biggest discovery of all, the 'true' Masaccio, was unveiled. We were told that he was a brilliant colourist, a worthy predecessor of Fra Angelico (who was probably older than he was), Domenico Veneziano and Piero della Francesca. And Masolino, according to the restoration team, has emerged as a more distinguished artist than he was considered before, a worthy competitor of Masaccio. Other discoveries resulted from the restoration too, as indeed they must, since that is one of the rules of the game. You cannot have a decent restoration without discoveries. The blurb accompanying the new slides of the Brancacci on sale is symptomatic of how restorations are 'sold': 'The results are astounding: the dark, grim appearance has given way to brilliant colour and light. Previously obscured details have reappeared. The stature of the cycle as one of the landmarks of Western European art is only reconfirmed by this remarkable transformation.' The decorative frieze and the heads constitute legitimate finds, even if they do not represent the Masolino-Masaccio confrontation as Baldini would have it. This category of discovery did not cause damage to the fresco cycle, and one is naturally contented at the rebirth of these modest fragments. Two fragmentary *sinopie* from the altar wall in the zone above the surviving frescoes have likewise been attributed, one each to Masaccio and Masolino. They are, under any circumstances, quite difficult to read though they, too, have to be considered

engaging data, the full evaluation of which may take years to complete.

But none of the physical or critical 'discoveries' in themselves should be offered as a rationale for the restoration in the first place. If, as Baldini proposes, Masolino is a better artist than we had tended to think, such a conclusion is hardly worth the costs, still less the risks, of restoration. Discoveries, new insights, critical brainstorms, attributional corrections and the like should not be the purpose of this or any other restoration. Of course, we should not be blind to new situations that result from cleanings. When we have been dealt a new hand, naturally new critical constellations can and should be constructed. As it happens, I agree with Baldini that the head of Christ in the centre of the *Tribute Money* is by Masaccio and not, as an influential current of critical opinion has tenaciously held, by Masolino (which would have constituted a collaboration within individual scenes). The reverse may be said for the cityscape in the background of Masolino's *The Raising of Tabitha*. Baldini achieved his judgement on the basis of the restoration, which was useful for his critical apparatus. But one should never lose sight of the fact that the purpose of the restoration of a world-class monument, like the Brancacci Chapel, is proper and timely conservation so that the frescoes may be preserved to instruct and edify future generations, as they have past ones.

Scholars may be curious to see Perugino's altar fresco painted for the Sistine Chapel, which was covered over by Michelangelo's *Last Judgement* in the 1530s. Should we remove the lower portion of the giant fresco to satisfy such curiosity? It is likely that, given the technology that is currently being developed, that wish may come true *without* sacrificing Michelangelo's fresco. Time will certainly bring possibilities that should preclude definitive action now.

I suggest that a need, or really a demand, for discovery lies deeply ingrained within the social fabric of modern life, closely connected with the notion of progress. How can one expect art much less art restoration to be immune? Our culture is dominated

by the mass media and the discovery of hitherto unknown heads by Masaccio and Masolino is news, enthusiastically picked up by television as well as newspapers. It makes little difference whether the viewers know who Masaccio and Masolino were, or appreciate the real importance of the presumed discovery. Cumulatively, such discoveries bring credit to everyone connected with the project – the Director, who appears to have priority over publication (not to mention close control over the reproductions); the restorer who actually makes the find; the Director General of Fine Arts in Rome (or wherever it may be) who can develop a dossier of what is found during his stay in office. But most of all, credit goes to the sponsor, whose chief motive for 'investing' in such enterprises in the first place is this favourable publicity. Many of the same factors were important in the Sistine ceiling restoration.

The public pronouncements concerning the Brancacci Chapel restoration have minimized the conservation aspects, though these must be considered the most crucial. The really important questions are how the frescoes will appear over the coming decades, what the effects of the cleaning methods will turn out to be, how the repainting will age, how the whole will respond to climatic controls, the limitation of visitors and the maintenance programme, if any. Whether the head of Christ was executed by Masolino or Masaccio or has been entirely repainted can be argued until Kingdom come, but if the head has faded or disintegrated, the discussion will be esoteric and recondite. In other words, there is a danger that the ends, themselves not exclusively artistic, have justified the means and overridden the risks with regard to many important restoration efforts including the Brancacci Chapel. Favourable publicity, either in print or on television, seems to be an immediate and much-desired goal. From the point of view of the media, the absolute truth as to whether Masaccio and Masolino were really responsible for those newly discovered heads or not is entirely irrelevant; but the public will have registered an awareness of a 'discovery', one which is said to be important. What the

53

discovery really was and its significance seem decidedly secondary. The effect has been obtained, even though over the next decade specialists may, one by one, annihilate the attribution.

The other discoveries that resulted from the Brancacci restoration, a strip of landscape or cityscape previously unknown, the clouds in the sky in the *Tribute Money*, the skilful use of aerial perspective in other scenes, the belief (entirely subjective, I fear) that Filippino Lippi intervened in a scene by Masolino (just as he did with an unfinished one by Masaccio), should not be belittled. There they are for scholars and specialists to debate. But the purpose of any radical and basically irreversible intervention should be exclusively conservation needs, and this aspect of the Brancacci Chapel restoration remains open to question.

One of the surprises reported by the restoration team was that the frescoes were in much better condition than one would have thought judging from their appearance. Professor Paolo Parrini, scientific co-ordinator of the works, stated in an interview that the walls of the Brancacci were 'in excellent condition' and further that 'the Brancacci *intonaco* was perfect . . . this, of course, was excellent news because a healthy *intonaco* is usually a sign of healthy fresco'. This information naturally came as a pleasant surprise, but it does raise a question: if their condition was really rather good, was the severe intervention that was actually engaged upon necessary? Were there no grounds to backtrack a bit and, in lieu of total renovation, to limit activities more exclusively to conservation measures? Professor Parrini, as well as being scientific co-ordinator at the Brancacci Chapel, is the President of Syremont, a company he founded in 1987 which is part of the Montedison group.[1] The solvent finally selected for the cleaning was one that his company developed. Even assuming that the product is good, perhaps 'the best' for the purpose, the question remains whether the manufacturer of a product is the ideal judge of the circumstances in which that product should be applied, in this case on one of the rarest fresco cycles of the Renaissance.

A persuasive analogy can be drawn between Syremont and the

research arms of pharmaceutical companies. They engage in study and research but at least in the long run, they must also be motivated to perfect and merchandize their products and create new ones. Indeed, the synthetic oil Fomblin, which was used on the *Ilaria* monument, is a product of another Montedison company, Montefluos. The staffs of such companies have collaborated with the Opificio delle Pietre Dure as well as other superintendencies, and are sponsors of certain of their publications. Whatever the integrity of the individuals involved, it would only be natural for them to prefer their own products. Professor Baldini has served at one time as the superintendent of the Opificio delle Pietre Dure in Florence, and at another as the Director of the Istituto Centrale di Restauro in Rome. He is also an official of Syremont. And seemingly by coincidence, his wife Dr Ornella Casazza, was appointed to supervise the restoration at the Brancacci. Presumably independent advice was taken and she was found to the finest candidate. In the same way Parrini was no doubt found to be the best person for the job of scientific director. Yet it is impossible to feel entirely happy about these arrangements. In any such team, there should be independent voices *not* committed to a particular product or chosen methodology, a voice arguing that before anything irrevocable is done, alternative possibilities must be considered on an equal basis.

The manufacturers need to test their products not only in laboratory situations but also in restorations, for at least two reasons. First, laboratory conditions can never unequivocally duplicate a work of art. Second, in selling new treatments, applications and products, use on a major artistic monument is probably the most persuasive testimony of all. Just as sponsors almost exclusively seek to support the restoration of major, highly visible works of art, so the chemical industry seeks association with those same major works of art. ICI proudly paid for the Louvre's somewhat dubious treatment of Veronese's *Marriage at Cana*. Caponi was keen to declare that he had used on the *Ilaria* the same preparation that had been applied earlier on the Brancacci Chapel frescoes.

After all, if the product could be used in the Brancacci Chapel, it must be good. We are familiar with the endorsement system from the advertising industry. The fact that stone and *intonaco* are distinct materials, and that marble and paint have different aesthetic qualities does not seem to have entered into the decision-making process.

As if to underscore what I have said above, Parrini avowed in a particularly frank statement that his company was active in the art field because 'it is an excellent testing laboratory for our products and also because it is excellent for our image'.

Undoubtedly, new products do require testing and retesting. But it is inconceivable that anyone would want tests to be undertaken on the *Ilaria*, on Masaccio's frescoes, or, for that matter, on Michelangelo's Sistine Chapel ceiling, but rather on objects of lesser cultural significance that are in urgent need of immediate intervention. Once sufficient time has elapsed to evaluate the effects of these products – twenty years is a good rule of thumb – they can be considered for application to masterpieces, where there is a genuine need for them. New products and procedures should win the approval of independent national and international agencies, much as new drugs must, before being placed on the market. Masterpieces cannot be used as a laboratory, except, of course, in cases where they are in danger of imminent destruction, and action must be taken forthwith. Even the determination of the degree of urgency in the state of any given work or building is hardly a simple matter, and serious differences of opinion among specialists can arise. The Tower of Pisa may or may not be poised to topple: the experts are at odds as they are over possible structural reinforcements.

A decision to backtrack, to do no more than was required to safeguard the Brancacci frescoes might not have been appreciated by those closest to the intervention, namely the sponsor, the chemical companies, the restorers and the directors of works. Yet, in retrospect, it might well turn out to have been the wisest course.

The Brancacci Chapel restoration, like that of the Sistine Chapel ceiling, will under any circumstances be considered a landmark of its time in the field, yet the claims of its restorers may come to sound hollow as the years pass. In quite the same way that we are accustomed to hearing unrestrained criticism of the efforts of all earlier restorers, *all* of them, the defects of the restoration in the Sistine Chapel and the Brancacci Chapel will become increasingly obvious. It could be argued that neither restoration was motivated strictly by conservational urgency. The search for discoveries, the need to establish new commercial products, the pursuit of publicity which fuels further developments in the same direction, all played their part. And there was perhaps an unacknowledged desire to make the frescoes more readable, more pleasing and more suitable to the dominant aesthetic of the age. The Brancacci frescoes are decidedly more suitable for reproduction as a result of the restoration, true enough, but at what price?

On the subject of price, another change has taken place in the viewing of the Brancacci frescoes. For the past half millennium or more, artists of every style, direction and persuasion, and the art-loving public, not to mention the curious and the reverent, were able to approach these frescoes naturally, by walking down the vast nave of the church. Often a sleepy Carmelite monk sat nearby to turn the miserable lighting on or off or to field a banal question from a tourist. One could linger, contemplate, daydream, pray, meditate, move in the mind's eye back in time to the glories of the early Renaissance. No longer. You cannot enter the Chapel through the church at all, but must get in line, buy a ticket and then be run through the place, clocked by a faceless employee of the faceless, and as far as I can gather nameless, co-operative which has been given jurisdiction over the Chapel. You are allowed in there for exactly a quarter of an hour, ironically Andy Warhol's fifteen minutes of fame. The frescoes have been museumized, and as a result their context has been severely disrupted.

We are afforded ample opportunity to purchase the publications that the restoration team has produced, laid out right there

on the spot. In fact, we cannot avoid the sales stand, which is passed both on the way in and on the way out, as is now usual at major museums. And we can purchase overpriced colour postcards to send a fragmentary glimpse of the new glory back home to Indiana or East Anglia.

Is this a happy result of modern sponsorship?

Shortly after the public relations triumph of the Brancacci restoration the same sponsor decided on the restoration of another Masaccio fresco. On the wall of the left aisle in the third bay of Santa Maria Novella in Florence, one comes upon the *Holy Trinity*, a sizeable fresco probably painted at the end of 1425 or in 1427, again by Masaccio. If the *Expulsion of Adam and Eve from Paradise* is an icon of Renaissance art for its precise balance between form and expressive content, arguably the finest in its category, the *Trinity* is the earliest and perhaps most influential application in Italy of linear perspective within a solemn religious drama. In this fictitious chapel painted on a flat wall, Masaccio has demonstrated, within the scale of life-size figures, the operation of perspective as conceived by Brunelleschi. In fact, many scholars believe that Brunelleschi collaborated with his younger colleague in devising the intricate spatial operations within the painting. We also find here the language of the new architectural style enunciated in particular by the same Brunelleschi, which was partially a revival of classical antiquity and partially a thoroughly new, innovative idiom. Here, too, one can find the most current figurative statements set forth by Donatello in Masaccio's two-dimensional transliteration.

From a cultural point of view, the *Trinity* is a virtual *summa* of the first articulation of the Renaissance, which was to define Western art and architecture of the next five hundred years. Is it any wonder that Olivetti Corporation, munificently shelling out hard-earned lire for nearly a decade in a questionable and surely hopeless effort to revive Leonardo's *Last Supper*, would seek to become associated with such a distinguished work?

While deeply involved in the *Ilaria del Carretto* controversy and

my legal defence, which required maximum attention, I was reluc-
tant to move off course and on the whole I remained silent about
the Sistine Chapel ceiling and the restoration of the Brancacci
Chapel frescoes. When, however, I got wind of Olivetti's inten-
tion to sponsor treatment of the *Holy Trinity*, and the allocation
of 400 million lire (about £200,000 or $350,000) to the project,
together with triumphant public relations announcements of the
forthcoming rehabilitation, I had to act. I decided to write concern-
ing my deep reservations to the Chief Executive Officer of Olivetti,
Carlo De Benedetti, and also to the official who would have to
authorize the restoration, Dr Antonio Paolucci, Superintendent of
Fine Arts in Florence. My letters were sent out in the autumn of
1990; I received no answer to either but nonetheless I had registered
to both individuals my conviction that before permission for a new
restoration of Masaccio be granted, a thorough independent evalua-
tion of the results of the Brancacci Chapel restoration must be
sought – an evaluation not only by those responsible for the work
but by outside experts, by artists and by the interested general
public. My point was that the *Trinity* was painted by one of the
artists of the Brancacci Chapel at the same time and presumably
with the same colours and technique, and that consequently before
going ahead a thorough discussion was necessary.

A second letter, repeating essentially the contents of the first and
this time sent registered mail, also received no answer from the
sponsor. On the other hand, the Superintendent, whom I have
known personally for twenty years, was more reassuring. In fact,
he communicated to me informally that nothing would happen
without ample testing. On the other hand, my more basic point,
that outside experts and especially artists, as well as representatives
of the interested public, should participate in discussions, was
ignored.

Masaccio's creation is a remarkable pictorial as well as theolog-
ical statement in the main church of the Dominicans in Florence,
where Orcagna had painted an enormous *Inferno* and Brunelleschi
had carved a refined wooden *Crucified Christ* – a cousin to the Christ

59

on the Cross, in Masaccio's *Trinity*. Masaccio's painting represents two quite different concepts, which are brilliantly united. We have in a triangular configuration a Crucifixion with St John and Mary below. And we also have in a vertical reading a representation of the Trinity, which has given rise to the fresco's usual title. Christ is on the Cross, above him, the Holy Dove, and above and behind, the standing God the Father supporting the arms of the Cross. The Crucified Christ is the *trait de union* between the two themes and is central to both. The entire double scene is introduced by the patrons, husband and wife, shown in profile in order to separate them from the sacred figures. The man was probably a member of the Lenzi family, to whom the chapel belonged. Obviously, Masaccio's was a remarkable solution and, beyond even that, it offered the donors a visually convincing three-dimensional chapel framed by massive classical pilasters which in reality did not exist.

At this point we may return specifically to the issues raised by the promised restoration. The main corpus of the fresco was whitewashed at some imprecise date but presumably in the sixteenth century when interest in the 'primitives' was low and the area was covered over with an altarpiece. The *Trinity* was rediscovered in 1861 and transferred with a good portion of its wall from its original position to the inner façade. Of course, this quite understandably produced losses. Only the bottom portion, which consisted of a sharply foreshortened altar table resting on columns and a plain marble tomb with a skeleton on it, remained in its original place. There was also a text in Italian, which translated reads: 'I was once as you are and you also shall be as I am,' an eternal warning that commands belief in the Trinity. In 1951, the fresco was repositioned in its original place above the painted tomb (that of Adam) which had never been moved. On this occasion the entire remarried fresco was restored by the most prestigious practitioner of the time, Leonetto Tintori.

The *Trinity* has survived five serious incidents that we know about: first, the fresco may have been covered over with whitewash

and the area was blocked from view by a large altar in the sixteenth century; second, presumably the whitewashing was removed in the middle of the nineteenth century; third, the upper portion of the fresco and its wall were transferred to the inner façade of the church, also in the last century; fourth, the fresco was returned to its original site and reunited with the lower portion, about forty years ago; and fifth, at the same time a thorough restoration and cleaning was undertaken. A sixth event may well represent the final straw that could break the camel's back.

Even an elementary visual examination reveals the degree of damage the painting has suffered, in addition, I should add, to the normal ageing. There are large areas of the surface where the *intonaco* has been totally lost. A good deal of not especially disturbing filling in as well as other adjustments were made by Tintori. He repaired and repainted areas of drapery and architectural detail which were lost. While what is now seen at Santa Maria Novella is by no means a perfect fresco, the work does present itself quite respectably and much of its power as an image has survived. What is quite clear is its fragile state, but notwithstanding the vicissitudes of time it is still a stirring monument which can be studied, revered and enjoyed.

What are the advantages and what the potential drawbacks (and there are *always* some) to still another intervention on the *Trinity*? Here lies the crucial question. What is extraordinary is the fact that the Olivetti Corporation announced that the 400 million lire was available long before the actual need for the restoration was confirmed by the appropriate superintendencies. The momentum of success surrounding the Brancacci Chapel restoration seems to have swept the *Trinity* along with it. Who would refuse such munificence?

Happily though, I have been reassured privately that no work will now start until there has been a thorough campaign of tests, which could take six months or even years, and the Superintendent of Florence has stated publicly that if it is found that restoration is not necessary, nothing will be done. Yet were it not

for some voices of opposition, and a perceptible change in the climate of opinion about restorations, the painting might already have been put under the knife. As it is we can hope that good sense will prevail. Perhaps some of the available money can be put to use elsewhere, to conserve perhaps less prestigious frescoes in Florence, for example, which are in far greater need.

The case of the *Trinity* is particularly interesting because there is a chance, even a good one, of reaching a consensus about the need for and the desirability of the project before it begins. If there are grounds for not going ahead this time, voices of caution will have been vindicated. The objections raised in this book concerning several specific restoration activities will be of value if they prevent the repetition of earlier mistakes.

III

The Sistine Chapel

By James Beck and Michael Daley

The primary purpose of the painter is to make a plane surface display a body in relief, detached from the plane, and he who in that art most surpasses others deserves most praise, and this concern, which is the crown of the science of painting, comes about from the use of shadows and lights, or, if you wish, brightness and darkness. Therefore, whoever avoids shadows avoids what is the glory of the art for noble minds, but gains glory with the ignorant public, who want nothing in painting but beauty of colour, altogether forgetting the beauty and marvel of depicting a relief on what in reality is a plane surface.

Leonardo da Vinci

THE SISTINE CHAPEL lies at the epicentre of Western civilization. The private chapel of the Pope, head of a religion with over a billion adherents, it stands within the small but absolutely sovereign Vatican state. Michelangelo's ceiling fresco (his first), painted between 1508 and 1512, fuses the walls and ceiling of the Chapel into an unprecedented amalgam of real architecture, illusionistic

63

architecture and diverse figurative arrangements which stands unequalled to this day in artistry and inventiveness. The gigantic fresco embodies a theological programme of unparalleled richness. Michelangelo's religious images have an archetypal force which still, despite endless replication and mimicry, establishes in most minds the images of the Deity and the personification of the Judaic and Christian heroes. A generation later (on Christmas Day, 1541), Michelangelo, having sacrificed paintings of his own and of Perugino, completed the artistic and theological fusion of the Chapel interior with his stupendous, single, uninterrupted depiction on the altar wall of the *Last Judgement*. The building's decoration could scarcely be more culturally precious, theologically resonant or artistically sublime.

Between 1980 and 1990, under the direction of Fabrizio Mancinelli and Gianluigi Colalucci, sponsored by Nippon Television Corporation (NTV), the ceiling frescoes received the most drastic cleaning in their history. In return, NTV received the lucrative copyright worldwide in all film, television and still photography during and for three years after the restoration, calculated section by section. The current cleaning of the *Last Judgement*, apparently funded by the same sponsor, is expected to last until around 1995 or 1996, by which time absolute rights in portions of Michelangelo's imagery in this holy place will have been held for up to fifteen years by an international corporation. The effective control may last even longer, until new photographs are taken and made available.

In fact, it seems that NTV may make a profit on its sponsorship. The sum paid to the Vatican for the 'opportunity' has been put at between $3,000,000 and $4,175,000. When James Beck requested black-and-white photographs of the cleaned frescoes for study, he was asked to specify intended usage and quoted a price of $300 per print. There are over 300 figures depicted on the ceiling, so that the bill for a complete set could approach $100,000. The fee charged for the reproduction of the cleaned *Jonah* in this book was also substantially the highest. Thirty television pro-

grammes, a range of books published worldwide, reproductions and so forth also contribute to NTV's return on its expenditure.

The controversy surrounding the cleaning erupted almost from the beginning. It turns on a single, simple point: did Michelangelo modify and embellish his frescoes after the application of the *buon fresco* layer with traditional *secco* media such as size or glue-based painting, or not? If he did, then the restorers' removal not just of dirt but of everything down to the frescoed plaster has falsified his work and partly destroyed one of the greatest masterpieces of Western art. If he did not, and the ceiling's glue paint was, as today's restorers contend, the work of earlier restorers and not Michelangelo himself, then the present state of the ceiling is indeed a revelation, and Michelangelo should be celebrated not for the sculptural qualities admired in his own lifetime and up to 1980, but as yet another colourist in tune with present-day preferences.

Fresco painting could be, and normally was, adjusted *a secco* after the plaster had dried. Some colours responded badly to the lime in wet plaster, and so needed to be applied later, on the dry fresco surface. Alterations might be necessary: some tones might need to be harmonized, others moved towards more dramatic contrasts. All this has been explained in the previous chapter. If Michelangelo had wanted to deepen shadows, strengthen the sense of three-dimensionality, create an impression of coloured form emerging into light, and enhance the rhythm and balance of the whole composition with darker accents, he could only have done so *a secco*. Critics of the restoration have no doubt that this is what he did.

The restorers and their supporters, on the other hand, dismiss the idea that Michelangelo would ever have modified or darkened the vivid colours they have exposed. Overturning centuries of observation and much that is known of the history of Renaissance art, they assert that the darkening of the ceiling is the product of dust and soot together with glues applied as a varnish not just to shadows but over the entire painting. They believe that the real Michelangelo now stands revealed for the first time.

The following account is a critique of the presentation of the restoration no less than of its method. The euphoric descriptions and well-orchestrated statements of the restorers and their proponents received support from the media worldwide and with it general praise from the international community of art historians, especially specialists in the Renaissance. All was not entirely rosy, however, for even during the early days, some members of the restoration community and others who were practising artists made their severe reservations clear publicly and privately to Vatican officials, and eventually to the press. By the mid-1980s, when the opposition, who continually sought more detailed information, requested a halt in the work, the controversy had grown into a genuine dispute. Yet no comprehensive report on the restoration has ever been issued by the Vatican, and, perhaps even more indicatively, there has never been an open and free debate or open discussion among the interested parties. Had the facts been more fully known, and their implications or interpretations debated openly, much of what we hold to be damage could have been avoided. Nor is it ever too late to publish and debate such information, not only because the *Last Judgement* is still being worked on but also because we can learn from experience, and can in the future avoid the mistakes of omission that have surrounded the Sistine ceiling cleaning. We will argue that what has been widely accepted as a scientifically proven case for this particular restoration was in fact a misreading of evidence and a failure to recognize the aesthetic logic of the work.

An enormous amount of heat has been generated by the arguments over the Sistine restoration. Since nothing can now be done to reverse this vast intervention, the reputations of the restorers and their advisers and supporters, not to mention the Vatican itself, rest on their vindication of what was done. As happens in such cases, the competence, motives and characters of those who have attacked or even questioned the restoration have drawn a lot of fire. Even with goodwill the issues are difficult enough. The magnitude and complexity of this restoration

make it all but impossible to disentangle the interlocking issues and interests. Technical, professional, ethical, artistic, aesthetic, cultural, sociological, political, financial and historical concerns are all present and have in varying ways had an impact upon one another. An infinite number of questions could be asked. The most important are these: Why was the cleaning undertaken in the first instance? What is claimed to have happened during the cleaning and what actually did happen? What are the consequences likely to be? And what can be learnt from the experience?

While the controversy has raged, few have asked whether a cleaning was in fact necessary, or whether the risks outweighed the benefits. The evidence of those who have seen the ceiling at close hand in the past is worth reading. In the late nineteenth century, Charles Heath Wilson (a painter) found it filthy and 'obscured by [a] veil of dust, soot and cobweb' which lay on top of the *buon fresco* and glue-size painting (which he took to be Michelangelo's own). He was concerned that removing the dirt would be risky, as the glue-size painting had already suffered by being 'washed by labouring men with water in which a caustic has been mixed'. Today's restorers have removed, in addition to dirt, almost all this *secco* painting. Venanzo Crocetti, who worked for four years on a restoration in the Thirties, recalled in 1987 that, with the exception of the lunettes (the semi-circular sections of wall above the windows), 'the general condition of health of the Sistine Chapel [at that time] could still be considered excellent'. In 1967, Alexander Eliot discovered that, seen from above the dust and pollution carried in by tourists, the frescoes had a surprising 'brightness and clarity'. In summary, there seems not to have been any pressing need for a cleaning.

Explanations of why the task was undertaken are remarkably inconsistent. One of the earliest accounts was given in May 1982 by Patricia Corbett, managing editor of *Retina*: 'Despite some fear on the part of the Vatican authorities, the bold decision to restore the ceiling was made on short notice almost as an afterthought.'[1]

67

From 1965 to 1974 Vatican restorers had been cleaning the frescoes on the lower walls of the Chapel in order to help prevent them from being overpowered by Michelangelo's tumultuous works on the lunettes and ceiling. This was a *mezza pulitura*, a mild 'semi-cleaning' operation. (It was recently announced that in view of the more radical full cleaning of Michelangelo's frescoes it is necessary to clean these frescoes once again and with a more radical method in order to dispel their now 'dark' appearance, which disrupts the Chapel's 'homogeneity'. This operation was already underway in the spring of 1993 with work on the scenes nearest the *Last Judgement*.) In 1979, the east wall, which faces the *Last Judgement* and was painted by Henrick van der Broeck and Matteo da Lecce, was restored. 'Finally,' Corbett wrote, 'only Michelangelo's ceiling was left. Professor Carlo Pietrangeli, Director General of the Vatican Museums, says "No one was able to resist the temptation." '

The temptation comprised, Corbett explained, the results from a single test cleaning patch on one of Michelangelo's lunettes, the one of Eleazar and Mathan. What was revealed was 'so encouraging that it was decided to take on the whole ceiling. By the summer of 1980 the work had begun.' Corbett made no mention of opposition to the cleaning but predicted that as a result of an intended removal of yellowed and flaking nineteenth-century glues, 'more surprises are surely in store to dash yet more cherished theories'. People had 'gotten used to seeing Michelangelo's work through a murky veneer', she said; 'the question arises whether he will be so appreciated once the entire ceiling has been cleaned'. She did not explain why removing the glue would be so disturbing to the aesthetic logic of Michelangelo's painting but her trepidation was shared by Dr Fabrizio Mancinelli, one of the co-directors of the restoration and Curator of the Vatican Museums' Byzantine, medieval and modern collections, who told Corbett he feared that this 'radical restoration can be made palatable only if it is done in small doses'. The previous year, a more sanguine Maestro Gianluigi Colalucci, chief restorer and co-director, had quoted an

art historian's confession that 'Everything we've been saying about his colours and tones has been about the dirty Michelangelo, the sculptor and moulder of three-dimensional form in painting. Now we will have to take a new look at Michelangelo the colourist.'[2]

Thus, early reports implied that aesthetic curiosity and excitement had been the dominant motive, but the cleaning's rationale was reformulated as opposition to its results grew: 'In the course of restoration of the two frescoes by Matteo da Lecce and van der Broeck,' Colalucci said four years later, 'various checks were run on the lunettes painted by Michelangelo, which ascertained that in several places minute flecks of colour were lifting from the surface, necessitating an immediate restoration.'[3] Preliminary preparations, study and research, he went on, 'took more than six months for the team to complete'. All of it, apparently, undertaken on the Eleazar and Mathan lunette.

In the same year, 1986, Dr Mancinelli told the *Christian Science Monitor* (11 September) how hairline cracks had been 'noticed' during the cleaning of the lunette. But, he said, what had 'caused the most damage and led to the current cleaning was the fact that the glue [on the frescoes] yellowed, hardened and eventually cracked, becoming the nemesis of generations of restorers'. The explanation seems to have been new, not part of the original plan, but it suggests that the problem was an old one, which pre-dated generations of restorers. This discovery of an old technical problem was given greater and greater prominence. Mancinelli claimed here that his predecessors at the Vatican had been 'terrified of removing it [that is, the glue] for fear of damaging the Renaissance master's work'. The restoration was only undertaken by the present team with 'much trepidation' and 'only when it could no longer be postponed',[4] but by the following year, 1987, M. Kirby Talley, Jr, the founding director of the Netherlands State Training School for Restorers and an authority on artists' techniques, materials, restoration practices and ethics, was referring to 'extensive areas of flaking' which had been found to be 'progressive' and which were about to lead to 'an uncontrollable situation'.[5] Also in

1987, Dr Mancinelli reported to a conservation conference in London that 'it was the discovery of widespread flaking that led to the decision . . . to undertake the cleaning even though initial tests showed unequivocally that such cleaning would lead to a radical revision of the prevailing understanding of Michelangelo as a painter'.[6]

By the following year the situation had worsened. Dr Walter Persegati, the secretary and treasurer of the Vatican Museums, told the *Bible Review* that the 'weight of encrustations upon the paint surface has caused the surface to break away from its ground'.[7] By 1989, accounts were bloodcurdling: 'the glues have', the *National Geographic* explained, 'shrunk and puckered, scabs of glue have fallen away pulling pigment with them. [This] slow destruction by glue pox has been the Vatican's principal motivation for cleaning the ceiling now.'[8] In 1990, Professor Kathleen Weil Garris Brandt, a spokesperson for the restoration, said when asked about the size of the flakings, 'Oh! Some are bigger than your hand.'[9] But in 1991, Dr Mancinelli, in his splendidly produced *The Sistine Chapel*, reformulated his earlier accounts: research on the Eleazar lunette had, in fact, uncovered 'minute desquamations and losses of pigment', after which it had been 'determined that this was not just a localized phenomenon but one that affected with varying degrees of seriousness the whole of Michelangelo's fresco cycle'. The glue itself was not the problem: it was 'variations in the chapel's microclimate' which caused the glue to contract and pull away the colour 'at its weakest points'.

Of course, had the restorers not diagnosed the glues as varnishings put in place by earlier restorers, the option of removing them entirely would not have been available. Had they shared their critics' judgement that even a portion of the glue-painting was an integral part of Michelangelo's work, the task facing them, however severe or alarming the glue losses were, would have been to make good those losses in the short term while finding a means to counter the environmental conditions responsible for them. Removing the glue-painting of Michelangelo himself would never

have been acceptable. It is certainly true that small losses of glue and pigment were to be found in some parts of the ceiling but no evidence has been presented that these losses are recent. No evidence either has been offered to support the claim that the problem was progressive. (How could it have been when the interval between the 'discovery' of the glue threat and the commencement of cleaning was scarcely more than six months?)

It has sometimes seemed almost as if the contraction of the glue has been exaggerated in a *post hoc* justification for the removal of the glue-painting whether it was by Michelangelo or not. Fear of sliding into such a controversial position may account for another substantial revision, and then re-revision, that the restorers' account has undergone. Early reports acknowledged Michelangelo's use of glue-painting on the frescoes. In 1981, Mancinelli observed that 'some of Michelangelo's greens were applied *a secco* [that is, mixed with glue and painted on to the dry plaster surface] and had almost vanished'.[10] Two years later, he spoke of 'some greens and blues [that were] *a secco* as they could not be done otherwise'.[11] Quite abruptly in 1986 – a year of clamorous opposition to the cleaning – he changed tack: 'Technically speaking, the lunettes are all executed in *buon fresco* with nothing being done *a secco* and without even those retouchings which were normal to harmonize the painting.'[12] Analysis had revealed, he added, that Michelangelo 'made sure to use only those colours that he knew were suitable to fresco: the reds are almost all ochres (anhydrous oxides); the greens are ferrous silicates; the blues are exclusively lapis lazuli, with no trace of azurite'.

No explanation was given for this volte-face. But whatever occurred between 1983 and 1986 to reverse Mancinelli's analysis also convinced his colleague Colalucci who likewise insisted that Michelangelo had used 'only colours suitable to fresco, avoiding any that would have required application *a secco*'.[13] In 1987, he was more explicit: 'We know that it was common practice for many painters to make use of colours – blues, certain greens and reds – which have to be applied *a secco* because of their sensitivity

71

to the aggressiveness of lime, but Michelangelo excluded these from his palette. Even blue was applied in fresco using ultramarine (lapis lazuli) or smalt, demonstrating that he considered that to resort to painting *a secco* was to diminish the quality of the fresco.'[14] In 1986 Colalucci put a figure on the portion of *buon fresco* painting in the Sistine: lunettes, 100 per cent; ceiling, 99 per cent. The new position was reinforced the following year by Professor Brandt. She claimed in an article in *Apollo* that while the restorers had been 'on the look-out' for the *secco* passages referred to in the earlier literature, they had been 'surprised not to find any'. The conservators had, she said, been left wondering whether 'harsh cleaning by earlier restorers might have removed them'.[15]

When we drew attention to these inconsistencies,[16] the restorers again revised their position.[17] Yes, they admitted, 'a green colour applied *a secco*, not always well conserved, was found'. It seemed odd that no mention of blues was made. It was normal for lapis lazuli, which Mancinelli had claimed (incorrectly, it transpired) was the only blue used on the ceiling frescoes, to be applied *a secco*. That is because its beautiful but very expensive qualities are weakened by being incorporated into the caustic lime which is active in the wet plaster of *buon fresco* painting.

Matters became further confused when in June 1991 Gianluigi Colalucci announced that the restorers had abandoned the controversial cleaning solvent (AB57) for their impending cleaning of the *Last Judgement* on the grounds that something 'very safe, very soft' was called for by Michelangelo's extensive use of lapis lazuli, 'a very expensive and delicate pigment'.[18] Asked at that time whether the lapis used on the ceiling was applied *a secco* or as *buon fresco*,[19] Mancinelli said neither: the blues on the ceiling were not lapis but 'almost entirely smalts [ground glass]'. Whatever their composition, blues demonstrably perished during the cleaning. There was a particularly dramatic loss from the sky of the *Temptation* panel. It is recorded in a sequence of photographs published in 1991.[20] The 1986 general report on the lunettes[21] contains an intriguing item. Before cleaning commenced, it

records, a dilute solution of the acrylic resin Paraloid B72 was applied in order to 'consolidate' certain 'less secure pigments or those not well suited to fresco [i.e. *buon* fresco?]'. The colours identified as needing such consolidation were 'blues, reds, greens, etc.' – precisely those traditionally applied *a secco*. A comparison of colour photographs taken before and after cleaning makes it clear that losses of all these colours occurred during the cleaning.

The more complete the restorers' denial that Michelangelo had painted any parts *a secco*, the greater the need to explain away the very large amounts of glue-painting which were found and consistently removed from the ceiling. If it had not been applied by Michelangelo, then by whom and when? Again, the explanation offered by the restorers fluctuates.

In 1981, with the restoration underway but before the upsurge of criticism, Mancinelli was clear about the ceiling's previous restorations – it had had only two major cleanings, one in 1625 and another between 1710 and 1713.[22] 'The real trouble', Mancinelli said, 'started in the nineteenth century when restorers began using resins and glues to make the frescoes appear cleaner'. He claimed that as the originally clear substances (applied as 'varnishes') aged they darkened. In fact, though, engraved copies of the frescoes, of which a continuous series has been made by a wide variety of artists since they were first painted, do not record any progressive darkening, or indeed any change of appearance. Critics of the restoration were not slow to point this out. Supporters were therefore forced by the logic of the visual record either to move the notional glue applications back in time or to challenge the reliability of the copies. (They have in fact done both.)

Both Dr Mancinelli and Patricia Corbett had placed the origins of the glue in the nineteenth century, but in 1985, Mancinelli suggested that glue had first been applied, as varnish, not then but probably in the eighteenth century.[23] In 1986, his position shifted further: the 'glue varnishes were applied perhaps at the time Mazzuoli was at work [1710–13] or perhaps even earlier'.[24] Almost

immediately, in the same article, he converted his speculation into fact by arguing that these hypothetical applications had 'succeeded in fixing the dirt and the soot that the cleanings had not removed' which had caused the frescoes to acquire 'their romantically sombre character'. By September of that year, Mancinelli suggested that the glues had been applied 'possibly as early as the sixteenth century'.[25]

Also in 1986, Colalucci moved the glue applications even further back in time: 'very soon' after completion of the ceiling, treatments for salt efflorescence commenced 'with quantities of warm animal glue varnish, sometimes with the addition of a very small proportion of vegetable oil such as linseed or walnut oil'.[26] Colalucci's detailed recipe and precise dating might appear to be based on documentation, but they are not. His hypothetical application is no more than an elaboration of a confusingly reported record of the Vatican's appointment of a *mundator* (cleaner) or group of *mundatores* to clean the Sistine frescoes. The *mundator* is said by Colalucci to have been appointed 'very soon' after 1541 in order to keep the frescoes clean when the ceiling was 'being destroyed by saltpetre and cracks'. In addition, he suggests, 'a restorer proper ... was required' but he cites no evidence of an appointment.[27]

The following year, 1987, M. Kirby Talley, Jr, asserted with similar technical exactitude and chronological vagueness 'that the earliest treatment dates from the second half of the sixteenth century – relatively few years after the *Last Judgement* in 1541 – when hot animal glue was applied with sponge and brush'.[28]

The first documented instance of repair (as opposed to cleaning) occurred sometime between 1559 and 1585. The documents related to the work of Domenico Carnevale who carried out repairs and some repainting of the so-called Sacrifice of Noah, but they contain no evidence of his having cleaned or 'varnished' any part of the ceiling. On the contrary, Dr Mancinelli has claimed that the darkness of Carnevale's quite limited repaints is a measure of the soot and dirt that was present on the ceiling as he worked. In short, whenever the appointment of the *mundator* or *mundatores*

took place, there is in fact no evidence whatsoever of any glue being applied as varnish to the ceiling. Circumstantial evidence and the total absence of contrary documentation point also to the fact that the first 'restorer proper' did not apply any either. The best hope today's restoration team has for establishing a glue-varnishing of the ceiling is with the two 'major' cleaning campaigns. The claims that have been made concerning these restorations call for a certain attentiveness even in the best of circumstances.

In 1986, Colalucci suggested that 'probably two campaigns of restoration in particular have had the greatest effect on the condition in which Michelangelo's frescoes have appeared until now: these are the restorations carried out by Simone Lagi (or Laghi) in 1625 and by Annibale Mazzuoli in 1710–37'.[29] Lagi was recorded in a note in a seventeenth-century manuscript, and Colalucci quoted the following extract:

> the procedure used was as follows: that it [the fresco] was cleaned figure by figure, with linen rags, the dust was removed with slices of cheap bread or any such lowly stuff, scrubbing hard, and sometimes when the dirt was more tenacious, the bread was moistened a little, and so they returned to their previous beauty without receiving any harm.

Colalucci commented, 'That is as much as it says. The note does not mention at all the use of substances to revive the colours or of glue varnish.' Nonetheless, he went on to claim that Lagi would have used glue but would not have mentioned the fact out of 'obedience to the principle dear to restorers of the past of pre-serving the secrets of their craft'. Colalucci is here surely pulling legs. What secrets was Lagi guarding? The glue recipes were in all the treatises after Cennino Cennini's of the early fifteenth century. And why would he trouble to apply hot glues above his head – always a filthy job – when the cleaning had already proved, as the record indicates, perfectly satisfactory and not injurious? Nonetheless, Colalucci had unreserved support the following year

from M. Kirby Talley, Jr, who told how Lagi had 'first dusted the ceiling and then cleaned it using bread'.[30] Such a cleaning, he maintained, would 'leave a great deal of the surface dirt behind, necessitating an optical revival of the colours'. Although no record of the action existed, what was 'undoubtedly applied by Lagi after his cleaning in 1625 was a layer of glue varnish' which darkened and became a 'filthy veil over the frescoes', or so we are supposed to believe.

But there is a much more serious objection to Colalucci's assertions: the document he quotes does not even refer to Michelangelo's frescoes but only to those on the walls below his. In May 1990, we asked the Vatican's restorers: 'Does *any* documentary evidence exist to support the claim that hot animal glue was repeatedly applied to the frescoes [of Michelangelo] over the centuries in order to revive the colours?' Colalucci conceded in reply that there was none.[31] In 1991, Mancinelli re-stated Colalucci's account of the 1625 cleaning (which he attributed to 'Simone Lega') but also conceded 'It is not clear if Michelangelo's frecoes were included in this intervention. The surviving documents suggest that they were not, since all the payments discovered so far pertain to the scenes [below] from the lives of Moses and Christ ...'[32]

Dr Mancinelli's reference to payments 'discovered so far' is puzzling. In fact, two historians, Edith Cicerchia and Dr Anna Maria de Strobel (a member of the Scientific Advisory Committee to the Restoration), have conducted an extensive search of all Vatican archival material for any documents or payments related to the ceiling. If payments have not been found yet they are unlikely to be in the future. The fact that payments record work done on the walls and not on the ceiling should be accepted at face value because, as Walter Persegati, the Vatican Museums secretary and treasurer, has pointed out, the Vatican keeps all its bills down to the tiniest items of expenditure.[33] Thus, if scaffolding had been erected bills would account for the material and labour costs involved (which would have been considerable – Michelangelo's scaffold had cost 500 ducats, a large sum). Such are the Vatican's

records that we often can tell not only who worked on what and when, but even what they ate for lunch. We know for example that when Maratta worked in 1702–3 on Raphael's *stanze* frescoes, bills recorded the consumption of:

antipasti (anchovies, salami, mortadella, liver, calves' brains and prosciutto), soups (with rice, thin noodles, eggs, vegetables, herbs, gooseberries and almonds) or alternatively macaroni; meat (veal, tripe, lamb, goat, chicken, pigeon and skylarks) or fish (red snapper, fresh sardine, cod, croaker, grey mullet, sea bass and caviar); eggs and vegetables on the side (beans, green beans, cabbages, tomatoes and green salad or lettuce); cheeses and fruit in season (cherries, sour cherries, strawberries, pears, melons, figs and roast chestnuts) and even some chocolate with lady fingers.

In 1992, Mancinelli returned to the 1625 cleaning, quoted the same document describing the dusting, the bread and so forth, but now added: 'All the recorded payments were for work on the walls, and it is not clear whether the ceiling was cleaned at this time.'[34]

This admission came too late – it *had* seemed quite clear to the scores of historians and critics who accepted in good faith the apparently documented claims of the restorers and based their accounts on them. Among them the late Professor Frederick Hartt, co-author with Mancinelli and Colalucci of *The Sistine Chapel*, wrote with absolute confidence in *Art Bulletin* (1989) about the 'disastrous effects that the 17th and 18th century glue has had on the Sistine frescoes'.[35] Robert Hughes, the art critic of *Time*, wrote in April 1987 of a ceiling 'freed of 478 years of accumulated grime, crude repaints and successive coats of darkened glue size applied as varnish by 17th and 18th century restorers'.[36]

The truth is that up until the twentieth century the ceiling had had one documented major cleaning, not two, and that

there is no evidence for supposing that this single cleaning of 1710–13 had been completed with a coating of glue varnish. But the *impression* had been created that two earlier teams of restorers had coated the ceiling with glue. In the business of restoration, impressions have great power. There is no forum for establishing facts publicly. No courts of appeal are available. No institutionalized or formalized mechanisms have been devised for evaluating claims that the artistic integrity of a work of art has been injured or violated. Even the tradition of scholarly criticism has been set aside. Of course, individual projects are questioned, but the criticism is not countered by argument. Rather, the dissident critics are marginalized or dismissed as inexpert, or malicious. Negative evaluation of a restoration is construed as either an impudence, a presumption or an attack on the professional integrity of the restorer. Faith tends to support authority. 'They wouldn't take any chances with such an important painting . . .' 'They must know what they are doing . . .' These are understandable, instinctive, non-partisan responses to controversy. They are, alas, frequently misguided. Once people accept, in good faith, that a particular restoration has been 'scientifically' validated and 'expertly' executed, there seems to be no limit to the implausible rationalizations they will be prepared to accept in support of its outcome.

The case for the Sistine restoration was given its least inhibited expression shortly before Christmas 1986. A press-release issued on behalf of the Vatican Museums by Arts and Communications Counsellors (an offshoot of the New York public relations firm Ruder and Finn Inc.) announced: 'The most startling revelation coming out of the cleaning is that Michelangelo painted in brilliant hues . . . this discovery has brought scholars to reassess their view of Michelangelo as a painter.' Michelangelo, who had previously been thought of as 'essentially a sculptor who translated his sculptor's vision into an almost monochromatic painting', must now be thought of as 'one of the great colourists of Western Art'.

The press release was echoed and elaborated a year later by Professor Kathleen Brandt in an influential article ('Twenty-five Questions about Michelangelo's Sistine Ceiling') in *Apollo*.[37] The cleaning, she suggested, had shown Michelangelo to have been a 'brilliant colourist' and manipulator of 'dazzling fresco hues [which were] incandescent with colour' and contained 'streaks of humming bird delicacy'. Given such a display of 'blazing colouristic pyrotechnics', it was inconceivable, she felt, that Michelangelo would have wished 'to tone down' these colours with 'murky layers of glue and overpaint'. And according to Dr Mancinelli, the cleaning had 'brought to light a totally new artist, a colourist quite different in character from the unnaturally sombre figure who had in the past fascinated generations of historians, connoisseurs and fellow artists'.[38]

These claims were bold: could centuries of experts have been so wrong? If the quality of colour that had been 'revealed' by the 1980s cleaning was so marvellous how is it possible that not a single contemporary noticed it? Were they all fools? No one, not even Ascanio Condivi or Giorgio Vasari, Michelangelo's biographers and devoted followers, ever spoke of colouristic innovation. In fact, their accounts of the ceiling scarcely mention colour at all. When his colour was mentioned by others it was usually as his Achilles heel: 'I shall not speak of Michelangelo's colouring', the Venetian critic Lodovico Dolci announced, 'because everyone knows that he took little care in this article.' The young Tintoretto painted the slogan, 'The drawing of Michelangelo and the colouring of Titian' on the wall of his studio. This juxtaposition was a commonplace. Paolo Pino, for example, held that 'if the colour of Titian could be added to the design of Michelangelo we should then have the supreme god of painting, seeing that each of them is already a god in his own sphere'. If Pino's judgement was faulty, so too was that of Michelangelo himself: speaking of a Titian Venus he observed 'God was right in doing what he did, for if these painters knew how to draw, they would be angels not men.'

For all this, droves of historians sang the improbable new tune.

In *Art Bulletin* in 1989 Hartt described Michelangelo, on the basis of this cleaning, as 'the most sensitive, resourceful, imaginative, and influential colourist of his time in Central Italy'.[39] Four hundred years earlier Armenino had shared this laurel between Raphael, Sebastiano del Piombo and Perino del Vaga. Even earlier, Vasari had told how Michelangelo had struck a deal with Sebastiano in order to vanquish Raphael: Michelangelo would supply designs to be coloured by Sebastiano. For all this, Hartt singled out for special praise Michelangelo's drapery which 'vibrates with electric contrasts of hue and much iridescence', rather as Patricia Corbett had spoken of Michelangelo's 'radiant chromatism . . . brilliant and daring colourism . . . shimmering veils of colour'.[40]

To explain why this colour went unnoticed at the time, other, contradictory, arguments were then brought into play. First, there was after all nothing remarkable about Michelangelo's colours, his palette was just like everyone else's: 'People who know what fresco painting looks like before and after the Sistine ceiling will not be surprised by the colours that are emerging' (John Shearman, Professor of Art History at Harvard and a member of the Vatican's Scientific Advisory Committee);[41] second, Michelangelo had to use 'dazzling colour' for a specific functional purpose, 'to reach down to us through sixty feet of cavernous once smoky space' (Brandt);[42] third, Michelangelo's colours were no more brilliant than those employed by other artists immediately below his own on the walls of the chapel (Brandt);[43] fourth, Michelangelo employed brilliant colours on the lunettes in order to compete with the dazzle of sunlight entering the windows (Brandt).[44]

Dissenters were not gently treated. Professor Brandt, who is a widely published and highly esteemed scholar of Italian Renaissance art, was particularly unforgiving. Her role in the restoration and in its accompanying hostilities is distinctive and instructive. In her *Apollo* piece, she disarmingly conceded that she was not a conservator but rather 'an historian specially interested in technique and conservation [who had] held a kind of informal watching brief for the cleaning operation since its inception in 1981 [*sic*]'. The brief

had an unacknowledged formal dimension: Professor Brandt was also the official spokesperson on 'scholarly and general information' for Arts and Communications Counsellors, and at some point a consultant on the restoration itself and a member of the Scientific Advisory Committee set up by the Vatican to supervise the restoration.

Professor Brandt's 1987 *Apollo* article reads like a skilfully constructed, media-oriented, semi-official presentation. She scorned critics, 'whose claims sounded more and more like the wild cries of some ferocious mutant of Chicken Little'. And the analogy was extended: 'Many believe that the critics, like the benighted bird, were misunderstanding insufficient evidence, to draw mistaken conclusions to the alarm and detriment of the neighbours'. Her message was clear: 'insufficient evidence' requires silence, not better evidence. Criticism is unwelcome. Those provoking 'the so-called controversy' by challenging the restoration were not, she said, dealing with real or concrete issues but were suffering from 'culture shock'. In the view of Dr Giovanni Urbani (a former director of the Istituto Centrale del Restauro, in Rome), this was understandable given the unfamiliarity of critics with works of art undergoing restoration: 'A masterpiece like Michelangelo's ceiling, half cleaned, half dirty, presents a brutal and crude impression to people who are not familiar with works of art during the restoration process.'[45] Urbani did not explain why seeing a picture half-cleaned should be disturbing and not reassuring. The Vatican, he said, 'should have closed the Sistine during the entire project'.

In fact, restorations are usually highly secretive affairs, as was true of the Brancacci Chapel. The Sistine Chapel was an exception for good reason. On days when the Chapel is closed to members of the public, admissions revenue at the Vatican Museums falls by 60 per cent. Revenue from the Vatican Museums runs at an annual rate of $10,000,000. Closing the Sistine Chapel for the decade spent cleaning the ceiling would have resulted in the loss of $60,000,000 of revenue. But Professor Brandt warned in 1987 that if criticisms persisted, the shutters would have to go back up:

'I do sometimes worry that the Vatican might one day shut off the constant flow of information about what they are doing, out of self-defence. If there were real problems it would be vital to know about them. Fortunately, everything I know about the team's high skill and level-headedness makes such a black-out unnecessary.' Brandt has never elaborated on how or why curtailing the free flow of technical information should constitute a form of defence. Meanwhile, her confidence has proved to be misplaced. Even though the final official report on the cleaning of the ceiling has not been published, work has begun on the cleaning of the *Last Judgement*. This restoration has been closed to public view by the erection of a screened scaffold. Our requests to visit the work in progress have been refused categorically by Professor Pietrangeli, Director General of the Vatican Museums (though Colalucci graciously allowed James Beck to view the restoration). The cleaning is not to be filmed. Even *The Burlington Magazine* has complained of the difficulty faced by scholars wishing to gain access to the ceiling in order to photograph the work in progress.[46]

The most fascinating aspect of Brandt's *Apollo* article is that it puts the onus of proof on to the critics as if the critics were the ones who were operating on Michelangelo's fresco: 'No valid evidence has been presented to show that Michelangelo or other painters working at the time of the Sistine Chapel used an all-over veil of tone or colour over the finished fresco', she wrote. But of course, the ceiling itself was evidence – its surface was almost entirely covered with glue-size painting. In 1992, Mancinelli described the ceiling's glues thus: 'a thin coating was applied fairly evenly over the whole surface; particular figures and details were singled out for additional treatment'.[47] This contradicted earlier claims that the first glue applications had been made by *mundatores* in response to local outbursts of salt efflorescence. This being so, caution should have been the overriding rule. Would not it have been more prudent for the people who were taking off such veils to provide incontrovertible evidence first that what they were removing was *not* original? Throwing the burden of proof on to

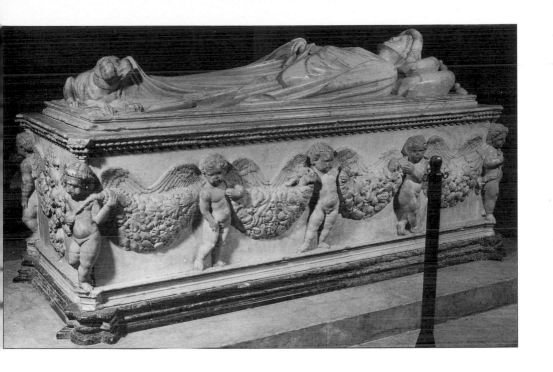

1. Jacopo della Quercia, *Ilaria del Carretto*, San Martino, Lucca, *c.* 1406–8. Before restoration (*above*) and afterwards – shiny, less modulated and harder to read.

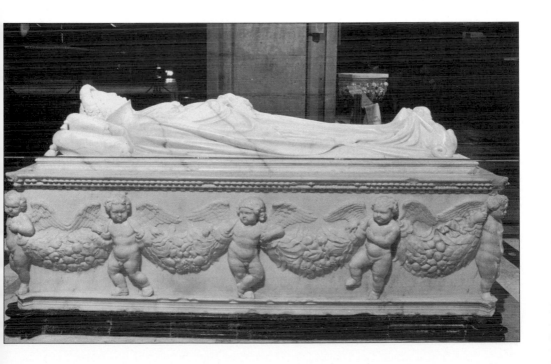

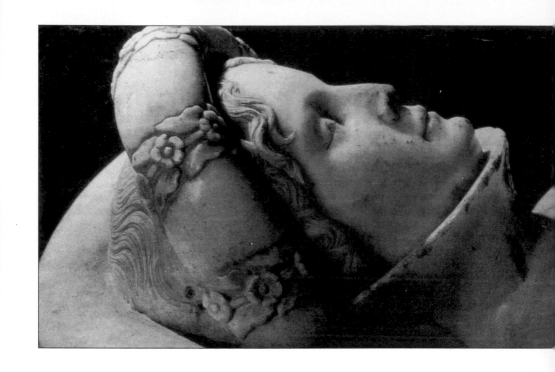

2. Della Quercia, head of *Ilaria* before restoration (*above*) and afterwards.

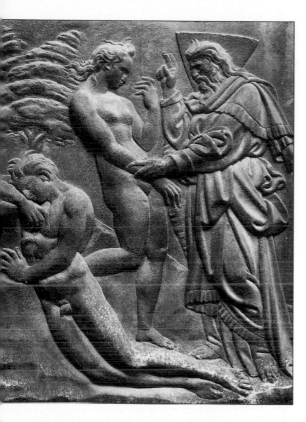

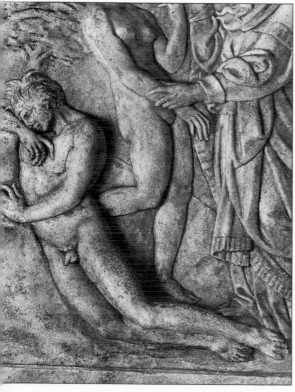

3. Della Quercia, *Creation of Eve* (detail), San Petronio, Bologna, *c.* 1425–38. Before restoration (*above*) and afterwards. The relief now appears as if a drawing, the artist's intention altered.

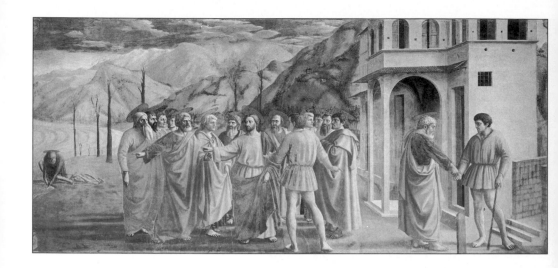

4. Masaccio, *The Tribute Money*, Brancacci Chapel, Santa Maria del Carmine, Florence, *c.* 1427–8. After restoration (*above*) with the newly painted bridge at right; (*bottom left*) detail of St Peter with the fish before restoration, and (*bottom right*) cruder and with leaves lost from the bush.

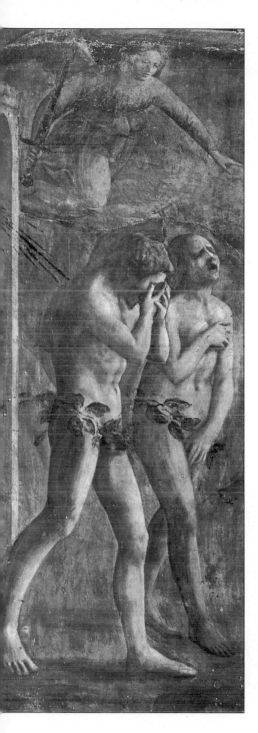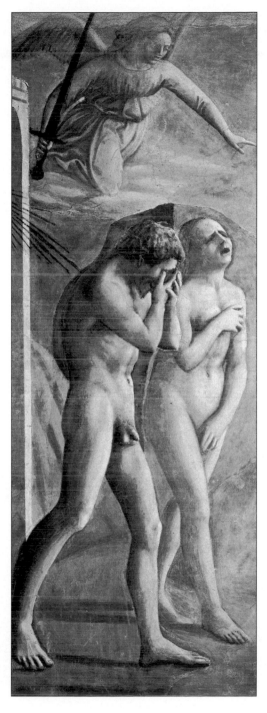

5. Masaccio, *The Expulsion of Adam and Eve*, Brancacci Chapel, before restoration (*left*) and afterwards with the *giornate* now emphasized.

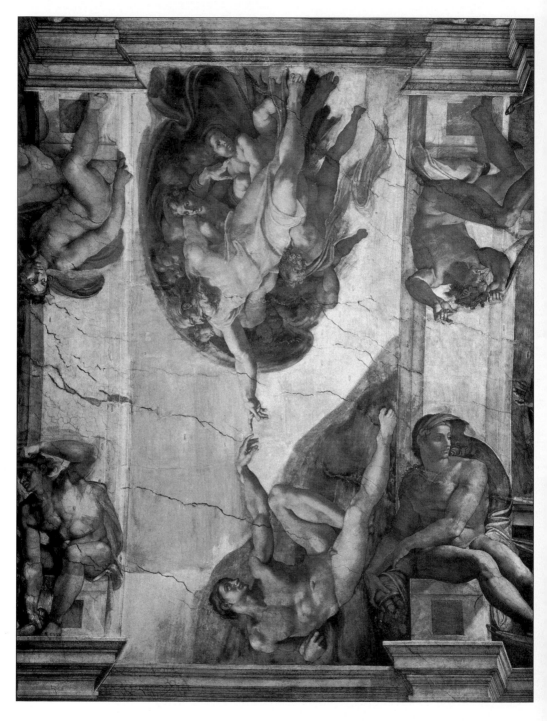

6. Michelangelo, *The Creation of Adam*, Sistine Chapel ceiling, 1508–12, before cleaning and apparently in satisfactory condition. God's delicately transparent garment is now heavier and the highlights have been displaced.

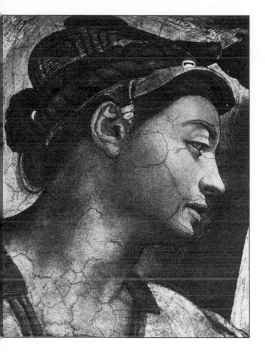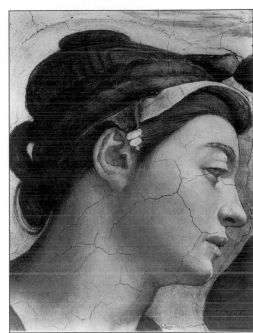

7. Michelangelo, Sistine Chapel ceiling. The head of the *Erithraean Sibyl* before cleaning (*top left*) and afterwards with shading lost. The right foot of the *Libyan Sibyl* before cleaning (*bottom left*) and afterwards with the *pentimento* and the shadow lost.

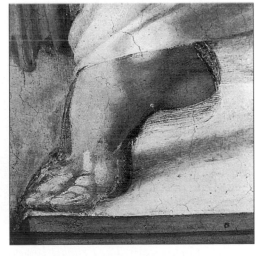

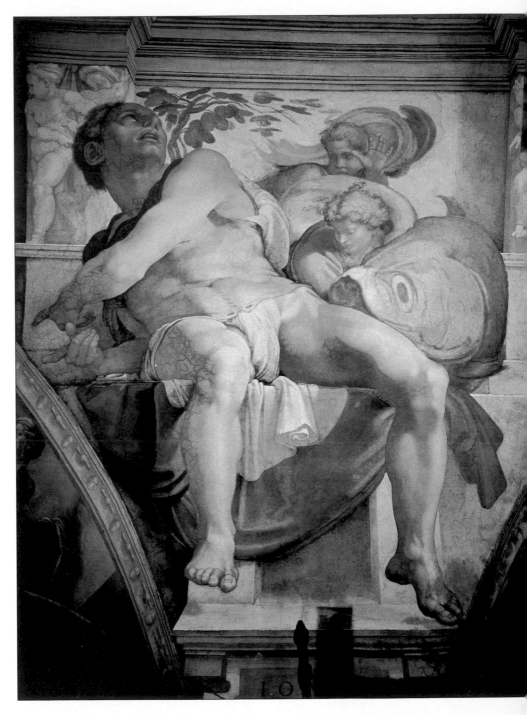

8. Michelangelo, *The Prophet Jonah*, Sistine Chapel ceiling, after cleaning; the dramatic shadow cast by the left foot has disappeared.

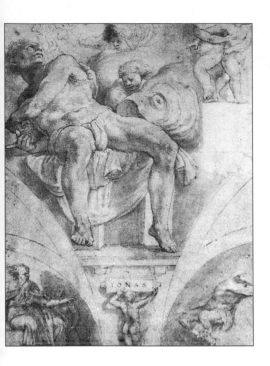 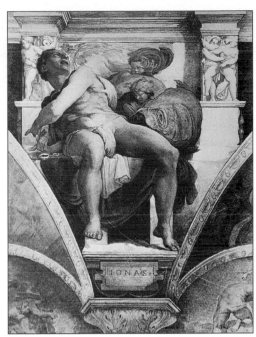

9. Four copies of *Jonah*: Clovio's wash drawing, between 1524 and 1534 (*top left*); Piccinni's drawing , 1886 (*top right*); Rados' engraving, 1805–10 (*bottom left*); and Conca's drawing, 1823–9 (*bottom right*). The shadow appears in each.

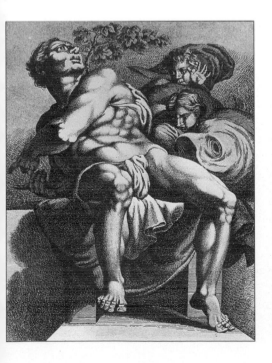 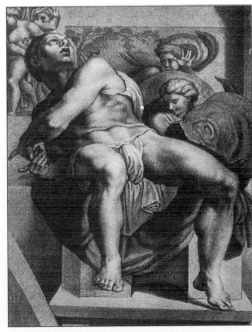

10. Bramantino, *Adoration of the Kings*, National Gallery, late 1490s. Detail before restoration (*above*) and afterwards with shading removed from the right-hand container.

11. Uccello, *The Battle of San Romano*, National Gallery, *c.* 1450. Head of horse before restoration (*above*) and afterwards with detail and modelling removed.

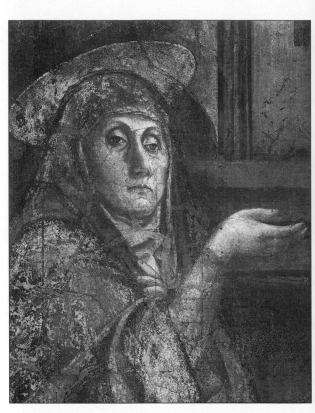

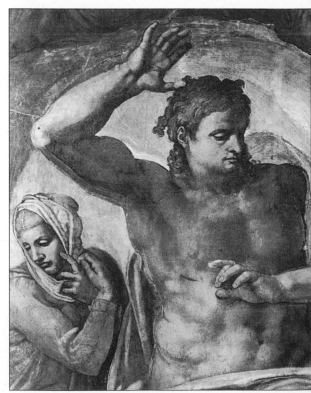

12. (*top*) Masaccio, *Holy Trinity*, Santa Maria Novella, Florence, *c*. 1425, detail of the Virgin. Note the fragility of the surface with diverse losses and repainting, but with the marvellous expression retained. This is now scheduled to be cleaned. (*bottom*) Michelangelo, *The Last Judgement*, Sistine Chapel, 1534–41, with the visible *pentimento* under the right arm. This is being cleaned (1993).

opponents may be effective public relations, but in a long-term scholarly or scientific presentation it is inadequate. Here, too, lies one central problem for the entire restoration. With an eye constantly on the press, decisions and pronouncements seem to have been made not for the sake of informing, but in order to influence.

A few years earlier, very serious mistakes were made in the conduct of the restoration of Raphael's Loggia in the Vatican. Mancinelli is quoted as saying: 'It is the best demonstration that a restoration can also not go along well.' Then it was a question of the solvents and other factors. Pietrangeli was able to shrug off the mistakes by pointing out that the damaged paintings were not by Raphael himself only by his pupils. But following this, are we supposed to take the Sistine cleaning on trust?

In attempting to answer criticism Brandt also maintains that photographic evidence of the state of the ceiling before cleaning is not dependable. The amount of light used can alter appearances and, alas, photographs can be retouched. In fact, the ceiling was photographed immediately before work was begun by the leading art photographer Takashi Okamura. His pre-intervention images, which look marvellous, should be used in comparisons with the 'new' Michelangelo of the restoration. Apparently, Professor Brandt believes Okamura used too much light, which cut through the veils of glue. But what he showed was there – including the glue-painting with all its shadows and *chiaroscuro*. No amount of extra light can enable a camera to record what is not already present.

Brandt's charge of 'culture shock' is reminiscent of one made during an earlier cleaning controversy. Opponents of the London National Gallery's cleaning policy during the 1940s were said by the *Sunday Telegraph's* art critic Eric Newton to be suffering from what he dubbed the 'shocked eye'. This condition afflicted not philistines but 'the connoisseur and the artist – the visually sensitive man with a quick eye and a profound reverence for what he has seen'. Newton was no more inclined to take seriously the objections of the quick-eyed, artistically reverent than is Brandt: 'The

battle is . . . rather unreal since the arguments against cleaning are mainly nostalgically emotional [while] those on the other side are chemical and scientific'. Newton accepted that terrible errors had been committed *in the past* but was confident that then contemporary standards were foolproof. A generation later Brandt likewise accepts that major errors have occurred since Newton's time but, nonetheless, dismisses her opponents as emotional and unscientific, as people who 'misunderstand insufficient evidence' and draw 'a mistaken conclusion'. Her role, she is clear, is to 'dissolve some of the murky argument and preserve a few facts'.

Defending the contention that Michelangelo was a more brilliant colourist than had been realized, Brandt makes no mention of the oration delivered at Michelangelo's funeral service in Florence, which praised him for 'the fleeting sombre colours with which he had formed such rare and lofty shapes'.[48] She ignores the strictures Michelangelo himself made against vivid colouring. On one occasion he is said to have condemned 'those simpletons of whom the world is full who look more at a green, a red or similar high colour than at the figures which show spirit and movement';[49] on another, to have said it was 'poor artists [who] cloak their poor technique with a variety of tints and shades of colour'.[50]

Indifference to seemingly concrete evidence has been a common feature of the case put forward by supporters. Dr Nicholas Penny, Clore Curator of Renaissance art at the National Gallery in London, described in March 1991 the emergence of the 'new' Michelangelo as 'one of the great revelations of our time'.[51] The transformation, he claimed, 'is so absolutely amazing that it is bound to give people a shock'. It might well have given Dr Penny a shock: when in 1968 the National Gallery cleaned its panel painting *The Entombment of Christ*, which it holds to be by Michelangelo, it uncovered colours not brilliant but 'restrained or even sombre' and in places having 'the rather more subdued tones associated with fresco painting . . .'[52] The scientific analysis and restoration undertaken at the time by the Gallery's conservation

department established that Michelangelo achieved his muted, sombre effects partly by 'toning down' his colours with grey paint. He did this over flesh colours, over drapery and over the landscape – in short, over a good deal of the painting. The National Gallery's publications and reports hold that the *Entombment* (which is undocumented) was begun by Michelangelo shortly before he began work on the Sistine ceiling in 1508 and was worked on further at some point after its completion in 1512. Indeed, the clear differences in artistic handling which exist in the *Entombment* are said by the Gallery to be a consequence of Michelangelo's experience of having painted the ceiling. The reliability of these accounts of restorations, however, seems uncertain: when National Gallery staff were reminded recently of their predecessor's report they (a) dismissed it as 'ancient';[53] (b) accepted that Michelangelo had 'used thin semi-transparent grey toning or modelling in oil on this altarpiece';[54] (c) said that the report was in error and claimed that the grey paint was in fact 'dirt' which had incorporated itself into the oil paint at a time when the painting had served as a fish stall;[55] (d) accepted that the grey paint was grey paint where it occurred in areas depicting flesh but held it to be 'surface dirt and blanched varnish residues' elsewhere.[56]

In the absence to date of any official and final account of the work done by the restorers, their various evolving 'position statements' must stand in lieu. One such is Dr Mancinelli's chapter in *The Sistine Chapel,* published in 1986. In it, he stressed that Michelangelo's use of colour 'had a primary structural role' and was used 'constantly pure'. Because of this colouristic luminosity, Michelangelo had been able to 'abandon almost altogether traditional *chiaroscuro* modelling'. (Chiaroscuro creates an illusion of three-dimensionality within a painting by mimicking the kind of tonal, light to dark, gradations that real forms show in the real world.) Mancinelli accepted that the Sistine frescoes of Michelangelo had seemed, for centuries, to historians, connoisseurs and fellow artists to have embodied the most accomplished chiaroscuro effects, but insisted nonetheless that the present cleaning had led to the 'surprising conclusion that

the kind of suggestive painting by shadows for which Michelangelo was admired until a few years ago was essentially the product of candle-smoke and still more of glue varnishes'.[57]

This claim caused bewilderment, particularly to artists. Frank Mason, the American muralist and Vice-President of the National Society of Mural Painters, had already protested in a letter to Dr Pietrangeli that, in the cleaning of Michelangelo's figures: 'The anatomy has been disturbed, and the relationships of light and shade have been destroyed. We artists now find anatomical defects and changes in foreshortening that are unbearable to the eye.'[58] Mason implored Pietrangeli to reconsider the cleaning technique.

This appeal and another from the Fine Arts Federation of New York were refused. John Shearman asked: 'Can you imagine what it is like trying to restore a painting with hordes of artists petitioning the Pope all the time to get it stopped?'[59] Dr Pietrangeli, in his foreword to *The Sistine Chapel*, had acknowledged 'the artists who brought a different sensibility from that of professional critics or restorers'. Their criticisms, he added, were of value but only insofar as they 'spurred us on to an even greater punctilio (if that were possible) in the documentation of the restoration, so that a full report of the criteria adopted and the methods used should be available for all those interested in the present or the future'.[60]

But what of Dr Mancinelli's claim that Michelangelo's chiaroscuro was the product of soot, plus varnish applied by restorers? It can only be fanciful: how could soot deposits from candles and braziers arrange themselves along the designs of an artist? And why would the dust and soot transform Michelangelo's paintings on the ceiling and upper walls of the Chapel but not those of Botticelli or Perugino on the lower walls? The claim is also contradicted by Michelangelo's own preparatory drawings for the ceiling. Where previously they were in complete accord with the frescoes, they find themselves today significantly more volumetric and convincingly three-dimensional than the same images as they now appear

on the restored ceiling. This odd contradiction seems to have been missed by the Vatican's art historian advisers who include, let it be said, several world-class experts on the master's drawings. If the cleaning is correct, we must conclude that the artist, at that time more a sculptor than a painter, was flat in the paintings but three-dimensional in their conception and in their preparation. Even more improbably, we must believe that while Michelangelo had designed his figures with an emphatic chiaroscuro, he had not carried it through into his own painting and that the resulting 'deficit' in modelling had been made good so convincingly by accumulations of soot and discoloured varnish that the most expert onlookers had been, for centuries, deceived. (Parenthetically, certain specialists challenge the attributions of a portion of the drawings associated with the Sistine, considering them to be copies by pupils or followers. Even if that is true, the evidence of the drawings would still be damaging, because the copies would be fully volumetric, while the original painting was not: an equally impossible scenario.)

Yet for all its improbability the soot theory is vital to the restorers' case. Because glue varnish cannot be invoked before the only recorded cleaning in 1710–13, if at all, soot alone must account for the alleged failure of Michelangelo's contemporaries to recognize his revolutionary use of colour.

M. Kirby Talley, Jr, went so far in 1987 as to attribute to the 'rapid and pernicious' darkening of the ceiling by smoke and dust during Michelangelo's own lifetime the fact that he was seen 'to have been a sombre colourist at best, and a bad colourist at worst' and even for having been thought of as a 'linear artist or "designer" rather than the obvious colourist he is'.[61] Yet contours are by definition sharp, precise, decisive. Soot is arbitrary, imprecise obfuscation. How could the latter produce the former? Besides, did Talley think Michelangelo's reputation as a linearist was the product of sooty pollution on a single work?

We are looking at a unique art historical phenomenon: on the basis of a single cleaning, with an experimental solvent, of a single

work by probably the most studied artist in the history of art, much of the art-historical establishment has been prepared to change its view fundamentally. Would it not have been more sensible to judge this cleaning by the historic record rather than vice versa? After all, the record is compendiously rich and it is also consistent. Recall that eyewitnesses made no mention of a dazzling chromatic invention or innovation. Rather, they were astonished at an unprecedented virtuoso display of chiaroscuro and sculptural illusionism. It was as if Michelangelo had succeeded in painting above our heads the very marble monument to Julius II that he was being prevented from making by the ceiling's commission. It was a triumph of artistic will over material circumstance.

Michelangelo had given, in the words of Paolo Giovio (who wrote a short biography of him), 'such emphasis to the light in contrast to the shade that even knowledgeable artists were induced to believe in the truth of the figures he painted and to see what was flat as solid'. Vasari, in his life of Michelangelo, marvelled at the ability to portray even 'the divine majesty' in 'the firm and tangible terms that human beings understand'. Tangibility was the means by which truthfulness was realized: Condivi (who wrote his biography in close association with Michelangelo himself) was proud of the corporeality with which God had been invested, an effect he commented to have been 'executed with such great artistry that wherever you turn, He seems to follow you'.

The artistic and technical means by which these grand sleights of hand were produced have been recorded. Benvenuto Cellini proclaimed: 'Michelangelo today is the greatest of all known painters, both ancient and modern, only because he copies every figure that he paints from carefully studied models in sculpture'.[62] His only possible rival, Cellini thought, might be 'the talented Bronzino' – 'all the others wallow in cornflowers and in a juxtaposition of varied colours fit for deceiving peasants'. A sculptor notorious for exaggeration, Cellini might be suspected of grinding a professional axe, but Vasari confirms the practice: Michelangelo 'first made models in clay or wax, and from these, because they remain

stationary, he took the outlines, the light and the shadows, rather than from the living model'. This not only helped him to imbue individual figures with three-dimensionality, it also made possible a convincing evocation of space itself: by studying the shadows cast by one model on another, or on a wall or floor, he could make his figures seem to be occupying real space and, therefore, to stand out 'in living relief'.[63] No one, Vasari insisted, ever 'did better work of this sort than our Michelangelo Buonarroti', a man sent to earth 'to show single-handed the perfection of line and shadow, and who would give relief to his paintings'. Michelangelo himself concurred: 'painting and sculpture are one and the same thing ... both proceed from the same faculty ... painting should be considered excellent in proportion as it approaches the effect of relief'.[64]

Vasari, in a treatise prefixed to his 1550 edition of *Lives of the Artists*, laid bare precisely the means by which the sculptural illusion was to be realized and, almost as importantly, the means by which it is now undermined. When he objected to colours that were 'laid on flashing and vivid in a disagreeable discordance', it was precisely to avoid the emergence of figures which seemed 'painted by the patches of colour rather than the brush, which distributes the light and the shade over the figures and makes them appear natural and in relief'. All pictures, Vasari went on, whether in oil, in fresco or in tempera, must be 'so blended in their colours that the principal figures in the group are brought out with the utmost clearness, the draperies of those in front being kept so light that the figures which stand behind are darker than the first, and so little by little as the figures retire inwards, they become also in equal measure gradually lower in tone in the colour of both the flesh tints and of the vestments'. Recall as well the view of Michelangelo's older contemporary and competitor, Leonardo da Vinci, which is printed at the head of this chapter.

This programme described by Vasari and by Leonardo might have been designed to produce the very effect for which Michelangelo's lunette paintings were acclaimed prior to the recent clean-

ing, but which Dr Mancinelli now specifically rejects as being the product of dirt: 'the lunettes have hitherto been interpreted for centuries by scholars as *chiaroscuri* with light and shade distributed so that the figures seem to be emerging from the darkness'.[65] The novelty of Mancinelli's departure is clear from another treatise on fresco painting published in 1587 by Giovanni Battista Armenino who, after studying the Sistine Chapel frescoes, urged painters to diminish their figures 'with such skill and dexterity as to [cause them] to appear to die away in the shade and to lose their brilliancy by degrees, so that it may be seen that the light does not produce the colours, but only makes them visible'. Paulo Giovio confirmed in 1525 that Michelangelo had 'used a gradually diminishing light to suggest some figures in the distance, almost hidden . . .'[66]

The novelty of Mancinelli's view is clear from the artistic and photographic record. The fact that the ceiling has been copied and engraved by subsequent artists throughout its history makes visual tests of Mancinelli's thesis possible. For example, if the shadows had been added to Michelangelo's painting by subsequent restorers, then early copies would be expected not to show them, while later ones would. Or, if the shadows had somehow been produced by discolouring glue which had been applied overall as a varnish, then the copies might be expected to record the gradual emergence of these shadows. In fact nothing of the sort occurs. All the copies of the ceiling – regardless of their stylistic variations – tell the same sculptural, shadowy story. Even though some copies were of other copies, there is no evidence of the ceiling's having undergone an evolution or a modification in any of the copies for close to half a millennium.

However, features recorded before any restorers were appointed and repeatedly copied have disappeared in the course of today's restoration. To give a single example: of the many hundreds of figures on the ceiling, probably the most admired (and copied) in Michelangelo's day was the Prophet Jonah. In the view of Condivi

it was 'most admirable of all . . . because contrary to the curve of the vault and owing to the *play of light and shadow* [italics added], the torso which is foreshortened backward is in the part nearest the eye, and the legs which project forward are in the part which is farthest. A stupendous work, and one which proclaims what great knowledge this man has in his handling of lines, in fore-shortening and in perspective.' Vasari was no less impressed: 'Then who is not filled with admiration and amazement at the awesome sight of Jonah . . . The vaulting naturally springs forward, fol-lowing the curve of the masonry; but through the force of art it is apparently straightened out by the figure of Jonah, which bends in the opposite direction; and thus vanquished by the art of design, *with its lights and its shades* [italics added], the ceiling even appears to recede.' Countless copies of Jonah from as early as within twelve years of the ceiling's completion record a strong dark shadow cast from his left leg, running along the ground and merging with a larger shadow framed by drapery at the top and the two architectural piers of his 'throne'. This shadow existed uninterruptedly for more than four hundred and sixty years before perishing in the current cleaning. The excuse often given that the many engraved copies are unreliable does not stand. One of the best and earliest copies was not an engraving but a pen and wash drawing carried out by Giulio Clovio, described by Vasari as a most 'excellent illuminator or painter of small things . . . who has far sur-passed all others in this exercise'. He was 'the Michelangelo of small works'. His copy clearly shows the shadow. A second wash draw-ing made at the same time as Clovio's by an anonymous artist is housed at Windsor Castle. It, too, records the shadow.

Lack of historical verification may account for two features of the supporters' campaign: a disparaging tone, and technically fanciful explanations. Let us return briefly to glue varnish as a case in point. Manuella Hoelterhoff informed readers of the *Wall Street Journal* that 'in the 18th century janitorial squads slathered animal glue on the vaults with long poles'.[67] Dr Walter Persegati was more precise: the glue had been applied with 'brushes on

poles some ten metres long'.[68] Frederick Hartt spoke of the 'disastrous effects' that 'irregularly applied blotches of glue – applied with sponges on long poles [in] the seventeenth and eighteenth centuries', had had on the ceiling.[69] His recently revised *History of Italian Renaissance Art* speaks of a 'sloppy' coating of animal glue and even Greek wine added in the eighteenth century 'to brighten things up'. (The reference to Greek wine is a confusion. The wine, actually a native Italian variety, was used as a solvent to clean surfaces, not as a sealant to bring out colour.)

No factual basis for any of these claims has ever been established. No record has surfaced of poles, brushes or sponges having been purchased, assembled or used. No one is known to have been paid to apply glues. A moment's thought would establish the notion of brushes more than thirty feet long as an absurdity. Assume that a restorer is standing on the top of a thirty-foot-high step ladder armed with a thirty-foot-long brush. Where is the pot of hot glue? At his feet on the top of the ladder or on the ground? If the former, he must pass most of the length of the brush through his hands and then cantilever the brush head into the pot, load it with glue, wipe the excess off the brush on the edge of the pot and begin passing the length of the brush handle through his hands while raising the gluey brush end up towards the ceiling. When the brush approaches the ceiling thirty feet above his head the restorer, grasping the very end of the thirty-foot-long implement and maintaining his balance, must finally begin his brushing motion. The prospect is worthy of Laurel and Hardy.

Although these accounts have no technical credibility, or historical basis, they do serve a polemical purpose. They carry the commonsensical implication that only an ignoramus could confound 'sloppy', 'slathered' and 'crude' workmanship with that of Michelangelo.

Hartt was proud of having made nine visits to the restorers' scaffold during the cleaning. He found on these occasions a layer of soot and glue so dense that he could scarcely see the surface of the fresco. But his testimony conflicts starkly with that of

Alexander Eliot, the former art critic of *Time,* writer and painter, who with his wife spent over five hundred hours contemplating the ceiling at touching distance. The Eliots, with the assistance of the American Council of Catholic Bishops, conducted preliminary research in 1967 for the close-up documentary film *The Secret of Michelangelo, Every Man's Dream*. On ascending for the first time to the top of a sixty-foot aluminium scaffold provided by the Vatican, the Eliots were dumbfounded. Alexander Eliot reported in the *Harvard Magazine* of April 1987: 'With the exception of the previously restored Prophet Zachariah, almost everything we saw on the barrel vault clearly came from Michelangelo's own inspired hand. There are passages of the finest, most delicately incisive draughtsmanship imaginable. Michelangelo's loving depiction of fingernails, eyelids and tiny wrinkles stand in contrast to tremendous transparent swirls of colour – which must have required a broom-sized brush – created with enough energy to shame a Japanese samurai.' The Eliots' observations stand documented in their film for ABC television.

Eliot's claim in the *Harvard Magazine* that the 'continued destruction of such frescoes as this constitutes the greatest and least necessary disaster in the history of art' is endorsed by the distinguished Italian sculptor, Venanzo Crocetti. Early in his career, Crocetti also worked as a restorer of pictures, and during the 1930s he was employed as an apprentice in the Vatican Laboratory of Restoration during which period he spent 'four full years' on the scaffolding then present in the Sistine Chapel. Crocetti's view was then and remains today that Michelangelo's frescoes were well preserved and were not in need of restoration: 'The general condition', he wrote in a paper prepared years earlier but published in *Oggi e Domani* in December 1989, 'still today can be considered excellent', a fact which, he believes, has been contributed to, in part, by the smoke of the Chapel: the absorption of its greasy substances had 'strengthened the colour, leaving upon it a glittering shift of lightest varnish', thereby counterbalancing 'the aridity and fragility' typical of fresh fresco.

As for the large areas of glue present on the ceiling and applied with 'long brush stokes' – but not long *brushes* – one upon another, these in Crocetti's view could only have been the work of Michelangelo himself as he sought to make adjustments of colouring and tonality to the dry fresco surface. Precisely because these retouched and repainted parts, which occur chiefly but not exclusively in the 'shadowed zones', were not 'incorporated' into the fresco itself, they risked perishing in the present cleaning along with the dirt and soot. This risk, he felt, was particularly great, given the 'aggressive' nature of the solvent used by today's restorers. Indeed, the solvent has done particular damage in Crocetti's judgement to 'the light–dark system, the principal cardinal point in the frescoes ... around which there move even the structural values of the whole work'. (The solvent and its effects are discussed further in the next chapter.)

This destruction of shadows was of fundamental aesthetic significance to the entire fresco cycle: 'And where have those grave shadows of the figures, extended in the grounds with pertinent differences of intensity according to the beat, been left? These forms or masses of shadow had comprised a compositional element in themselves, sometimes adding to, sometimes counterbalancing other conformations.'

It might be thought that an informed assessment like this would have been taken seriously by the Vatican authorities, especially as Crocetti, hitherto, had enjoyed a lifelong association with the Vatican, and to this day serves nominally as an adviser to it. But Crocetti too was dismissed. His request to visit the scaffolding, in order to see at close hand the solvent application which he felt was producing disastrous results, was turned down even though the Vatican authorities have constantly claimed the restoration to be 'open' to examination.

Though Crocetti was kept away, bringing substantial numbers of people on to the scaffolding while work was going on seems to have been part of a strategy to create the perception that the restoration really was 'open'. A continuous stream of journalists

were brought there, leading to the maximum possible coverage on a continuing basis. As the restoration proceeded, a constant flow of discoveries, new colours, new modalities, hitherto unknown figures or elements, all seen just a few feet away, were regularly announced by the international press. The Sistine Chapel restoration became one of the major art stories of the decade. Of course, viewers had nothing to guide them, no background, no point of reference, and the entire spectacle was totally uninformative as regards technical matters. But it served to win over and inspire enthusiasm amongst specialists and experts, who otherwise might have had reservations. Out of those who had seen the ceiling from the scaffolding, the restoration team created a powerful army of proselytes who spread the word far and wide. The experience of being there on the scaffolding, cheek by jowl with Michelangelo Buonarroti, the sculptor-painter-architect-poet, in the company of one of the directors of works or a restorer explaining the activity, divulging what appeared to be little secrets and discoveries about Michelangelo's immense fresco, was unforgettable. Who would belittle the possibility of obtaining insights into the creative processes of one of the most complex artists of all time?

One should understand, however, that direct confrontation had little to do with the restoration, its correctness or its wisdom. After all, only very few individuals had ever seen the ceiling up close before the restoration or, for that matter, seen at arm's length any other equivalent large-scale fresco. They had nothing to compare it with. Michelangelo is overpowering; up close, nice and clean, nothing can rival him, especially as the entire story of Western religion and culture unfolds around you, there in the Sistine Chapel. But the actual cleaning process cannot be evaluated merely by getting up on the scaffolding and having a look. After the cleaning you cannot see the 'before' any longer, and even with photographs of a particular segment in hand, its previous state would not tell much because of the gigantic shifts in scale. You would see some of the 'dirty' portions, which would naturally look even more dirty next to the recently 'clean' parts. To be able to

say, 'it looked good to me' or 'it was much easier to read', has nothing to do with comprehending the methodologies used in the cleaning, the philosophies resting behind them, or the losses that have occurred.

In effect the Vatican team seems almost to have used Michelangelo's own mighty artistic power to cloud a demanding and disinterested evaluation of the results of the cleaning as it progressed along the ceiling.

The estimation of Michelangelo's *secco* painting reached by Eliot and Crocetti in the light of their separate scrutiny of the ceiling's surface echoed views expressed in the nineteenth century. In 1876, the painter Charles Heath Wilson gave in his biography *Michelangelo Buonarroti* an invaluable report, technically detailed and artistically informed, of the state of the frescoes when he saw them. Before Wilson ascended the scaffold built for him by the Vatican authorities he did not believe that Michelangelo had retouched the ceiling when dry. Yet he found that 'the frescoes are extensively retouched with size colour, in the manner then common, evidently by the hand of Michelangelo'. Wilson could not only see this size painting clearly, he could touch it:

'The colour readily melted on being touched with a wet finger and consisted of a finely ground black, mixed with a size probably made according to the usage of the time from parchment shavings ... The shadows of the draperies have been boldly and solidly retouched with this size colour, as well as the shadows on the backgrounds. This is the case not only in the groups of the Prophets and Sybils, but also in those of the Ancestors of Christ in the lunettes and the ornamental portions are retouched in the same way. The hair of the heads and beards of many of the figures are finished in size colour, whilst the shadows are also thus strengthened, other parts are glazed with the

same material, and even portions of the fresco are passed over with the size, without any admixture of colour, precisely as the force of water colour drawings is increased with washes of gum . . . These retouchings, as usual with all the masters of the art at the time, constituted the finishing process or as Condivi expresses it, alluding to it in the history of these frescoes, '*l'ultima mano*'. They were evidently done all at the same time and therefore when the scaffold was in its place.'

Two of Michelangelo's early biographers, Condivi and Vasari, state that Michelangelo was prevented from carrying out portions of the *secco* work that he had wished to apply. Of the two accounts, Condivi's is generally taken to be the stronger for it was in effect Michelangelo's own. When Vasari published his first version of Michelangelo's life in 1550 the artist was dissatisfied so he arranged to have his follower and student Condivi write a new one, to put the record straight. Condivi reports that, 'It is true that I have heard him say that [the ceiling] is not finished as he would have wanted it, as he was hampered by the urgency of the Pope . . .' Vasari, too, reported in his enlarged and revised version of the life (in 1568) that: 'Michelangelo wanted to touch some parts of the painting *a secco*, as the old masters had done on the scenes below, painting backgrounds, draperies and skies in ultramarine [that is, lapis lazuli] and in certain places adding ornamentation in gold in order to enrich and heighten the visual impact.'

These accounts have been widely taken to prove that Michelangelo did not apply *any* work *a secco*. But the key surely lies in Condivi's phrase 'not finished as he would have wanted it' ('*e vero ch'io gli lo sentito dire, ch'ella non è, come egli avrette voluto, finita . . .*'). Condivi and Vasari both report that the Pope repeatedly demanded to know when the work would be finished. On one occasion Michelangelo provocatively replied 'when it satisfies me as an artist'. The reply is only sensible in terms of an artist making adjustments and refinements to his own satisfaction. And cer-

tainly, when the Pope finally lost patience and threatened to have Michelangelo thrown from the scaffolding if he did not stop, it turned out that there were no unfinished sections awaiting treatment in *buon fresco.*

Vasari, in fact, spelt out which *secco* parts had not been carried out – those requiring gold and ultramarine, by far the most costly and visually rich ingredients in a painter's armoury. Today's restoration apologists have used that statement to suggest, very plausibly, that had *secco* work been carried out it would have been for the purpose of enriching, not depressing, the chromatic force of the frescoes. They also enlist Vasari's admonition to artists in his treatise on fresco (1550) not to apply *secco* work to frescoes.

But Vasari's generalized, rhetorical prohibition is easily discounted. First, he did not follow his own advice. Second, he acknowledged that 'many painters' added *secco* work (as how could he not, writing eight years after the unveiling of the *Last Judgement* which, as today's restorers have admitted, contains a great deal of it?). Third, he did not at any point say that Michelangelo had painted the ceiling without recourse to *secco* work – which would, given its enormous size, have been a stupendous technical achievement clamouring for recognition which Vasari of all people is unlikely to have withheld. Finally, when Nicolò da Modena, more than thirty years after the ceiling, did actually carry out a commission entirely in *buon fresco,* Vasari was astonished. 'He painted [the frescoes] so harmoniously that they look as if they had been done in one day. He therefore merits great praise, especially as he never retouched them as is now so frequently done.' But then who remembers Nicolò? It is hardly the technology which counts but rather the imagery and the invention.

And just as relevant as Vasari is the treatise of 1587 on fresco painting by Giovanni Battista Armenino who went to Rome in 1550 and stayed for seven years copying 'the best pictures', including Michelangelo's *Last Judgement.* As the fresco begins to dry and no longer absorbs the colour with the same force as before, the painter, Armenino instructs,

must then finish it off with moist and dark shade tints ...
the muscles of naked figures as being of greater difficulty,
are painted by hatching them in different directions with very
liquid shade tints, so that they appear of a texture like granite;
and there are very brilliant examples of this painted by the
hand of Michelangelo ... they can be perfectly harmonized
by retouching them in *secco* ... in retouching the dark parts
in this manner, there are some painters who make a water-
colour tint of black and fine lake mixed together, with which
they retouch the naked figures and produce a most beautiful
effect, because they make hatchings upon the painting, as is
usual to do while drawing upon paper with black lead ...
Some persons temper these dark tints with gum, some with
thin glue ... this I affirm from what I have both seen and
done and also what I have been told by the best painters.

It seems highly probable even on the testimony of his bio-
graphers that Michelangelo did, in fact, carry out much *secco*
work. Yet the restorers and their supporters remain unmoved:
the very notion that Michelangelo might have applied glues to his
own fresco is to Professor Michael Hirst of the Vatican's Scientific
Advisory Committee a 'nonsense'.[70]

Before ending this chapter three minor points should be raised.
There is a test which restorers traditionally employ when consider-
ing removing a paint or glaze film from a picture: did the upper
layer of paint or glaze crack with the lower layers or did it run
into pre-existing cracks? If the latter, then the paint or glaze can
safely be regarded as additional and inauthentic. When the
Washington National Gallery decided to clean the magnificent
Feast of the Gods by Bellini and Titian, they found 'all of the figures
in the foreground had been toned down with grey overpaint. The
fact that the overpaint lay in and over the flake losses in the original
paint supplied absolute proof that it had been applied at a later date
than the original.' The paint, accordingly, was removed. Charles

Heath Wilson applied the same test with the same confidence to the Sistine ceiling: 'There can be no doubt that nearly all of this work is contemporary, and in one part only was there evidence of a later and incapable hand. The size colour has cracked as the plaster has cracked, but apart from this appearance of age, the retouchings have all the characteristics of original work.' The glue, on Wilson's testimony, had cracked with the plaster, not run into any pre-existing cracks. The ceiling is known to have cracked before any restorers were hired. Even at this late date it is possible for us to check Wilson's observations, as the Italian painter Mario Donizetti has demonstrated: a comparison of photographs taken before and after cleaning shows that the size of the cracks in the fresco remains constant. If glue had been applied over cracks it would have run into them and either filled them completely or lined their sides, in which case the cracks on the cleaned fresco would now be wider than before. They are not.

The second point concerns the famous fragment of fresco which was fortuitously discovered, late in the present restoration, buried in a repainted deep crack in one of the ceiling's *ignudi* above and to the left of the Persian Sibyl. The crack is believed to have been repaired by Carnevale in 1565 or 1566, and the fragment was found to be free of glue. This was presented (and widely accepted) as the clearest imaginable proof that the glue-painting had not been applied by Michelangelo. In truth it proves nothing of the sort. Wilson recorded that Michelangelo's glue additions, though very extensive, were not total: 'There are very few indications of retouchings on the carefully painted nude figures and so far as it was possible to observe they are untouched by size colour.' The fact that a fragment of nude figure should be found without added *secco* work confirms Wilson's testimony, not contradicts it.

Third, the restorers have employed one other weapon: their scientific analysis of 'stratigraphic cross sections'. Minute samples of the surface are suspended in polyester resin which, when hardened, is cut to expose cross sections of material to microscopic examination. Because this method revealed particles of dirt beneath

the glue, it was claimed that the glue could not have been applied by Michelangelo. But *secco* additions would have been made, at the earliest, as much as three to six months after the *buon fresco* painting, to allow the process of carbonization (where the pigments are fixed by the formation of calcium carbonate crystals) to take place, and the colours to 'settle down'. That there should be dirt or soot particles trapped underneath glue applied by Michelangelo is not surprising: he worked on the ceiling over a four-year period during which the Chapel remained in full use for services and ceremonies and would therefore have been lit and warmed by all the usual soot-producing apparatus of the period. Moreover, he worked on scaffolding above the windows throughout the year, in fair weather and foul, and, by all accounts, for abnormally long hours each day. He must therefore have had his own sources of soot-producing light and (in winter) heat only feet away from the fresco surface. Any glues applied by him would inevitably have trapped dirt and soot. Anyone inclined to be seduced by what the restorers claim for stratigraphy should examine their accounts with care. As on some other points, their descriptions fluctuate and can be ambiguous: 'Observations and tests made before and during cleaning *can* distinguish Michelangelo's original surface from the coats of dirt and glue above' (Brandt)[71]; 'Stratigraphic sections *can sometimes* show that glue was applied on top of pre-existing dirt (deposited after the frescoes were finished) but scientific evidence *cannot always* give clear answers to the most important questions' (Brandt)[72]; 'Under the glue were *further traces* of dust and soot' (Mancinelli)[73] (all italics added). Furthermore, there is no indication where the tests took place nor how frequently.

Is it not possible that the scientific hand has been overplayed? Has it not been accepted a little too readily and uncritically? Contrary to impressions, the 1979 investigations brought little that was new to the task. As far back as the Thirties X-ray and ultra-violet techniques had shown that 'the overpaintings were lying quite brightly *a secco* on the fresco layer itself; these overpaintings proved themselves undoubtedly the painting of the Master himself.'[74]

In summary, the weight of evidence supports the belief that the glue-based painting was Michelangelo's own. No hard evidence has been offered to corroborate the claim that it was applied by anyone else. The assertions of the restoration's apologists appear inconsistent from one statement to the next and with one another. On such a shaky foundation, can it conceivably have been right to alter one of the greatest paintings in Western history fundamentally and forever, to re-present a masterpiece from another century according to the standards of our own transitory time? The ceiling is certainly cleaner, and pleasure may be given to those whose eyes are better attuned to the colours of a Matisse or a Mondrian, a Frank Stella or a David Hockney, than the sometimes sombre world of the sixteenth century, but the authentic masterpiece of Michelangelo, held in trust for future generations whose tastes will be different from ours, is now severely damaged.

IV

The Physical Condition
of the Sistine Ceiling

By James Beck and Michael Daley

IF AUTHENTIC PAINTING by Michelangelo has indeed been lost in the course of a scientific restoration, many questions need to be answered. Did a blunder occur because of or in spite of the use of a scientific approach? Has too great a dependence on scientific data undermined crucial powers of aesthetic discernment and judgement? Is the scientific method of restorers rigorous or slipshod? Is the scientific status of modern conservation legitimate or bogus? Do restorers always follow their own scientific ground rules?

There is a widely accepted prohibition against using untested materials on important works of art. Writing in *The Burlington Magazine* in November 1987, Professor Brandt acknowledged that the *strappo* technique of removing frescoes from walls and remounting them as portable pictures 'was another technique widely hailed in the 1960s which has proved unsatisfactory'. Noting that 'such new materials and methods have often appeared to be panaceas when first developed', she asked, 'How long then does it take for a material or technique to prove itself safe?' There was 'reassuring concord that for inorganic substances, an experience of about twenty years may be sufficient'.[1]

Writing the following month in *Apollo*, Brandt said of the Sistine

Chapel restoration: 'The substances used for the cleaning . . . have been used successfully for over twenty years'; their 'chemical and physical action is known and stops once the process is finished'; and 'the cleaning chemicals do not actually come into contact with the fresco surface'.[2] We disagree with all these claims.

During the mid-1970s, the Vatican Museum's own laboratory produced a new solvent. It was used in the Loggia already mentioned, on the cycle of frescoes known as 'Raphael's Bible', but was abandoned when a film began to develop over the paintings. Although a 'cure' was found later, Dr Mancinelli conceded that 'What was damaged cannot be undamaged.'[3]

Very shortly after that mishap, the Vatican restorers undertook to clean the entire Sistine Chapel cycle of frescoes by Michelangelo with another new solvent, AB57. This had been developed by Professor Paolo and Laura Mora, at Rome's Istituto Centrale del Restauro, and it was devised to attack and dissolve the calcium encrustations that build up on marble. Because the surface of fresco is chemically identical to that of marble and frequently also suffers from calcium encrustations, it was thought that AB57 might be an appropriate treatment. Technical papers on the solvent's characteristics and possible applications were published by the Moras in 1972, 1974 and 1977. At that period the mild cleaning of frescoes on the lower walls of the Sistine Chapel was nearing completion. It had begun in 1964 under the supervision of Dr Deoclecio Redig de Campos, who was succeeded in 1979 as a curator and as Director of Chapel restorations by Dr Mancinelli. The final stage of the wall cleanings dealt with the two minor sixteenth-century frescoes on the east wall by Henrick van der Broeck and Matteo da Lecce. Mancinelli decided that 'Redig de Campos's cautious policy of removing only part of the layer of grime and foreign substances . . . was not appropriate in this situation'.[4] Both frescoes contained much *secco* work. That of van der Broeck was accepted by Mancinelli's team as original work which had been damaged by earlier cleanings. Rather than clean and repair the *secco* work, which he felt

gave only 'disappointing results', Mancinelli decided to carry out 'a more radical cleaning' and remove it entirely, even though this would, self-evidently, contradict the artists' intentions, and expose such bright colours as to contrast with all the other frescoes. Nonetheless, Mancinelli felt that the gains achievable on these minor frescoes were such as to outweigh the consequential need to 'return to the scenes on the side walls and [do] a more thorough job there too'.[5] Clearly, once all the wall frescoes were cleaned to match da Lecce's and van der Broeck's work, then by the same aesthetic logic the cleaning of Michelangelo's frescoes became inevitable.

It has not always been made clear in the Vatican's accounts that the aesthetic 'need' was a by-product of a singular technical innovation: on St Valentine's Day in 1983, *Newsweek* reported: 'As recently as 1976 while cleaning paintings by the other artists on the side walls of the Chapel, workers deliberately kept the colours muted so that Michelangelo's frescoes wouldn't look too faded by comparison. "Even then it entered nobody's head to start on Michelangelo," says master restorer Gianluigi Colalucci. But when a new cleaning solvent was developed, Colalucci tested it . . .'

The 'testing' of AB57, to which Colalucci had referred, seems to have consisted, in fact, of the radical removal of *secco* work from van der Broeck's and da Lecce's mural in 1979. It was while this experimental work was being carried out that the Vatican team found themselves 'unable to resist the temptation' of applying the new solvent to one of Michelangelo's lunette frescoes. Their delight at the altered colouring was said to be such that the decision was taken immediately to clean all of Michelangelo's frescoes even though they, too, were covered with *secco* work which, like van der Broeck's, had been regarded for centuries as authentic. Walter Persegati said in 1987: 'These tests brought forward such colours that we were both scared and excited.'[6] Before starting on the ceiling, he continued, 'we spent six months analysing samples of plaster dust, colour and grime in our laboratory. It was decided

that the procedure developed on the van der Broeck and Matteo da Lecce was applicable to Michelangelo's frescoes. Therefore we decided we had to do it.'

Four reasons for the restoration have been advanced: (a) the need to eliminate the glue contraction problem discovered in 1979 during the cleaning of the east wall frescoes; (b) the need to liberate the exciting and surprising colours revealed by the application of a test patch of AB57 in 1979; (c) the ceiling had to be cleaned because the walls had been cleaned; and (d) (this account was given in 1983 by Alan Levy), 'Because Michelangelo worked almost alone on the Sistine ceiling and the great *Last Judgement* . . . the Vatican decided in 1978 that his work ought to be restored by one man rather than a committee. The choice for the job was Colalucci, who at forty-eight had just become the Vatican Museums' chief painting restorer.'[7] If Levy is correct the decision to clean the ceiling was taken before AB57 was tested in the Chapel and before Mancinelli's appointment.

The choice of cleaning agent was itself controversial but, in addition, its method of use seemed to breach a number of restoration conventions. Not only was the solvent new and largely untried, its actions were not even 'spot'-tested on the whole of the ceiling itself prior to the decision to clean. Its 'testings' were confined to those parts in reach of the scaffold then attached to the east wall. Dr Mancinelli has admitted that his team was obliged to 'test' the solvent each time the portable scaffold was moved along the ceiling during cleaning. The testing can only have been a ritual once cleaning began. There was little chance of reversing the policy because the radical elimination of *secco* painting was itself an irreversible act. Confidence in the soundness of this momentous decision rested on a curious *non sequitur*. Colalucci wrote in 1986: 'The early trials [of AB57] were not carried out on Michelangelo's frescoes but on the fresco by Matteo da Lecce . . . which presented a surface of exactly the same stratification.'[8] But how could it have been known in advance that the condition of the *ceiling* was identical to that of the wall fresco painted by another artist half a century

later? In fact, Mancinelli acknowledged that the surfaces of the lunettes were very different from those of the ceiling though both were the work of Michelangelo.[9] And of course if the stratification of the ceiling's and da Lecce's surfaces were not identical – whenever and however that fact was established – that could only suggest that Michelangelo had also used *secco* painting. It is not easy to see how a product tested for less than a year in the Chapel could ever have been thought suitable for the cleaning of the most important fresco cycle in the world. Mancinelli described it in 1987 as a 'non-experimental product',[10] and in 1991 he claimed that it 'had been used elsewhere for years and was therefore fully tested'.[11] We asked in June 1992 when and where it was first used to clean frescoes and whether, before the Sistine operation, it had been used on any major fresco cycle. So far we have received no reply.

Right or wrong, what might the long-term consequences of the decision actually be? How *safe* is AB57? How effectively was it controlled? Its inventors, the Moras, admit that it is an aggressive substance and claim only that it is less so than its common predecessors, such as acid, detergent, caustic soda and potash. Colalucci must have accepted their view when he spoke to the art writer Alan Levy:

[AB57] was created mainly for marble but the Moras experimented with it on frescoes. It is like paste. It can be on for a minute or ten minutes. The effect varies with the amount of time it spends in contact with a surface. The danger is that if you leave it on a minute or two too long it will go beyond the foreign substances and start removing the paint. So control of time is crucial. You can see little areas where I've applied AB57 in two or three stages. Each time I take it off well before it's too late. Then I look at it and gauge how much more time it will need . . . Here's a tiny patch where I left it on too long. In this little experimental patch you see completely solid violet paint, but around it you can see

the gradations of dark and light, which are the shadings of Michelangelo's own work.[12]

Within four years, Colalucci had abandoned this control of the solvent by constant observation and timing. In its place a standardized procedure was adopted, described in the 1986 'General Report on the Lunettes': 'First application, three minutes followed by removal and washing with water. Left to dry for 24 hours. Second application, three minutes followed by washing and leaving to dry as before.' These three-minute applications were said to have been 'rigorously measured'.[13] Colalucci explained the reason for the change of procedure: the size of the ceiling required that the work be carried out by a team. Individual restorers, responding to the evidence of their own eyes, would draw different conclusions. Therefore, in order to obtain a 'homogeneity of result' – a 'primary objective' – they must be denied the opportunity to judge for themselves how long the solvent should remain in place. Solvent applications had to be predetermined, Colalucci felt, in order to avoid 'either emotional involvement or complex mechanical manipulation on the part of the restorers'. When asked in 1985 at the Wethersfield Conference in New York why he did not adjust the timing according to what his eyes were witnessing, he replied: 'Because emotional or subjective conditions must not be permitted to intrude upon science.' The scaffolding, he added, did not permit stepping back to assess effects and the continuous bright lights of the Japanese film-makers 'fatigued one's eyes'. The activity of the film crews was itself a distraction as was also his having to entertain up to sixteen VIP visitors a day, he added.

This was a very serious departure from good restoration practice, which requires close and constant vigilance and control on the part of the restorer. Only the year before, the Moras had advised that cleaning should never be thought 'entirely a technical matter . . . confined merely to the choice [of solvent]'. The method of application was 'no less fundamental'. The restorer's responsibility, at all times, for the control of the solvent's actions was absolute. Respon-

108

sibility could never be abdicated or left to 'depend on the natural uncontrolled action of the products'. Rather, it must always depend on 'the precise wish and aim of the restorer guided by his critical interpretation'. By failing to observe this rule the restorer 'deprives himself of the principal alarm signal when faced with new situations; he gives up looking ahead and allows the problem to resolve itself mechanically so that subsequently he can impose the result as an accomplished fact'. To do this, however, is to 'ignore the very foundation of restoration'. By that means, the Moras concluded, 'Under cover of the alibi of scientific objectivity, we withdraw from the cultural commitment that restoration implies.'[14] Complaints from artists notwithstanding, the standardized three-minute applications of AB57 appear to have persisted until at least December 1989. Note though that in a paper delivered in 1987 Colalucci described a different procedure, where solvent was applied for 'from two to four minutes' in order to allow 'the conservator to clean gradually and sufficiently evenly'. More recently, however, in 1992 Mancinelli spoke of 'the mixture [being] applied for three minutes then wiped away'.[15]

The Sistine team seem also to have departed from the Moras' recommendations in their technique for removing the AB57 from the frescoes. The consequences may turn out to be horrendous. To see why the absolute separation of AB57 from the fabric of a painting is so urgent requires a brief consideration of the distinctive chemistry of fresco and of that of the solvent itself.

In pure or *buon fresco*, earth or mineral (not organic) colours are mixed with water and brushed on to the still-wet surface, a specially prepared lime plaster. This lime is prepared by burning materials (like chalk, marble or limestone) which have a calcium carbonate content. The burning drives off the carbonic acid which the materials contain, thereby converting the calcium carbonate into calcium oxide. This oxide is then soaked in water ('slaked') which further converts it into calcium hydroxide. Lime in this state is the special, almost magical, ingredient of fresco painting. Mixed with sand (or ground marble) for bulk, it forms the lime-

plaster of fresco painting. When the water-based mineral colours are brushed on to it (while it is still wet) two things happen: the particles of pigment nestle with the crystals of sand and lime on the surface, giving it colour; and the water is absorbed by the plaster mix and partially dissolves its lime content. As the plaster dries, this dissolved solution of lime makes its way by evaporation to the surface where it absorbs from the atmosphere the very carbonic gas which was driven from it originally by burning. This absorption enables it to return chemically to its 'full' or complete state as a thin layer of calcium carbonate crystals. These crystals 'lock' the mineral pigments into place permanently on the surface.

Thus, in pure *buon fresco* a calcium surface is formed which is chemically identical to that of marble: both remain porous, permitting the migration of air, water or pollution between their crystals. When fresco or marble absorb moisture from the atmosphere (or from rising damp or rainwater seepage), the water's acidity dissolves particles of calcium carbonate, which are brought to the surface and deposited by evaporation. Over time, this causes a build-up of a tenacious, obscuring film of calcium carbonate. As the film develops, it traps and incorporates surface dirt. The more polluted the environment, the more disfiguring is the build-up. In the case of outdoor sculpture this gives rise to notoriously intractable 'black crusts'. A cruel problem faces restorers: these crusts are chemically identical to the art object being liberated. Any substance capable of attacking the one will attack the other also.

In 1984 the Moras said of the build-up of calcium carbonate films on frescoes: '[they] present problems for which, as yet, there is no satisfactory solution'. Even today 'Mechanical means [i.e. scalpels or abrasives] may still have to be adopted even though there is a risk that these would produce inevitable alterations to the painted surface',[16] or even the loss of 'at least half the paint'.[17] Formerly, the only alternatives to physical action were acids, detergents, caustic soda or potash, which could dissolve the film. Distilled water – which also dissolves calcium carbonate – could be used but

it was slower. The problem with all these is their penetrative power, their tendency, as Laura Mora has put it, 'to advance rapidly in depth' and to 'corrode in depth' – in other words, to attack the painting and its film simultaneously.

The Moras' contribution to a solution of the problem was the formulation of AB57. It too, Laura Mora accepts, is hazardous: 'Everything is dangerous, even water if you happen to try cleaning paintings done in gum arabic with it . . . you have to know your materials and how to use them.'[18] The case for AB57 is that it does its job less riskily then its precursors.

In the case of the Sistine Chapel, the question arises: was it asked to do the *right* job? Professor Alessandro Conti, a specialist in art restoration techniques at the University of Siena, thought not.[19] He contends that, even before his glue-based *secco* work, Michelangelo made great use of thin, calcium 'lime-washes' (see Chapter II). This 'series of glazings . . . endowed the frescoes with their special treatment of light and shadow and depth of field' – the very feature celebrated in 1525 by Paolo Giovio but attributed in 1986 by Dr Mancinelli to soot and varnish discolourations. In 1986 the restorer Leonetto Tintori urged the Sistine team privately to preserve what he termed 'Michelangelo's auxiliary techniques' which in his view included oil painting as well as glue-based *secco*.

But even apart from what we believe has been the destruction of Michelangelo's *secco* work, the choice of AB57 for the cleaning is controversial: Toti Scialoja, a painter and former professor at Rome's Academy of Fine Art, complained that 'The substances they are using are too powerful, ammonia and soda, the stuff you use to clean your bathtub.' The same sentiment, phrased more tactfully, was shared by other restorers and scientists. The restorer Mirella Simonetti, in an unpublished paper of September 1992, generously made available to us, recalled how at the symposium 'Problems of Restoration in Italy', held in Rome in 1986, 'the chemist Dr Paolo Bensi, who considered [AB57] too corrosive for the removal of animal glues, asked for an explanation'. His question

was sent to the chemist in the laboratory of the Vatican but no public response ever emerged.

What exactly is AB57 made of and what is it capable of doing? The answer is inevitably rather technical. The Moras described it as a water-based solution of 'slightly basic salts together with chelating, thixotropic and surface active agents as well as fungicides' designed for 'removing insoluble salts'.[20] A typical mix 'which has given results in use' is the following:

Water	1000 cc
Ammonium bicarbonate	30 g
Sodium bicarbonate	50 g
'Desogen' of 10% strength	25 g
Carboxy methyl cellulose	6 g

This composition 'satisfies the requirements because, if the original surface of the painting is unaffected by water, then the mixture will have no deleterious action on it'.[21] Note that the solution was intended to work on 'incrusted materials', that is otherwise insoluble *mineral* deposits – it was not designed for organic materials such as the size-based *secco* which, as Charles Heath Wilson noted, 'readily melted on being touched with a wet finger'.

AB57 was to be controlled by the strength of its mixes and by eye; the restorer assessing 'the transparency of the incrusted materials'. The process was intended to be slow – often lasting many hours – so that control could be maintained. Because the solution is water-based, it was 'essential for the success of the operation that the products remain humid *in situ* and that the surface being treated [be] kept as moist as possible'. The Moras recommended that the solution be applied through a moist compress (such as Japanese paper) or within organic gels. The gel they themselves adopted and the one used in the Sistine Chapel was carboxy methyl cellulose. An important characteristic of the gel is that it discourages absorption of the solution by the fresco: 'It [AB57] is purely superficial in its action as penetration is *limited*' (italics added).[22] This is as much as the Moras claim: the gel does not eliminate but greatly retards penetration and works chiefly on the

112

surface. There is nothing in their account to support Brandt's claim made in 1987 that 'the cleaning chemicals do not actually come into contact with the fresco surface'.[23] In fact the gel is, in part, intended to prolong the contact. Without it, no cleaning would take place. The Sistine team have sometimes implied that while AB57 removed the organic material from the fresco, it made no contact with its lime plaster surface. This is important and calls for examination.

During the cleaning, it is claimed, a thin layer of dirt was deliberately left in place to protect the fresco from environmental pollution. But the dirt which first settled on the fresco would have been incorporated into it by the process of carbonization (crystal-forming). This dirt is not removable and offers no protective barrier. On the other hand, any dirt settling after carbonization and forming a discrete layer would have been penetrated by, and incorporated within, any glues applied by restorers. How, then, could today's restorers have removed only the glue and left the once-digested dirt in place? Or do they believe that the glues had *not* penetrated the dirt? If they do, how can they argue that it was detaching paint from underneath the dirt? Even supposing that Colalucci had separated the glue from the dirt, how was he able to leave it intact and in place during the repeated spongings carried out to remove the corrosive ingredients of AB57 from the fresco surface? If a thin coating of material has really been left on the ceiling it is likeliest to be traces of the dissolved glues and the cleaning mixture, and not a discrete layer of original dirt. This is alarming. Consider the particular mixture of AB57 used in the Chapel. The 1986 Report on the cleaning of the lunettes described it as: 'A mixed gelatinous solvent, consisting of a solution of ammonium bicarbonate, sodium bicarbonate, Desogen (a surf-actant and anti-fungal agent), carboxy methyl cellulose (a thixotropic paste) dissolved in distilled water.'[24] In addition, 'in the case of salt efflorescences consisting of calcium carbonate, there was added to the solvent mixture a saturated solution of dimethylformamide.'

A number of points should be made here. First, the thixotropic

113

gel used (carboxy methyl cellulose) has been found to encourage the retention of sodium, one of the two principal salts in the solution. Sodium attacks the molecular structure of lime. Second, the Vatican team used, to remove *organic* materials, a mixture very much like that recommended by the Moras to remove insoluble *mineral* deposits. Third, when the restorers did encounter *mineral* efflorescences, they added a solution of ethylene diamino tetra acetic acid (also known as EDTA or its brand-name, Idranal). Yet the Moras had written in 1974 that AB57 with EDTA produced a 'weak' aggressive action when used on frescoes and should be avoided.[25] Mirella Simonetti recalls how she saw, and objected to, the use of EDTA during a visit to the Chapel scaffolding in 1982. She considers this departure from the Moras' own guidelines a serious error, because this mixture would produce 'reactions within the interior of the pictorial layers'. In addition to removing the *secco* painting, AB57 in this formulation chemically altered the *buon fresco*, causing 'a breakdown in the molecular structure [and] bringing about a disintegration [which] in turn causes the division of the components and dicohesion of the lime'. Once the fresco was weakened in this fashion, the process would continue: 'even water can favour such a process'.[26]

In Simonetti's view, it is precisely this chemical disruption which is responsible for the much-praised brightness of the fresco colours: 'AB57 . . . appears to have skinned and weakened the pictorial substance. Such was sketched out by P. and L. Mora, according to whom the Idranal could have rendered the carbonate of calcium [that is, the fresco itself] . . . soluble and attacked it.'[27] In the *Washington Post* of 6 April 1990, Maestro Colalucci said: 'I must confess I harbour a lingering almost subconscious fear that someday someone will come out, unexpectedly, with a really intelligent observation that will show all of us to have been blind.' Is that person Mirella Simonetti? Are her claims technically sound? Do they support the charges of aesthetic injury made by critics? There can be little doubt that the answer to these last two questions is yes. A comparative study of the effects upon marble treated by

AB57 with Idranal and without it has recently been concluded.[28] 'AB57 made with EDTA produced severe dissolution of the marble, while AB57 made without EDTA did not appear to alter its surface . . . Results showed severe etching by the AB57 mixture containing EDTA (AB57 for stone cleaning), and this mixture is emphatically not recommended for use on marble, with the exception of a surface which has been altered to a "black crust" principally composed of calcium sulfate, soot and silica.' A surface cleaned with such a mixture 'may appear "whiter" but this may be attributed to increased scattering of light as a result of etching; not to cleaning'.

Simonetti comments: 'The most noticeable difference between the appearance before and after the cleaning is that of the luminosity.'[29] She found it 'difficult to imagine that the elimination of the organic portions of the nineteenth-century glues could have produced such a startling change' and offered a chilling explanation: 'visually the effect caused by AB57, [which] alters both the proportion and the rapport between the calcium carbonate (lime) and the pigment, is to lighten the pictorial surface'. This effect of lightening is produced by the physical removal of crystals from the fresco itself in a process that begins 'from the moment that the combination of substances of AB57 attacks the surface'. Simonetti's account is corroborated by the recent comparative study: 'All decrease in gloss [in the marble] can be attributed to two different mechanisms: chemical dissolution of the marble and mechanical removal of calcite crystals'.

Simonetti believes that (quite apart from other problems) the physical and chemical disruption of Michelangelo's fresco surfaces has undermined 'the decorative elements of the cornices and vaults' – illusionistic bands of painted architectural moulding with which Michelangelo subdivided the great continuous expanse of the ceiling into smaller units and panels. They had not been repainted or modified in the past and were, before the cleaning, distinctly 'whiter' than all other parts. Without this clear tonal distinction, Michelangelo's brilliantly original pictorial devices

'lack their proper ornamental function as pictorially incisive and defining elements'. No wonder that so many historians were astonished by the 'metamorphosis' of Michelangelo's tonal schema into a chromatic one. But what a pity they failed to heed those who spotted the error immediately. Venanzo Crocetti for instance saw in an instant, when watching film of the cleaning, that while the first three-minute application of AB57 had the effect of cleaning the colours, the second, a day later, altered them, and by doing so disrupted their vital aesthetic interrelationships. Had he been allowed to visit the scaffold and add his own informed objections to those of Simonetti at a time when only the lunettes were being cleaned, perhaps the ceiling might have been spared its radical treatment.

Today, even if the Vatican team were to concede that the brilliance of Michelangelo's new colours is a chemical deceit purchased at the cost of a physical and chemical weakening of the frescoes, the dispute would not be laid to rest. The need to avoid further deterioration would still be there. Having used AB57 with Idranal, did the restorers succeed in removing all traces of it from the fresco surface or not? The ingredients had been selected by the Moras because 'they are easy to wash off with water'. It was important that they should be, both because carboxy methyl cellulose may encourage sodium retention, and because 'Desogen' is a detergent as well as a fungicide. Detergents are non-volatile, that is, they do not evaporate. That gives them, as the Moras put it, 'the disadvantage of remaining in the painting unless removed after treatment by rinsing with water'.[30] Recent tests have shown rinsing to be far less efficient than was once supposed.[31] Water alone may not be an ideal cleaning agent.

The Moras have recommended two methods of removing AB57: washing with water; and applying absorbent compresses. There are two sets of problems with washing. First, the water used for rinsing off the chemicals is absorbed into the porous fresco and so can itself introduce particles of soluble and corrosive ingredients. Second, its own chemical composition can be deleterious:

tap water may contain solutions of sodium, iron, copper and chloride, and unless it is packed with sufficient calcium bicarbonate water will attack the calcium carbonate of fresco. Even distilled water (which is free of impurities) 'by slowly dissolving calcium carbonate, attacks the original structure'.[32] Compresses neatly and ingeniously avoid leaving ingredients in the fresco. Salts borne in water are moved towards the surface of greatest evaporation, where they concentrate and are deposited. When a compress of moist material (such as paper pulp, kaolin or absorbent clay) is held against the fresco, the 'effective' evaporating surface is transferred from the painting to the compress, and water and salts are drawn safely away. This fail-safe method was not employed in the Chapel.

Nor is it clear whether the water used for rinsing was distilled. Accounts published so far are vague and inconsistent on this point. 'First application [of AB57]: three minutes, followed by removal, washing with water. Left to dry for twenty-four hours. Second application: three minutes, followed by removal, washing and leaving to dry as before' (Colalucci, 1986).[33] '. . . [T]he mixture [AB57] together with the extraneous substances was removed with water and a soft sponge. After twenty-four hours a second application was carried out in the identical way. . . . The work was concluded with abundant rinsing, repeated at intervals of up to several months. The last rinsing was done with distilled water' (Colalucci, 1987).[34] 'The mixture . . . is removed with distilled water' (Mancinelli, 1991).[35] 'The mixture . . . [is] then wiped away with a sponge soaked in distilled water . . . [After twenty-four hours] the procedure is repeated' (Mancinelli, 1992).[36]

Because compresses were not used, any of the non-biodegradable, water-activated corrosive salts or detergents left behind or absorbed by the fresco must now be expected to be found on the surface among the colours.

When Colalucci was challenged in 1991 (on Italian TV) on this point, he replied: 'AB57, first of all, is a solvent which has been greatly tested and is very old. The actual solvent is held

within a gel which does not allow the particles of the actual solvent to penetrate the plaster and the colour. However, the gel is removed and only a minimal (if any) percentage might remain, which has no influence on the colours.' Other restorers hold contrary views: Mirella Simonetti regards one of AB57's ingredients – bicarbonate of soda – as an 'extremely damaging' residue because, when combined with the sulphates of calcium and air-borne sulphuric anidrites, it produces sodium sulphate – a whiteish dust which corrodes the fresco and destroys its coloured surface.[37]

It has long been recognized that air-borne sulphur attacks fresco (just as it attacks marble). As early as 1884 the Reverend J.A. Rivington explained in a paper delivered at the Society of Arts in London how air contaminated by coal and gas emissions destroys fresco: 'The carbonate of lime is converted into the sulphate, breaking up the paint and becoming itself disintegrated in the process of change.'[38] The air surrounding and invading the Chapel is notoriously contaminated. It contains, among much else, sulphur dioxide from coal-burning, nitrous oxides from car exhaust and hydrogen chloride from incinerated plastics. When combined with rain or other water, these substances produce sulphuric, nitric and hydrochloric acids respectively, all fiercely corrosive. In the form of perspiration and breathing vapour, water is brought into the Chapel by tourists. Breathing, additionally, gives off carbon dioxide. A recent report commissioned by the Vatican on the Chapel's microclimate noted that the very large numbers of tourists produce the following adverse effects: they carry in from the streets polluted dust and organic particles on their clothing and hair; their combined body heat raises the temperature by as much as 5°C; and they greatly increase the relative humidity of the air.

The moisture and carbon dioxide given off by tourists combines to produce carbonic acid which dissolves the calcium carbonate of fresco. Water vapours convert sulphur particles into sulphuric acid which also dissolves fresco. The body heat creates convective air currents which carry polluted particles up to the walls and ceilings.

Water vapour can activate the traces of salts and detergent left behind after the cleaning with AB57.

In 1981, Gianluigi Colalucci acknowledged the problems of pollution: 'Today there's much more pollution in the air that penetrates the Sistine, which is a minus, but on the plus side we're now using substances which resist smog . . . But if our work here is ever to be meaningful as it ought to be, something will have to be done to reduce the heat and humidity.'[39] Thus it was granted that after the removal of the glue and glue-paint – which, on everyone's admission, had for centuries provided a durable and effective barrier against airborne pollution – it would be necessary both to treat the ceiling with a protective, synthetic coating and to find some mechanical means of regulating the 'microclimate' of the Chapel.

The protective coating chosen was the acrylic resin Paraloid B72. The 'Report on the Lunettes' described how the 'final treatment', after cleaning, consisted of a 'thorough, complete and overall application of a solution of Paraloid B72'.[40] The treatment was highly controversial. Artists objected to the repellent 'synthetic' look and texture it imparted. Some restorers held that it would *worsen* pollution problems not alleviate them. Mirella Simonetti, for example, contended that although formation of the corrosive sodium sulphate dust might be 'temporarily blocked by B72' the resin itself was a hazard because it contains 'an electric charge capable of attracting and retaining the dust particles in the air, with all their impurities'.[41] Professor Christopher Frommel, Director of the Bibliotheca Hertziana in Rome and a supporter of the restoration, worried that 'According to the critics, B72 is something which may become opaque in the future. Are the critics right when they say tests should have been made and then a long period of time allowed to lapse before proceeding? Paraloid can close the surface to respiration. It can close the pores, and if that were to happen it might change the interior life of the fresco.'[42] But Laura Mora asked in 1987 'If you don't use Paraloid what do you use? Organic resins and inorganic fixatives such as lime water,

ethysilicates and barium hydroxide [used in the restoration of the Brancacci Chapel] all have serious drawbacks. Of the synthetic resins the acrylics are the best, and of the acrylics Paraloid is the least bad.'[43] Signora Mora was supported by Professor Giorgio Torraca, a leading scientist at the University of Rome: 'Cleaning and protection are equally important. Once the cleaning is done it is necessary to apply a protective layer. B72 is this layer.'[44]

These prestigious defences notwithstanding, at some point between 1986 and 1991, B72 was abandoned by the Sistine team, and not replaced. In the report of a London conservation conference published in 1991, Colalucci claimed, 'There was no final application to protect or saturate the painting.'[45] This had only been done, he claimed, on a single lunette and not (as the 1986 report and he himself in 1987 had suggested) on all the lunettes. Colalucci defended his change of mind in 1991: 'Our decision not to apply a protective material derived from the awareness that any new material which is not homogeneous with the original components of the fresco will undergo rapid degradation, causing, in the best of cases, aesthetic damage.'[46] If this is so, we must presumably expect some parts of the frescoes to deteriorate more rapidly than others. How long will the present homogeneity last? The areas likely to be affected were quantified by Colalucci in 1990: 'lunettes 50 per cent, ceiling 3 per cent'.[47]

Protection of the frescoes was, henceforth, to be entirely dependent on (a) the thin protective layer of original dirt if it is really still there, and (b) on the provision of 'suitable microclimatic conditions in the Chapel . . . plans are well advanced for the installation of equipment to control and correct the potentially damaging temporary fluctuations caused by large numbers of visitors'. These measures, Mancinelli reported in 1992, include 'a special anti-dust carpet for the stairs giving access to the Chapel; a new 'cold' lighting system . . . to eliminate updraughts . . .; hermetic window seals and air filters to exclude harmful gases and other pollutants; and finally an air-conditioning system to reduce and monitor changes in temperature and humidity'.[48] When Michael Daley

asked if the air-conditioning system would be capable of eliminating the great fluctuations triggered by tourists, he replied 'No. It will reduce the peaks and the troughs but will not eliminate the problem entirely.'[49]

Professor Brandt, the Vatican spokeswoman, has conceded that, 'Astonishingly, no one really knows what the ideal humidity for the fresco is, nor, for that matter, are reliable non-destructive tests for humidity yet available. Also, treatment itself, sunlight, air pollution, heating installation and crowds or visitors, all may interact to do future damage.' Thus, air-conditioning in turn, like synthetic resin treatments, might aggravate the very conditions it is intended to alleviate. One potential source of problems is in the monitoring of a system, an expensive and frequently neglected procedure. In 1985, the National Gallery in London was restoring a large altar panel-painting by Cima da Conegliano when an air-conditioning unit in the laboratory malfunctioned without detection overnight. The painting was subjected to a relative humidity level of 100 per cent – that is, it was saturated by as much water as it is physically possible for air to support. This caused, in the words of the Gallery's *Technical Bulletin*, 'swelling and buckling' which was still evident months afterwards and was eventually 'reduced on the hot-table'.[50]

Air-conditioning mishaps are not uncommon. When the Louvre Museum decided to clean (with sponsorship by ICI) Veronese's giant painting of *The Marriage at Cana*, it was obliged to do so in the gallery itself because of the size of the picture and in compliance with the sponsor's desire that restoration be publicly visible. Extraction ducts were installed to remove noxious, highly inflammable solvent vapours from the gallery. The ducts leaked during a storm, soaking the painting. An attempt to remove the painting from its frame for drying was unsuccessful. Temporary scaffolding proved incapable of supporting the weight of the wet painting and collapsed, causing a number of tears, three of which were between three and four feet long.

In 1950, the National Gallery in London decided to hang

Uccello's *The Battle of San Romano* (which was not in need of restoration) in a newly remodelled and air-conditioned room. After four years in its new home it was found to be suffering from cracking, loss of restorations and there was 'some danger to the original paint'. The panel 'was evidently not settling down' and its appearance had become 'thoroughly unsatisfactory' making necessary a five-year-long restoration.

Even today, however technically advanced or expensive a system might be, Professor Brandt concedes, 'the layman's hope that air-conditioning provides a simple technical answer to these problems is a myth'.[51] Artificially induced changes in moisture, heat and patterns of air convection can themselves 'do gross damage'.

In fact just before this book went to press, reports from CNR, Italy's national research institute, reached the front pages of the Italian press. Research by Adrianna Bernardi and Dario Camuffo showed that the 425 kilos of water freed into the air by the estimated 17,000 daily visitors to the Sistine Chapel were creating a cycle of evaporation and condensation resulting in continuous migration of vapour and salts within the frescoes. Very soon afterwards, a £650,000 computerized air-conditioning system donated by the Carrier Corporation was unveiled. A constant temperature of 25°C (77°F) is to be maintained day and night throughout the year. Temperature differences between the interior and exterior surfaces of the Chapel will thus be heightened, but there has been no discussion, in public at least, of risks associated with that. The most obvious risk is that external air-borne pollutants will be pulled in. During the 1970s sulphur and nitrous dioxides and hydrogen chloride, turned into acids by rainwater, reacted with the mortar in the five-feet-thick walls of the Raphael rooms. Penetrating the building, these compounds erupted as salt formations on Raphael's frescoes.

Had the glue-based painting which protected the fresco for centuries been left in place, the expensive and possibly self-defeating solutions being considered and introduced might not be needed at all.

122

V

Oil, Tempera and the National Gallery

By Michael Daley

SO FAR IN this book we have been concerned with sculpture and fresco. Of course, the majority of restorations are of works in oil or tempera, and these are usually carried out in secrecy by the conservation departments of leading galleries and museums. Many of these institutions have long-standing policies – even traditions – of radical intervention. They may not agree with one another over the methods they use or the outcomes they seek, but they are certainly alike in not seeming to welcome enquiry. The behaviour of London's National Gallery, reported in this chapter, is entirely characteristic.

Most controversies arise in connection with gallery-cleaned old master paintings. Many people are puzzled by their frequency and ferocity. After all, if we can send men to the moon, split atoms and replicate genes, why should the expert technical staffs of venerable national museums and galleries not be able to clean old masters without altering them irrevocably?

There are two reasons. The first is the almost infinite complexity and delicacy of these paintings; they are made up of many layers, sometimes of different materials which may respond differently – and unexpectedly – to treatments. More problematic still, the

top layers of paint or glaze may be virtually indistinguishable from the layers of varnish the restorer sets out to remove.

The artist begins to work from a support, which holds the paint in place. Until around 1500, most supports were wood; a single panel for small paintings, glued combinations for larger ones. After that date supports tended to be canvas stretched over wooden frames. Canvas provided a more portable but also a less rigid base. To the support was added a ground. Wood was usually given several coats of progressively finer and smoother gesso (a mixture of chalk or gypsum bound with glue size). Canvas needed a less brittle ground, and so white lead or zinc oxide in glue size were commonly used. These grounds were primed with a coat of paint or size to make them less absorbent and prepare them for the next stage, the paint layer itself.

The paint layer of an old master was built of many coatings which varied in thickness and transparency. Artists did not attempt – as many today do – to achieve all artistic effects (colour, tone, texture and transparency) with single dabs of paint. They assembled them step by step. A painting might consist of a layer of tonal under-painting, followed by a more precise 'modelling' of forms in variations of a single colour – brown, say, or green. The colours of the different parts of a painting might then have been laid over the modelling in the form of transparent glazes. Final adjustments of composition, drawing or reinforcements of modelling might be added as the final touches of a picture. Conversely, colour might be laid on thickly (impasto) with shading and other values established later by means of (transparent) glazes and scumbles. A Cima altar painting at the National Gallery was found to contain as many as ten separate stages of painting. Titian is reputed to have used as many as forty. A recent study of Leonardo da Vinci at the Louvre revealed as many as fifty separate layers. And these layers may have been applied in a variety of media. Pigments up to about 1500 were usually bound with egg (tempera), and after that date with drying oils (linseed, walnut or poppy). But many paintings combined both media, and some also used certain pigments bound with natural

resins, or mixtures of oil and resin. Because the surface of the paint layer is the artist's final statement, and is so exposed and vulnerable, it was normally given a final transparent coat of protective varnish – also a natural resin or a mixture of oil and resin. This also helped to bring the colours up to their full value.

Successfully combined, these materials produced works of great durability, though all are susceptible to ageing, internal decay and environmental assault. Moisture expands wood supports and contracts canvas ones. Age and exposure to natural light darken oil paint and make it translucent and brittle. When it becomes less elastic it cannot expand or contract with its support and may ultimately flake off. Varnish, like oil paint, darkens with age and may obscure the painting, although in doing so it at least forms a protective barrier against ultra-violet light, which makes some pigments fade.

Because varnishes discolour (turn yellow or brown), restorers throughout the ages have attempted to remove and replace them with fresh, clear varnish (which, inevitably, would itself discolour and have to be removed . . .). Two methods – physical and chemical – have been employed. Both were and remain inherently hazardous. A safe, risk-free method has never existed. The physical techniques involved rubbing the varnished surface of a painting with brick, sand, powdered glass or ash. Because paint is practically as abradable as varnish and because the surface is almost always *textured* – sometimes dramatically so – losses are unavoidable. Many attempts have been made to clean pictures with substances that would break down or dissolve the varnish and yet not harm the paint to which it was intimately related. Most varnishes are softer than most paint layers. Some varnishes – which contain oil – are harder than some 'paints', which may be either partly or wholly varnishes themselves. Many attempts have been made to find a cleaning solution capable of removing varnish: boiled oil of turpentine, urine, soap, caustic potash and caustic soda. In modern usage, these materials have been *almost* entirely replaced by chemically 'neutral' (that is, neither acidic nor alkaline) cleaning solvents such

125

as turpentine, benzene, toluene, alcohols, acetone and choloroform methylene chloride. For many restorers, these seemed the most unproblematic agents: they tended to dissolve or soften varnish faster than paint, giving an interval in which the former could be removed by cotton wool swabs; although in practice they inevitably permeate and soften the paint film, they do not break down its molecular structure. Once the solvent evaporates, the paint seems able to 'reform' itself as if nothing had happened. Because the drawbacks of solvents are being made increasingly clear by scientific research and analysis, many institutions are attempting to find alternatives. Detergent soaps which can cause irreversible harm to paint – abandoned during the nineteenth century – are thought by some experts today to be, in fact, safer and less destructive than the almost universally used neutral solvents.

Whatever cleaning agent is employed, however, problems of analysis and aesthetic judgement remain. A restorer must always be able to discriminate between original paint and later additions. In some instances, it is necessary to distinguish between a later addition made by a restorer and one made by the artist himself at a later date. Having removed what are taken to be 're-paints', the restorer must decide whether to leave the loss *visible* and injurious to the aesthetics, or replace it with further re-paint.

To exercise good judgements of this sort, a restorer must be able to think like an old master – science is of no help here: it cannot identify let alone analyse aesthetic values. This would be so even if an infinite number of 'tests' – which involve the destruction of tiny parts of the picture – were carried out. Restorers trained in the West do not, for the most part, have sufficient training as artists to be able to 'read' the language employed by earlier artists in the production of their works. A particularly common and disastrous blind spot is the failure to appreciate the function that glazing once served in the establishment of form within a painting. Many restorers talk and write as if glazings were only ever employed as a means of creating colour relationships.

Because of these deficiencies, restorers have become more

126

dependent on the use of chemical or scientific analysis of tiny paint samples in order to decide on the function that material once served on a painting. This is a poor substitute. To form a clear idea of the artistic and technical logic of a painting scientifically it would be necessary to 'test' every part of it – a physical impossibility. The absurdity of such programmes has, ironically, been recognized in 'backward' non-Western centres like St Petersburg where restorers spend many years (at least five) learning how to paint, alongside art students, before being allowed to start 'restoring' other people's paintings. The discrepancy between such schools and Western institutions and galleries like the National Gallery in London, and the Getty in Malibu is so great that the latter are seeking to 'colonize' their newly arrived Eastern cousins.

There have always been good restorers and bad. Originally, any painter – even the best – might be prepared to retouch or repair another's work. Later, restoration tended to become a specialism, usually for less successful painters. Even among these, standards varied; some were well trained and sensitive to the intentions of the original, others just time-serving hacks, rubbing down and repainting till nothing but the original composition remained. Today there are still many fine and sensitive restorers but a new and dangerous orthodoxy has arisen. I shall turn to this shortly.

Regardless of the standard of restoration, since the nineteenth century there has clearly been too much of it. When paintings emerge today which have by some fluke never been touched by restorers their condition is often magnificent. The Florentine-born restorer Marco Grassi confirmed in New York recently that paintings coming into his hands in the best condition are precisely those of minor and unfashionable artists whose work escaped the great restoration programmes of the nineteenth and early twentieth centuries. Their paintings are often 'impeccably preserved, so we have to think something terrible started in the nineteeth century when the painter/restorer trade began'.

Restoration has also always been subject to fashion. It is a

127

mistake to suppose that it can ever be free of the cultural impera-
tives of its own day. When we look at Greek carvings restored
in good faith in the eighteenth century they strike us as, in part,
eighteenth-century productions. Surfaces rubbed to the smooth
whiteness of the era's conception of antiquity look false today.
Paintings restored in the eighteenth century were made lighter
according to dictates of taste and fashion of which the restorers
were probably not even fully aware. Those restored in the nine-
teenth century, on the other hand, were made darker. There can
be no absolute, value-free objectivity, and that is true of our own
time as well. That is one reason why the irreversible, radical
restoration programmes widespread today are so terrifying.

Every generation of restorers condemns the excesses of its
predecessors but believes in its own technical mastery. Practices
excitedly adopted as recently as the 1960s and 1970s have already
been repudiated or furtively abandoned. In the 1960s there was an
enthusiasm for detaching frescoes from the buildings of which they
were integral parts. When an exhibition was mounted in London
in 1969 the entire art establishments of Italy and Great Britain
queued to lend their names to the enterprise. Now many frescoes
detached then still lie rolled up and unseen in museum basements.
The practice – first attempted, according to Pliny, by Caligula – is
now used only as a desperate last resort in cases of flooding or
earthquake.

Considering how great the risks are, one might expect restorers
to be prudent and circumspect, and to keep their interventions
to a minimum. In fact the opposite is the case with many prac-
titioners. Minimal interventions are an unpopular option for con-
servation departments for reasons that the next chapter will
explore.

The new restoration orthodoxy of our own day is also the second
reason why cleaned paintings are often greeted with anguish and
disbelief. In reaction no doubt to the excesses of past ages, science
rather than aesthetics now sets the restorers' goal, at least in
museums and galleries and among freelancers who seek work

from them. The white coat has replaced the artist's smock, and training in chemistry now counts for more than training in art. Restorers' dependence on analyses of material has undermined their capacity to respond to paintings as works of art. Restoration has become a quasi-scientific exploration whose end result cannot be anticipated. Whatever emerges must be accepted as a discovery, however artistically illogical it may appear and however damaged the painting may seem to the artist's or even the commonsense eye.

It may be interesting to look at all the points raised so far, especially the last, in relation to one institution. In a letter to *The Times* of 29 October 1846, signed VERAX, J. Morris Moore wrote that although he was 'acquainted with most of the finest pictures in Europe' and had 'seen the dreadful havoc committed on many of them', he had never seen a 'more flagrant case than that of [Rubens'] *Peace and War*' as restored by the London National Gallery. That Gallery has pursued a radical cleaning policy since its foundation, so its record comprises a model case history. Its first Keeper, William Seguier, was a dealer and restorer in partnership with his brother John. A 'committee of gentlemen' (all titled and one of them the President of the Royal Academy) was nominated by the Treasury to serve as superintendents and 'to give such direction as may be necessary from time to time for the proper conservation' of the pictures. Meetings were few, thinly attended and 'not conducted in a businesslike manner'. When he died in 1844, Seguier was succeeded by Charles Lock Eastlake who, the following year, had paintings of Rubens, Cuyp, Titian and Velazquez cleaned by John Seguier. This prompted Moore's famous letter. It began: 'Sir – I beg to represent to you that should the present pernicious system with regard to our national pictures be continued, in a very few years those noble works of great masters which we have collected at so much expense, will be utterly destroyed.' The Rubens, once 'pre-eminently rich and harmonious in colour', had been left 'almost as remarkably crude and discordant'. The ignorant removal of 'fine rich glazings' had destroyed the art which made objects appear to fade as they retire from the foreground.

In response to this attack, Eastlake told the Gallery's trustees that he needed a spacious, well-lit restoration studio. Then cleanings could be carried out on 'a more extensive scale'. It was because so few pictures had been cleaned that their temporary contrast seemed so shocking to connoisseurs. Eastlake was shortly afterwards superseded by Thomas Uwins, curator of the royal pictures. Under his stewardship, John Seguier cleaned nine pictures (by Veronese, Claude, Guercino, Canaletto, Poussin and Rubens) during the six weeks' summer vacation of 1852. This provoked another controversy and a parliamentary committee was set up. Writing again to *The Times*, Moore concentrated on Canaletto's *Stonemason's Yard*.

That picture has been literally flayed; the transparent colour on the shadowed side of the beams nailed diagonally on the masons' shed to give it support, has been nearly rubbed off . . . The like may be said of the fragments in the masons' yard; the effacement of half-tints and shadows has reduced them to unmeaning reliefless surfaces, similar in effect to the detached portions of a theatrical scene . . . This picture may be quoted as a sad instance of the passion now so fatally prevalent for reducing old pictures to as white an appearance as possible. The various white objects in it have been scoured, utterly regardless of the position in which they are placed, to an almost uniform whiteness. The consequence is that near and distant objects are jumbled together in unmeaning confusion, and that the linear perspective is forced into direct antagonism with the aerial. I will here remark, that the chalky veiled appearance of the immediate foreground is owing to the solvent having disturbed some portion of the body pigment. The sky has a smudged appearance, such as I know, from experience, to be the result of an improper action of some strong solvent . . . There is an absence of that freshness and sharpness of execution which, until the late cleaning, characterized this picture.

130

In 1955, when the Gallery cleaned the *Stonemason's Yard* once more, the restorer was obliged to concede that Moore's charges were not 'wholly unjust' – the shadows were indeed rubbed and the sky damaged. He did not comment on the solvent action but it is now becoming clear that Moore's comment on that was correct as well.

At the Parliamentary Committee of Enquiry in 1853, Uwins caused astonishment by denying that the old masters had used glazings at all. His evidence conflicted with that of his friend Eastlake and created 'an impression of want of candour'. A Gallery restorer, accused of having stripped varnish by friction from the entire surface of Rubens' *Judgement of Paris* to enable Eastlake to 'restore' a small fragment of missing paint, insisted that he had used a solvent but refused to identify it. Seguier admitted having removed glazes from a Velazquez but claimed that they were the work of an earlier restorer. Eastlake, who claimed to have supervised the restoration closely, denied knowledge of the removal. Following this and other scandals the Treasury replaced the Keeper with a Director – Eastlake.

Restoration at the Gallery then subsided and by the early years of this century scarcely more than one picture a year was being treated. But when in 1933 Kenneth Clark was appointed Director, at the age of 29, it began afresh. In 1938 Clark created the Gallery's Scientific Department. In his autobiography, he was quite candid about its purpose: 'Until quite recently the cleaning of pictures used to arouse extraordinary public indignation and it was therefore advisable to have in the background what purported to be scientific evidence to "prove" that every precaution had been taken.' (Recently an Italian art historian made a similar remark: 'Let's be honest and admit what all restoration directors will say in private. At the beginning of any restoration, you order as many tests as you can imagine, fully aware that only about 5 per cent of them will be any use during the project. The rest of the analyses are merely window-dressing.') When war broke out, the Gallery's pictures were evacuated to a cave in Wales, and this offered Clark

an irresistible opportunity: two restorers were hired to work full-time, undisturbed and unknown to the public. One of them, Helmut Ruhemann, was a zealot of 'scientific' restoration. After the war he was appointed to head the Gallery's new department of conservation, and he established the culture of radical or total cleaning that is still in place today.

Like Eastlake, Clark believed it was the novelty of cleaned pictures, not their actual condition, that caused the shock. However disturbingly bright they appeared at first, they soon lost their shine and settled down. That, he said, explained why when the sixty or so cleaned pictures were returned to the Gallery after the war, 'No one complained about them.' In fact, they produced an uproar which reverberated in the correspondence columns of *The Times* and the *Daily Telegraph* for over a year. The new Director, Philip Hendy, pre-emptively set up his own official enquiry, and invited two outside conservators to serve under a lay academic chairman, J.R. Weaver. Excluding all questions of taste and judgement, the Weaver Committee restricted itself to 'ascertainable facts'. Their central fact was that 'industrial tests' had proved scientifically that the Gallery's solvents could not possibly harm the paintings. The Weaver Committee reported immediately before the opening of the National Gallery's didactic exhibition of 1947, 'Cleaned Pictures', and its reassuring message was transmitted to the nation in a *Times* article by Weaver himself.

The reassurance did not endure. In the early 1960s an eminent conservation scientist, S. Rees Jones, Head of the Department of Technology at the Courtauld Institute of Art, explained that far from leaving paint unharmed, solvents leached organic material from it and gave it a matt chalky quality, leaving it more brittle and fragile, less glossy and elastic, less able to expand and contract with its support and therefore more prone to crack, blister and become detached. Solvents were ageing paintings prematurely, and to an extent that can only be guessed at even today.

Hendy did not reply to Rees Jones in the scholarly press but attacked him in the Gallery's annual report, which carries no

correspondence. Even so he was obliged to concede that leaching does occur and to agree that research into the matter was needed. In fact he had admitted in 1954 that 'What actually takes place when a solvent comes into contact with a varnish or a [paint] medium or a pigment is still fundamentally a mystery.' But he was not troubled by this mystery. He thought old oil films as resistant to solvent action as Formica. Only 4 per cent of their substance was leachable, he believed, and surface mattness is easily disguisable with fresh varnish.

Hendy was in turn challenged in the scholarly press by Rees Jones and by a second Courtauld scientist, P.L. Jones. The Gallery's scientists were misleading the public, and misunderstanding the nature of oil paint, they said. The figure of 4 per cent for leachable material was especially misleading. That figure was known to refer to the loss from an entire paint film, including its pigments as well as the medium that bound them. But when the pigment was discounted, the potential loss of organic material was 25 per cent and with common solvents like acetone as much as 47 per cent. P.L. Jones's own research at the Courtauld Institute had shown leaching to be capable of consuming as much as 70 per cent (by weight) of an artificially aged oil film.

The Joneses had left the Director in some difficulty. The Gallery's cleanings were invariably met by a chorus of complaints that the paintings had been ruined aesthetically. These complaints had been countered by science, but now that science was suspect. As it happened, the artistic consequences of the Gallery's cleaning techniques were again under fire from some of the country's most distinguished artists, critics and scholars: Francis Bacon and Frank Auerbach; David Sylvester and Laurence Gowing; Professor Anthony Blunt, then Director of the Courtauld Institute; Professor Ernst Gombrich, then Director of the Warburg Institute; Dr Otto Kurtz, the Warburg's chief librarian; and John White, Manchester University's Professor of Art History. Again, Hendy responded under cover of his Gallery report, dismissing the charges as worthy of attention only because their authors held prestigious

positions, and explaining how he had dealt with them: first he had set up an investigating sub-committee comprised of some members of his Honorary Scientific Advisory Committee, his Keeper, his Scientific Adviser, and himself; then he had invited the Scientific Adviser to prepare a statement of the claims made by the Gallery's critics and submit it, together with his own comments, to a secret session of the committee on which he himself sat. This committee had found 'no valid scientific criticism of the present National Gallery cleaning policy'.

The present Director and his staff may be wondering whether they can still support this view. They will certainly be aware of a paper published in 1992 by Aviva Burnstock (then a Higher Scientific Officer at the National Gallery itself) and Tom Learner, which confirms that leaching is a serious issue and points out that 'it is not known whether it occurs for several cleanings and eventually stops, or will occur to some extent during every cleaning'. Burnstock and Learner ventilated some other issues as well. First, most solvents cause swelling of the paint itself. 'The oil medium will attempt to swell in all directions but can only freely do so outwards. It is therefore extremely likely that the paint is plastically compressed sideways. On drying, the loss of any soluble material may lead to the formation of inaccessible voids in the film. Such voids near the surface could result in optical problems e.g. blanching.' Second, electron microscopes reveal 'signs of abrasion [of the paint surface] after treatment with cleaning solvents'. Third, pigments may become separated from the oil medium, lowering the colour value of the paint and in some cases leading to actual losses of pigment. Fourth, solvent-induced temperature changes risks splitting paint layer from layer. Last, solvents are also much more toxic to restorers than has been realized. All rather urgent issues, it might be thought.

The National Gallery's latest *Technical Bulletin* (Vol. 14) describes a 'distinct cleavage' in the paint layers of the sky in Canaletto's *Stonemason's Yard* but does not speculate on the cause. Whether it resulted from the 'improper action of some strong solvent' said by

Morris Moore to have been used in 1852 or solvents used in the subsequent cleanings of 1955 and 1989 has not been addressed. The solvents used in the 1989 cleaning are not identified in the *Bulletin*. I have asked the National Gallery's Director (Neil MacGregor) whether the institution is confident that a) its restorers fully understand the nature and extent of solvent action upon paint; and b) that no leaching of material from its paintings has occurred during the last thirty years. I also asked if the Gallery has carried out any research into these matters since the last cleaning controversy during the 1960s. In the letter of reply on behalf of the Director, the Clore Curator of Renaissance Art (Nicholas Penny) did not address any of these questions. When I drew attention to this omission in an article on the Gallery's cleaning policy, the Director also himself failed to address the questions in a letter of reply.

Two things can be said with certainty. First, the problem of leaching was identified as long ago as 1928, and more detailed measurement of leaching and swelling continued in the 1930s, 1950s and 1960s. Second, despite this, the problematic solvents continue to be used and are the chief weapon in the armoury of modern, 'scientific' restoration.

Burnstock and Learner are only the most recent of those who have emphasized how dangerous solvents are. Ruhemann was well aware of the earlier finds though he dismissed them as only of 'academic' interest and in need of 'more realistic tests'. When Ruhemann cleaned the *Entombment of Christ* attributed by the Gallery to Michelangelo he commented on a photograph of a test application, admitting that 'the cleaned strip here looks more unfinished than the uncleaned parts'. It would be helpful to see this photograph but the Gallery will not permit its publication.

Ruhemann was also open about his blunders. Cleaning another painting attributed by the Gallery to Michelangelo (the *Madonna and Child with St John and Angels*), Ruhemann found his solvents caused a 'persistent blanching' of the paint. In fact the white substance turned out to be gesso ground, which the solvent had dissolved through cracks in the paint.

Enthusiasm for the new, transforming capacities of scientifically produced materials and techniques may seem naïve in today's more sceptical climate but at the time it was a powerful influence. The combination of what one conservator called 'a knowledge of materials science' with traditional restoration skills gave birth to conservation in its present form. While critics were largely blinded by science for a generation, restorers, says Andrew Oddy, Keeper of Conservation at the British Museum, could convert 'what was originally a craft . . . into a profession'. In his view, it was specifically the adoption of synthetic materials, in preference to traditional natural ones – as employed in the art objects themselves – that 'revolutionized' the world of restoration and left its practitioners with 'a career structure parallel to that of the curators'.

To some extent, though, science has proved a Trojan horse. Besides restorers using scientific techniques, many bona fide scientists are also now employed in conservation departments and have shown themselves more active than is perhaps really welcome. As early as 1962 the Director of the National Gallery was complaining that 'Scientific conservation has undergone a misfortune common to all developing disciplines. It has become highly specialised. Information on methods and materials is accumulating at a rate which leaves the non-specialist behind.' Within a generation of its founding by Kenneth Clark, the Scientific Department had become 'self-contained within the Gallery, and intent on long-term research, with less day-to-day contact with restorers and art historians'. Today, the Gallery's seven restorers are shadowed by a Scientific Adviser who edits the Gallery's *Technical Bulletin*, a Principal Scientific Officer, a Senior Scientific Officer, two Higher Scientific Officers and a Scientific Officer. These scientists are as ready to expose the limitations and drawbacks of solvents and other products as they are to contribute to their development. In the early 1960s, polyethylene, which combines wax-like qualities with water solubility, was enthusiastically received until Margaret Hey at the National Gallery showed that as well as dissolving varnish it slowly softens paint. Aviva Burnstock, presently Head of Science at the

Courtauld Institute, has already been quoted in this chapter. Her work on the way in which traditionally used neutral organic solvents leach essential organic matter may have led the Gallery to place an embargo on all information about the agents it is currently using.

We do, however, know that the search is on for alternatives. Clearly, if the solvents now being used, such as toluene, isopropyl alcohol, ethyl alcohol and acetone, are dangerous then a substitute must be found. Not that restoration work will pause during this search. Holbein's *The Ambassadors* has disappeared from the walls for cleaning, presumably by current methods since there are as yet no others.

Hopes were recently pinned on newly developed water-based resin soaps as varnish removers, one researcher noting that since 'the chemical structure of natural resins [as used in varnish] is similar to that of some resin soaps, there is reason to suppose that resin soaps are better suited than common solvents for a controlled cleaning'. But unlike the solvents in use at present the cleaning agent in resin soaps does not evaporate and has to be washed from the surface. Recently tests were carried out to see how completely that could be achieved, even in ideal circumstances. The soap was made radioactive so that it could be traced and measured. It was found that significant quantities had become incorporated into the paint, where of course the cleaning agent continued to act.

Simultaneous raising and dashing of hopes is demoralizing the professionals, even if it is not yet slowing their activities. Certain branches of conservation may abandon chemical products entirely. Their use in the conservation of stone and building materials has proved calamitous, except to the manufacturers of the products. Some hope that physics may provide the answers. At the National Museums and Galleries Conservation Division lasers are being developed that can vaporize polluted encrustation on the surface of stone without entering – as all chemical products do – its innermost recesses. But it is hard at present to see how lasers can be adapted for varnish removal. Varnish and paint are too

137

similar, and the surfaces of paintings too subtle and complex. Perhaps the long infatuation with chemistry-led transformations of ancient and precious works of art may soon have to end, and be condemned as folly and cultural conceit. But its consequences will endure.

Trust in the objectivity and reliability of 'scientific restoration', however misplaced, has had a profound impact on scholarship. Because cleaned pictures are thought to be scientifically valid in their transformed state, historians feel obliged to revise their views. Paintings no longer create their own terms of reference but await processing by technicians. Restorers no longer work as it were under licence (Kenneth Clark kept his eye on Ruhemann by having him work in his office), but themselves set the parameters of judgement. 'Discoveries' and 'revelations' are to be made. Restorers may find themselves making authoritative, unchallengeable pronouncements: 'this can stay, that must go'; 'this – not that – is authentic'. These statements cannot be assessed by those without the same technical knowledge. Curators and historians find it rash to pronounce judgement on works awaiting a restoration that might make drastic changes. Cecil Gould declared the National Gallery Bonifazio *Adoration of the Magi* a Giorgione, after its cleaning. He was the first into virgin territory – all previous assessments had been made obsolete. In disputes concerning attribution the advantage lies with the scholar who bases his case on a recently cleaned painting because he will have seen the work in both states and he alone can cite, or even produce, the painting itself as evidence. An opponent basing his judgement on a pre-cleaned state must draw on memories or photographs. For this reason a historian may demand that a painting be cleaned before he expresses an opinion on it.

There has been a shift in the status of curators and restorers. Ruhemann wrote in 1968: 'Although the art historians in charge of pictures are officially responsible for the policies regarding cleaning, they naturally form their ideas in the first place from what they are told by their restorers.' Nuggets of information

are fed to the curators: 'Look, we've found that Perugino's/ Michelangelo's colouring was proto-Mannerist.' 'What was learned in the process of investigation and cleaning is discussed below by . . .' Some restorers show signs of reluctance to hand over their discoveries for scholarly assessment. John Larsons claimed recently that, properly speaking, restorers should be thought of as 'practical historians' and therefore professionally superior to 'documentary historians' who endlessly recycle surviving records. Certainly the National Gallery's *Technical Bulletin* increasingly contains disquisitions on what was found in place of descriptions of what was done. There are dangers in this. The agents of dramatic alterations are free to say as little as they choose about their actions and their judgements. They have a professional interest in radical as opposed to modest operations. And the scope of debate is throttled at source; when scholarship is produced by technicians, who but other technicians can challenge it?

At the National Gallery, the domination of science over aesthetic judgement seems to be absolute. Nicholas Penny, for instance, wrote recently that even though much destruction has been 'the responsibility of much-vaunted scientific technique', and even though 'something is lost however much is gained by any intervention', nonetheless 'conservators would be better advised to attend to the evidence supplied by laboratory scientists and archival historians than consult today's "man of taste" or today's artist, however passionately sure the latter may be that they understand what they love'. But when historians abandon the effort to understand art through imaginative response, they do not understand it more scientifically, or better – they cease to understand it at all. Artists, it is true, work with material, but they use it to produce effects. The only illuminating response to aesthetic and expressive effects is through imaginative engagement. Works of art are not so much fixities as interpretable sets of possibilities that artists have managed to make concrete and permanent. Each of us reads a picture differently, each has a personal response – educated and sophisticated or the reverse – to aesthetic relationships; but

scientific analysis cannot read or respond. Perhaps it is because they do not recognize this that scientific restorers' work often appears so crude, and produces results which to an artist are inconceivable.

Listen to artists and then restorers talking about painting. 'This brown spot, *representing* the ground on which one *imagines* the person to be standing, *gives* the turquoise and eggplant an *airy existence* which because of their intensity, otherwise could be lost [Matisse].' 'I have tried to *express* . . . the powers of darkness in a low public house by soft Louis XV green and malachite, *contrasting* with yellow green and harsh blue green, and all this in an *atmosphere* like a *devilish furnace* of pale sulphur [Van Gogh]' (my italics throughout).

Now here are David Bomford and Ashok Roy on Canaletto's *Stonemason's Yard*, cleaned yet again in 1989. 'Canaletto's *formulation* of greens, for example, is *characteristic*. The green paints *representing* canal water, grass on the quaysides and the foliage of the plants in the window boxes are all *based on* green earth as the principal pigment, with additions of Naples yellow, yellow ochre, white and black to modify tonalities. The *strongest* cold greens contain a high proportion of *terra verde* combined only with white, while the dense, *more yellow greens* incorporate the yellow pigments' (my italics again). How valuable is this fruit of the Gallery's pioneering interdisciplinary studies? Canaletto is known to have paid highly for his pigments, particularly for his blues and greens. That tells us they mattered to him. The interesting question – to be answered before the solvents and scalpels are used – is why? What part did they play in his artistic programme? More interesting to Bomford and Roy is what the pigments were. 'Naples yellow has been shown by XRD to be equivalent to synthetic bindheimite ($Pb_2Sb_2O_7$); see JCPDS file no 18–687'; the green earth pigment consisted of 'glauconite and celadonite [which] have closely similar consitutions, although their primary origins differ; the former is present in certain marine sedimentary deposits, while the latter occurs as inclusions in igneous rocks such as basalt.

They are difficult to distinguish by XRD. Both types are layered silicate minerals containing FE(II) and FE(III); also characteristic is a content of aluminium, silicon, potassium and sometimes magnesium . . .' Does this have a point or is it swank? If it matters that a green earth pigment was comprised of two ingredients practically indistinguishable under modern scientific analysis, don't the identity and properties of the solvents employed in their cleaning also matter? Bomford and Roy do not reveal what they were.

The technical apparatus employed in the Gallery's restoration programme may well be the finest in the world but it cannot address the magical transformation wrought by artists. What science can explain how a figure can be altered without being touched? Yet we know that Matisse revelled in such alchemy: 'The object is not of interest by itself: it is the environment which creates it . . . a glass of water with a flower is a different thing from one with a lemon.' More mundane questions than that are beyond the present capacities of science. In 1966, the painter Andrew Freeth challenged the National Gallery to 'state by what scientific method it is possible to know, when removing dirt and varnish with solvents, when they have arrived at Titian's final glaze?' The Director admitted that there was no method. He was prepared to trust his cleaners to make the necessary assessments by eye. Artists, however, have rarely shared this optimism. When a Rembrandt was cleaned at the Louvre, Degas exploded: 'Time has to take its course with paintings as with everything else, that's the beauty of it. A man who touches a picture ought to be deported. To touch a picture! You don't know what that does to me. These pictures are the joy of my life; they beautify it, they soothe it. To touch a Rembrandt! It's as though'

Helmut Ruhemann touched one of the National Gallery's Rembrandts with a variety of 'testing' solvent mixes: 1 part acetone to 3 parts white spirit was found 'safe', 1 part acetone to 5 parts white spirits was also safe but 'slow'; all colours except vermilion were found to be 'impervious to pure alcohol or pure

acetone'. The mix finally adopted was 1 part ethanol to 3 parts white spirit. Some parts were 'dabbed with pure ethyl alcohol'. On Velazquez's *Rokeby Venus* Ruhemann found it necessary to deploy pure ethanol and a bristle brush. Parts that would not yield to this treatment 'had to be scraped off'. Some were first 'softened by brief dabbing with dimethyl formaldehyde'. Having removed what he took to be varnish or repaint, Ruhemann then commenced his own retouching. But his own account of the painting reveals an uncertain reading of Velazquez's work and intentions: 'Cupid . . . is painted sketchily and *possibly* unfinished'; 'patches of paint *presumably* conceal pentimenti but *may have been* strengthened in an earlier restoration' (my italics). There was no uncertainty about his own ability to retouch though: 'After the cleaning, the gaps in the paint were filled with a putty of gilder's whiting, a little stand oil and glue; some burnt umber was added to match the tone of the original ground. The retouching was carried out with Paraloid B72 as a medium with powder pigments, xylene as a diluent and Shellsol E as a retarder.' And the whole painting was finished off with 'MSB2 . . . for preliminary, intermediate and final varnish . . . 3 per cent wax was added to the final (sprayed on) application.'

Goya must have been spinning in his grave. In 1801, he insisted that 'the more one retouches paintings on the pretext of preserving them, the more they are destroyed, and [that] even the original artists, if they were alive, now could not retouch them perfectly because of the aged tone given the colours by time who is also a painter according to the maxim and observation of the learned.'

Restorers will go to extraordinary lengths to undo the work of time. Restorers re-lining Sebastiano del Piombo's vast *Raising of Lazarus* judged it too dark even after cleaning. His oil paint had with age become more translucent. Light was entering the paint and being absorbed by the toned ground given to the work by the artist. The paint had acquired an 'aged tone'. The restorers decided to put history into reverse: a wax resin adhesive used to attach the paint film to its new canvas support was made a brilliant white.

142

This 'heightened the whiteness of the picture's [originally buff coloured] ground and so, through the partly translucent paint, heightened the colours.' There was 'reason to suppose' the painting had become 'darker than the artist intended'.

Artist and critics who remind restorers that they have no scientific or other reliable way of measuring artistic intention even of the present day, let alone of four centuries ago, are likely to be dismissed as inexpert, inherently unstable, confused and insufficiently qualified. Back in 1857, Horsin Déon defended the cleaning policy of the Louvre: 'It is understandable that the romantic amateur loves the rust and haze of the varnish, for it has become a veil behind which he can see whatever he desires.' Restorers are duty bound to uncover the true painting 'without heeding the clamours of the ignorant'. When Degas and others protested forty years later against the destruction of shadows in Rembrandt's *Pilgrims of Emmaüs* on the grounds that their loss robbed the picture of its air of mystery, 'the museum directors were supercilious [and] countered all criticism by stating their rights'.

Half a century later, Eric Newton, as already quoted, turned the expertise of artists against themselves: 'it is never the philistine who utters [protests]: it is the connoisseur and the artist – the visually sensitive man with a quick eye and a profound reverence for what he has seen. To the artist a cleaned Velazquez is rather like some venerable prophet robbed of his beard. He has lost both dignity and magic.' Why disregard the views of the quick-eyed and reverent? Because they are dupes of their own sensibility and expertise. The more you care about pictures, the more intimate you are with them, the more your eye will be shocked by change: 'The shock must be rationalised – your restorers have ruined the picture – my picture – the nation's picture – by clumsy scrubbing. Gone for ever are the delicate glazes, the subtle nuances, the sensitive brushwork.'

Note two things: first, Newton's condescending assumption that artists' eyes do not connect with their brains; and second, that even while parodying them he accepts that artists do not say

'I now *like* this painting less' but 'this painting has lost qualities and features which I judge to have been bona fide artistic devices'. The qualities most at risk, of course, are precisely those final touches and adjustments with which artists bring together the various compositional elements of a work. Who could be better qualified than an artist to detect the loss of such final refinements? Is it really conceivable that *all* the artists throughout history who complained about restoration have been deluded? Even Newton himself admitted, 'Certainly it is possible for an unskilled restorer to remove glazes and certainly many pictures have been ruined in the past.' Nonetheless, 'the National Gallery is fully aware of the risk' and now performs its 'delicate operations with all the care that knowledge and skill can bestow and all the precautions that science can provide, leaving behind ample records of everything that has been done'. This claim was repeated in 1985 by Nicholas Penny in a review of Sarah Walden's *The Ravished Image*, a critique of the Gallery's restoration policy. In the intervening forty years a succession of new scientifically developed and sanctioned techniques have been excitedly adopted and later abandoned.

In 1956, Pietro Annigoni, best known for his portrait of the Queen, visited the National Gallery, as he recalled in a letter to *The Times*:

> I noticed once more the ever-increasing number of master-pieces which have been ruined by excessive cleaning . . . I do not doubt the meticulous care employed by those renovators, nor their chemical skills, but I am terrified by the contemplation of these qualities in such hands as theirs. The atrocious results reveal an incredible absence of sensibility. We find no trace of the intuition so necessary to the understanding of the technical stages employed by artists in different pictorial creations, which cannot possibly be restored by chemical means.
>
> The most essential part of the completion of a picture by the Old Masters was comprised in light touches, and above

all in the use of innumerable glazes, either in the details or in the general effect – glazes often mixed even in the final layers of varnish. Now, I do not say that one should not clean off crusts of dirt, and sometimes even recent coats of varnish, coarsely applied and dangerous, but I maintain that to proceed further than that, and to pretend to remount the years, separating one layer from another until one arrives at what is mistakenly supposed to be the original state of the work, is to commit a crime, not of sensibility alone but of enormous presumption.

What is interesting in these masterpieces, now in mortal danger, is the surface as the master left it, aged, alas! as all things age, but with the magic of the glazes preserved, and with all those final accents which confer unity, balance, atmosphere, expression – in fact, all the most important and moving qualities in a work of art. But after these terrible cleanings little of all this remains. No sooner in fact, is the victim in the hands of these 'infallible' destroyers than they discover everywhere the alterations due, at different times, to the evil practices of former destructive 'infallibles'. Thus ravage is added to ravage in a vain attempt to restore youth to the paintings at any price.

Falling upon their victim, they commence work on one corner, and soon proclaim a 'miracle', for, behold, brilliant colours begin to appear. Unfortunately, what they have found are nothing but the preparative tones, sometimes even the first sketch, on which the artist has worked carefully, giving the best that is in him, in preparation for the execution of the finished work. But the cleaners know nothing of this, perceive nothing and continue to clean until the picture appears, to them, in their ignorance, quite new and shining. Some parts of the picture painted in thickly applied colour will have held firm; other parts (and those are always the most numerous) which depended on the glazes, of infinitesimal fineness, will have disappeared; the work of art will have

145

been mortally wounded . . . how long will these ravages in the domain of art and culture continue unrestrained and unpunished? The damage they have done is already enormous.

In 1970 Annigoni painted, in giant letters, MURDERERS on the doors of the National Gallery. In response, he 'got silence'.

Everyone now accepts that old masters used glazes and that restorers have often destroyed them. Is it possible to measure the damage of, say, the last half century? At the National Gallery I believe it is. During the 1930s Kenneth Clark had a number of excellent black-and-white photographs taken of details of paintings. These were published in two fascinating books, *One Hundred Details from Pictures in the National Gallery* (1938), and *More Details from Pictures in the National Gallery* (1941). In 1990, the Gallery produced an updated version with fresh colour photographs of many of the original details. In his foreword, the present Director, Neil MacGregor, wrote that in the intervening years many of the paintings had been cleaned and that 'The reader who can compare the earlier edition with this one will decide how much is gain, how much loss.' He added that photographs had become central to any serious art historical work well before the 1930s. They were of 'incomparable value' in determining 'questions of attribution': indeed 'modern connoisseurship had tended to concentrate on just those minute particulars – the form of an ear lobe or a finger joint – which photography can so effectively isolate'. Clark himself made 'very considerable attributional use of them here – to defend the *Virgin of the Rocks* as an authentic Leonardo'. Clearly, if it is possible to identify the elusive 'fingerprint' of an artist so successfully from photographs then injury must be demonstrable by the same means. What is revealed is a consistent pattern of loss: again and again, once deeply shaded and sculpturally modelled forms appear brighter and higher in colouring but flatter and thinner in modelling – often apparently in relief where they were once in-the-round. As it happens, there is even better photographic evidence than Clark's two invaluable books. The National Gallery

146

keeps a dossier on the restoration treatment of every painting. That on Rembrandt's *Margaretha Trip*, for example, was said by Ruhemann in 1968 to include fifty-three photographs, three high magnification photomicrographs and two colour slides (as well as two diagrams from micro-sections; four detailed reports of chemical analyses, partly carried out on cleaning swabs; and a systematic chart of special comparative cleaning tests). Every photograph contains a detailed explanatory caption. All the dossiers contain photographs 'taken before the treatment, to give a good idea of the picture's condition, and after the cleaning, and before restoration showing all the losses unmended'.

I have asked to see five dossiers but been allowed to see only two: the *Entombment of Christ* attributed to Michelangelo (cleaned in 1969) and Bramantino's *Adoration of the Kings* (cleaned in 1991), neither of which contained the customary material on solvents, solvent testings, swab analyses (to identify accidentally removed pigment) or, indeed, any testings or treatments. Five requests to see this material proved unsuccessful. The photographs in both dossiers recorded what I took to be injuries. When I asked permission to publish them, so that the matter could be debated openly, I was told that I would first have to submit my accompanying article to the Gallery so that its curators could be satisfied that 'the photographs are used or interpreted in a way they would find acceptable'. When I asked whether such a pre-condition was usual, the Press Officer replied, 'Yes, it's the standard thing with particularly delicate matters like cleanings.'

In the Bramantino *Adoration*, two coloured trough-like containers or caskets (one pink, the other green) stand side by side in the foreground. In design and form they are identical, differing only in their colouring. Before cleaning, both containers had tonal shading which made clear the form contained within the contours. After cleaning the green container still did, but the pink container appeared much flatter.

I wrote to the restorer, Jill Dunkerton, asking about this change: she agreed the absence of modelling was 'odd' and suggested that

'It is possible that a red lake glaze has faded, yet the red lake has survived along the upper edge and on the "feet".' She did not mention the green container. I quoted the Gallery's explanation in a *Spectator* article and suggested that the glaze had not faded but had been removed. This brought two responses from the Gallery. First the Curator, Nicholas Penny, claimed that the modelling (which he accepted had been removed) was part of a repainting carried out in the nineteenth century to conceal 'scattered flake losses' in the original paint. Then the Director, Neil MacGregor, sought to 'reassure readers' that the removed paint 'was almost certainly' put on by the Italian restorer Molteni in the mid-nineteenth century to 'suit the picture to contemporary taste'. Its removal, he implied, was deliberate and intended to return the painting to its original appearance. The heads of both the Restoration and Scientific Departments later denied that the pink container would, without question, originally have had shading on its chief surface.

These inconsistencies seem to me to betray the lack of coherence at the heart of scientific restoration. The glaze did not 'fade' because it was in existence immediately before the cleaning. If the nineteenth century repaint was applied to conceal 'scattered flake losses', then there must at that time have been unscattered, original glaze from which the losses had occurred. If that was the case, then today's restoration removed original work as well as the nineteenth-century repair. If the tonal glazing was not original but entirely of the nineteenth century, what of the surviving glazing on the green container?

The claim that Bramantino might have intended the pink area to appear flat is surely fanciful. Establishing the three-dimensional character of objects and figures and situating them in apparently 'real' space was, of course, a distinguishing artistic feature of his period. The idea that an artist might have chosen to shade only one of two identical forms is not really tenable. Wilful pictorial and conceptual inconsistencies like this are to be found in twentieth-century Cubist and post-Cubist paintings, but not before.

If the glazing was original, became damaged and was then repaired, why was it removed, and why was it not replaced? It appears that the Gallery's cleaning philosophy is that, whenever physically possible, *all* varnish and all previous restorations should be removed, regardless of aesthetic consequence. The object of cleaning is not purely aesthetic but also archaeological, to recover authentic paint. In the pursuit of this goal, Gallery restorers expose the sum total of all previous injuries and all physical deteriorations. Having arrived at that goal (which at least has a certain logic), with consequences that would startle most art lovers, having converted its paintings into what appear to be ancient, incoherent relics, whose originally glossy oil films have long been rendered matt and lifeless, the Gallery in apparent contradiction of its policy, meticulously fills in all the losses and abrasions with perfectly matching paint. Then coat after coat of synthetic varnish is applied until a seamless surface of clean, bright colours emerges whose glossy 'perfection' creates a plausible but deceiving impression of miraculous recovery.

Today's restorers may insist that the test of a restoration is technical propriety and not aesthetics: 'All previous restorations were contaminated by aesthetic taste and must, therefore, be eliminated. My interventions, uniquely, are not.' But no one, in any period, can paint without betraying cultural bias. Restorers working today do so saturated by post-Impressionist colourism and the flat surfaces of Abstract and Post-Modern art. Paintings intended to be 'read' in dim candle-lit churches and chapels are restored in brightly lit conservation studios by restorers whose eyes are acclimatized to the back-lit images of television and cinema. Art historians and restorers are largely trained by looking at brilliantly lit slides of pictures in darkened lecture theatres. With the best will in the world and with absolute consistency of approach, a restorer cannot intervene 'neutrally' in the work of another person from another culture, in another era.

In practice, however, we find that the Gallery's restorers are not consistent. I have argued that Dunkerton took off damaged

glazing from the pink stone casket and left it off. But in other parts of the same painting, she appears to have taken off sound repaints in order to replace them herself. Drapery insoluble by solvents seems to have been scraped from two figures and replaced, to differing degrees of finish: 'Fortunately the thickly glazed shadows on the red robe of the king on the left of the Virgin and Child have survived, making feasible the reconstruction of the missing folds. The shadows on the robe of Saint John the Baptist, on the other hand, are badly abraded and therefore have not been fully restored.' An attempt appears to have been made to repair glazing to the most crucial and delicate part of the painting, the features of the Virgin and Child, which were 'stippled in to suggest the modelling, but they have not been restored to the same degree of finish as the relatively well-preserved heads in the group on the right'. Why, then, was the pink casket for which a perfect model survived (the green casket), and which presented an infinitely simpler task, not also restored?

What rationale is operating? If the restorer is free to choose levels or degrees of restoration within a single work, on what grounds should the decisions be taken? When the Gallery restored Uccello's *Battle of San Romano*, the work took over five years. The Director described how the 'complete cleaning' exposed a greatly damaged surface and added: 'To restore scrupulously takes very much longer than to create freely, and the task of pulling the picture together again could have been further prolonged.' Then why was it not? 'It was thought better to stop at a point where the picture can be thoroughly appreciated again as a whole.' These claims are alarming: the picture was taken to pieces and only partially reassembled because a complete reassembly would have left it aesthetically less coherent. Two questions urgently need answers: Under what compulsion does the Gallery dismantle ancient paintings in this apparently risky fashion? And, what was not put back?

To answer this last point, we must know what the painting consisted of before cleaning – and this is the rub: the contents of a work

of art are as much a matter of interpretation as they are of fact. In the nineteenth century, Ruskin saw in the Uccello a 'morbidly naturalistic art'. In the 1930s the Gallery's Director, Sir Charles Holmes, saw the opposite. Uccello was not using perspective to create a sense of real space but was playing with it 'for artistic and decorative ends'. If we ignored the artist's attempted realisms – 'reduce them to simple terms of heraldry' – then 'their value for pattern making may be augmented to such a degree as to make the sacrifice of realism well worth the cost'. Sir John Pope Hennessy, in 1949, sided with Ruskin: the 'heraldry' of the painting was a 'veneer' behind which a serious naturalistic intention was evident. Even before its latest cleaning, the picture was, Pope Hennessy thought, 'over-cleaned'. This led to its geometries being more apparent than in its two 'better preserved [companion], panels in the Uffizi and the Louvre'.

Whose side did the Gallery take? That of their own former Director. More of the already injured modelling was sacrificed. What was left emerged flatter, more heraldic, less naturalistic than ever.

Many questions need to be answered, perhaps by the Trustees, in whom ownership of and responsibility for the nation's paintings are vested. If the Gallery is confident that it is not injuring works physically, why does it suppress information about its cleaning methods and substances? If it is confident that works have not been injured aesthetically, why does it not make its own photographic record of its interventions available for study, debate and publication? If, in fact, it is not wholly confident on either or both of these issues, why does it persist with practices which grievously offend artists and art lovers, and which have been thrown into serious question even by its own research scientists?

VI

The Restoration
Establishment

'Few problems are more controversial than the problem of
how to restore a painting. I have never encountered a practi-
tioner of that craft who approved of the work of another.'

Bernard Berenson

IS THERE, OR was there ever, a single interest group or constella-
tion in any sector of society prepared to relinquish even a modicum
of power without a fight? The operations of establishments are
similar whether they are governments, agencies, corporations,
religious sects, societies, political parties, or professions. All of
them contest what they consider to be their exclusive turf. Physi-
cians fight tooth and nail the ambitions of chiropractors,
homeopaths and acupuncturists; university professors fend off the
presumptions of teachers in less illustrious organizations; scientists
belittle those who see serious risks in their proposals; and so it is,
up and down the line.

One can hardly expect the restoration establishment to act dif-
ferently. Like those of their counterparts, their efforts divide into
two distinguishable spheres of activity: external, that is in relation

to the larger world; and internal or, so to speak, the family. The restoration establishment is dedicated to resisting invasion or limitation of its authority from the outside, and to keeping its practitioners in line. By that means hegemony is claimed and society thus obliged to concede absolute authority to the experts. After all, they know better. Not just anybody can presume to become a shaman.

In fact the professionalization of restoration practices is not yet as developed as that of many other modern specializations. The qualifying procedures that prevail in most countries are still somewhat disorderly and not always adequate. Nonetheless, professionalization is growing. Virtually all restorations nowadays are undertaken by trained specialists. The problem lies in the nature of the training they receive. In earlier centuries, restorations were conducted by trained artists, who occasionally turned to such activities. By the nineteenth century some artists specifically gave up making new art in order to keep old art alive and to pay the rent. Results were often acceptable, though the system was certainly open to abuse, and sometimes allowed less skilful painters to make a living out of rubbing down old masters and repainting them. Then restoration gradually evolved into an independent activity which became increasingly distant from the making of art. The restoration tradition was passed on informally, though often rigorously, in workshops. Since the end of the Second World War there has been a radical shift from that rather confused situation. Restorers no longer study art and then turn to restoration, but are trained as specialists from the start. They study computer science, chemistry, physics, a bit of art history and elementary drawing and painting. Now termed students of conservation, they learn the use of diagnostic tools, the various photographic testing techniques and the structure of colours. But they are not trained as artists and are not, as artists would be, attuned to the aesthetic issues that faced the original artist whose work they are treating. Arguably excellent technicians, the new breed may in many circumstances have little feeling and no experience of how a work has come into being.

153

A painter usually builds up his work as his own creative and artistic demands dictate. A Cézanne might begin a canvas by rendering pieces of fruit on a table, then paint the tablecloth, afterwards go back to the fruit and a pitcher, scumble in the background and finally delineate the table. He may move back and forth depending also upon what colour is on his brush at a given moment and its importance in the complex and subtle image he is creating. In contrast, restorers tend to work much more systematically, from top to bottom, from one side to another, or all over with certain treatments, and then to the particulars. That is one of the reasons why modern restoration tends to disrupt the equilibrium of a picture, as has been the case with Botticelli's *Primavera*, which the Uffizi very decisively cleaned a decade ago. Today it is virtually impossible to figure out, for example, where particular figures rest in space in relation to the others.

I do not mean to traduce the whole tribe of restorers. Make no mistake about it, there are restorers who are among the most dedicated, sincere, underpaid and overworked individuals in the whole vast art complex. In fact, any number of them are deeply distressed about the current state of affairs, but are to an extent frustrated in speaking out, for fear of losing assignments and with them their livelihoods. They are frontline soldiers, who frequently operate as freelancers and who may employ a few assistants from time to time. Only a few become public personalities whose fame transcends their field. Perhaps John Brearley, Maestro Colalucci and David Bull are among the most exalted.

The restoration establishment, of course, includes far more than just the practitioners. To start with, mention must be made of those who sell art: the dealers, the galleries, the runners and the auction houses that sustain the market. The larger 'old master' dealers have their own in-house restorers and all dealers rely heavily upon the skill of restorers in general. The needs of the dealers in terms of a restoration can be quite at variance with those of, say, museums or experienced collectors. Art dealers wish their pictures or sculptures to appear as attractive as possible to contem-

porary taste because, after all, they are for sale. The restorer is obliged to accommodate that requirement, or remain unemployed. In fact, 'antiquarian's restoration' is an unofficially but widely recognized category. One dealer actually told me that he often instructed his staff to liven up the lips of old portraits or put a bit of red in the cheeks or an extra spot of bright colour here and there. Small dealers sometimes do their own restorations in the back room, a practice more widespread in the past than today.

Surprisingly, modern pictures and sculptures receive an enormous amount of conservational attention, and the problems associated with them are if anything even greater than with those of works from the more distant past. The sense of craft, or at least of what craft signified in earlier times, has changed radically, as has the insistence on quality or at least on lasting materials and techniques. Extremely costly post-Second World War works of art are disintegrating after as little as five years. Putting them back together again is a greater challenge than fixing Humpty Dumpty. Dealers and all others involved in the art market, from antiquities to modern art, have a vital interest in and perennial experience with restoration. Almost every one can recount his or her own favourite horror story. They have to be considered active participants in the restoration establishment.

So are art collectors, who form an influential subcategory. Collectors want their investments and treasures conserved in the safest manner possible. At the same time they are determined to have their collections presented attractively. While not intimately involved in the establishment, collectors have a direct interest in its activity. And, of course, collectors come from all areas of society and have their own sometimes extremely powerful social, political and economic connections. When controversies arise about one or another restoration, the Sistine Chapel being the most notorious, the collectors and the dealers usually close ranks with the official restoration establishment, at least publicly.

Architects, those in the building and construction trades, and all their suppliers and jobbers also have a substantial stake in

restoration, broadly considered. Many architectural firms, especially in Europe, specialize in the renewal of buildings and historical sites. A complex activity, renewal can also be extremely lucrative, and certainly its practitioners are directly involved with and form a significant component of the restoration establishment. So, too, are the institutions that teach architecture and especially architectural preservation and restoration. The substantial resources involved are shared, of course, with the contractors and builders. These, in turn, although removed from artistic aspects, have a heavy financial stake in building restoration, and constitute a powerful lobby.

The extent of restoration can be seen at once in almost any Italian, French or German city one cares to name. In Florence, most of the major Gothic and Renaissance buildings are currently being, or have recently been, restored: the Baptistry, the Cathedral's vast cupola, Giotto's bell-tower, the Antinori and Pitti Palaces, and a host of other fourteenth-, fifteenth- and sixteenth-century buildings. These include Orsanmichele and its marvellous marble niches, the Loggia dei Lanzi and the pavement of the Piazza Signoria whose restoration has already been mentioned in a previous chapter. Equestrian statues of the Medici and most of the public fountains have been thoroughly cleaned although, given the city's air pollution, they become dirty again pitifully soon, ready for another bout of sandblasting. The charming little loggia, il Bigallo, has likewise been cleaned. A host of businesses and building activities are connected with, and dependent upon, restoration, with vast sums of usually public monies expended annually.

Connected too with the restoration establishment are the manufacturers of products used in their rejuvenations. Superficially, this connection might seem more remote, but when architectural restoration is included and the applications of the manufacturers' products are added up, the stakes become significant, and they promise substantial profits in the future. Millions of lire, pounds and dollars have been invested in testing and selling products connected with restoration.

156

The museums constitute still another fundamental component of the restoration establishment. The larger museums have their own, sometimes very substantial, conservation departments. Not only do they look after their own collections, they also execute restorations for smaller museums, public galleries and individuals. In America, the Getty Museum, the National Gallery, the Guggenheim and the Metropolitan Museum of Art are extremely active in restoration, and because of their prestige these institutions have an overriding influence on how restoration is carried out elsewhere in the country. The British Museum and the National Gallery in London function in much the same way, as national and even international flagships for restoration activity. The fact that over the past generation neither institution's reputation has been impressive has not stopped drastic and irreversible treatments. Unlike private restorers, those connected with prestigious organizations such as these, or the Louvre or Prado, have at their disposal sophisticated publications about restoration which seek to convince the general public of their expertise and promote their standing within the field. Furthermore, criticism is treated as unpatriotic and is usually brushed aside.

The museums' connection to the restoration establishment does not stop with their conservation departments. The reputations of curators and directors are often closely tied to restorative activities. Fundraising, alas one of the main functions of museum administrators, is often dependent upon a constant round of public presentations of restored works – the new Rembrandt, the new Van Gogh, the new Chardin, the new Pontormo.

More problematically, senior museum officials may be connected either directly or indirectly with the activities of the art market through attributions. A prestigious Biennial Antiques Fair has engaged the services of world-renowned scholars and museum officials who 'guarantee' the authenticity of the objects for sale. If a world-class curator upgrades a particular painting or sculpture in a private collection (or in the hands of a dealer), his opinion has immeasurable commercial value. To be made presentable the object

157

is then restored, perhaps even under the supervision of the expert himself, only to appear subsequently in an exhibition or auction sales catalogue. One of the greatest dangers of exhibitions, besides the very substantial risks involved with shipping works of art, is that standard practice demands that all or at any rate most of the works by Caravaggio, Mantegna, Manet, or whoever it may be, undergo cleaning in preparation for the huge media-orchestrated event of which they are part. Deadlines have to be set and met, which means that restorations may have to be rushed, as has been the case for the giant Venetian exhibition in Paris in 1993. Regardless of the problems the conservator may uncover in the course of his work, the pictures must be ready for the opening night; the show must go on!

A factor in understanding the power of the restoration establishment is the make-up of museum boards of trustees, composed of highly influential and wealthy members of the community, at least in the United States. These individuals, often valued donors, are barons of business and finance, and intensely loyal to 'their' museums, are reluctant to tolerate criticism of any kind. In some instances they are actually the owners of major newspapers, magazines and media outlets, so that unflattering opinions about the conduct of restoration in a particular museum are not appreciated. In Italy, in a slight twist in conditions, many of the major press outlets are owned by families who are either patrons of the arts or, more specially, patrons of prestigious restorations.

The art publishing and bookselling industry has to be regarded as part of the restoration establishment as well. There has been an explosion of monographs and exhibition catalogues closely connected with restoration. In addition to the most important art bookshops, museums like the Metropolitan, the Getty, the National Gallery in Washington, the Louvre, and the National Gallery of London have their own sometimes thriving publication departments. The elephantine exhibition catalogues, for example, are normally produced in-house with the collaboration of an

established publisher. Nor should the sale of postcards, slides, posters and souvenirs be forgotten.

Over the past twenty years, a vast number of art works, often the most important and prestigious paintings and sculptures in public collections, have experienced a new round of restoration (except in Eastern Europe so far, to some extent due to the lack of funding), while cycles of sculpture and paintings in churches and in public buildings have also been thoroughly renovated. New publications are constantly required merely to keep up to date. The explanation is simple: the images have changed. Think of the old views of the Brancacci Chapel: how inaccurately they reflect the current appearance of the frescoes. Like almost every product in contemporary society, art books become outdated. Renewing, revising, improving and replacing are part and parcel of the modern consumer society. Which begs the terrifying question: is it possible to avoid this throw-away attitude even when dealing with art treasures?

The financial gains surrounding restoration should not be underestimated. Every substantial restorative intervention is accompanied by new publications ranging from expensive coffee-table volumes that can cost up to £500 and slick magazine articles to postcards and slide sets, and that whole new dimension, the video disk. In the case of the Sistine Chapel restoration, even the usually staid *National Geographic* featured a heavily illustrated cover article entitled 'The Sistine Restoration. A Renaissance for Michelangelo'. The Sistine restoration has been the subject of short films, television programmes, endless books with more promised, tote bags, T-shirts, calendars and the rest, most of them sold at museum bookshops. The sales pitch for the new slides of the Brancacci reads: 'The results are astounding: the dark, grim appearance has given way to brilliant colour and light'. Characteristically one article singing their praise is entitled, 'The History of a Miraculous Restoration'. The two activities, the publication and the restoration, are so closely connected that often one is not certain whether the restoration is undertaken for the media coverage or vice versa.

159

In any event, the entire depository of works of art through-out the world is witnessing a massive recycling. To a much lesser extent, the same has occurred in the past but at a slower pace and usually with less radical imperatives, as has been true of society's other enthusiasms. In the case of Jacopo della Quercia, virtually his entire oeuvre has been treated (in my view mistreated), from his reliefs and statues on the façade of San Petronio in Bologna, to the sculptures of the Fonte Gaia in Siena (which are now about half done), to a statue of a standing Apostle in Lucca Cathedral, not to mention the *Ilaria*. The same may soon be true of Masaccio's frescoes. Restoration provides the specialized press, and publishing and related industries with an endless flow of new or reconditioned subject-matter, both supplying the images and creating the demand for them.

In the arts the issue of sponsorship has vast significance. Corporate and private wealth, sometimes channelled into foundations, has had a prodigious and undoubtedly beneficial effect in underwriting a wide variety of cultural activities – classical music concerts and festivals, dance, opera, film festivals, literary prizes, public television and fine arts endeavours of every sort. Without its funding, especially over the past two decades, the condition of the arts throughout the West would have been much less vital.

The role of sponsorship in restoration is more worrying. The three cases treated in this book had different sponsors, each with its own characteristics and goals. A local bank, the Monte di Lucca, was the benefactor of the *Ilaria* restoration. The bank has the image of Ilaria as its symbol; quite naturally, it wished to highlight its connection with the monument. One can readily appreciate that a less glamorous intervention, such as a simple dusting of the monument or the installation of better lighting, would not have had any substantial public relations value.

Nonetheless, criticizing sponsors, though a common reaction to the rash of restorations, misses the point. The motives of sponsors are obvious, for a company gains from connection with a

Masaccio, a Michelangelo, a Jacopo della Quercia, or a Barnes Foundation Treasures exhibition to an extent that it would not from lesser works. The requests of sponsors should, however, be rigorously and uncompromisingly directed by the responsible authorities. Obviously, sponsorship of restoration can in itself be an indispensable aid in the general battle for funding in the arts, but the authorities must learn to resist undesirable or unnecessary projects. In Italy, in particular, banks are required by law to spend substantial sums each year on cultural activities. The authorities need not therefore accept the sponsors' priorities; they have the scope to impose their own. The sponsors must be guided and they must also be educated.

The sponsor of the Brancacci Chapel restoration, the Olivetti Corporation, has a distinguished record of involvement and sponsorship of the arts that goes back to the 1930s. In recent years Olivetti has promoted outstanding exhibitions and is without question a progressive and well-informed advocate in the fine arts. From the point of view of the company's public image, this has significant value. Its exhibitions, such as 'The Treasures of San Marco' or 'Michelangelo's Drawings', have been valuable both to the company and to society. But Olivetti, like most sponsors, is highly selective: Michelangelo, Leonardo da Vinci and Masaccio are not minor masters.

That the restoration of the Brancacci frescoes brought about a rather clinical, not to say brutal, result is obviously not the fault of the sponsor. Olivetti acted in good faith in working with the selected team, one that had an impressive track record. On the other hand, arguably the company could (and should) have insisted upon a much more open atmosphere surrounding the intervention. It could and should have insisted upon public discussions *before* work actually began. The methodology selected could have been explained and defended. I also believe that a public and open appraisal of the results now that the restoration has been concluded is an absolute requirement. Here, I suggest, the sponsor could be insistent. The promised official report has finally appeared, four

161

years after completion – and long after critical judgements have been made – but no evaluation in the form of a symposium or open discussion is contemplated. Besides, the report is not independent, it simply offers an uncritical presentation and has been produced by those who carried out the intervention and their collaborators. In my view, it has little scientific value.

The sponsor of the Sistine Chapel restoration has been the Japanese mass media company, Nippon Television Network Corporation of Tokyo. Reports of the precise amount of money, and the exact terms, have oscillated in the public report between $3 million and $4 million – either of those figures relatively a small sum considering the magnitude of the enterprise and its lofty artistic status. The Japanese entrepreneurs, in contrast to virtually every other sponsor of this kind, set terms that provide them with a profit, apparently a very handsome one at that. They retained photographic rights in the ceiling for a period of up to twelve years. Any reproduction of the restored portions of the ceiling brings Nippon Television a handsome fee. Even after the exclusive rights run out, the Tokyo-based media corporation, which also 'sponsors' similar projects in China, will continue to own the rights to the colour transparencies and can sell them at a hefty price at least until another campaign of photography is undertaken. As time passes the amount of money contributed by Nippon Television may well appear ridiculous in relation to the return. In fact, their 'sponsorship' may come to be regarded as one of the best business deals of the period in the fine art world, even before any public relations advantage is taken into account.

Foundations constitute a category of sponsor with unique characteristics and motivations of its own. They are not always as healthily divorced from the restoration establishment as they need to be. The Samuel Kress Foundation's involvement in the controversy surrounding the Sistine restoration is a case in point. The Foundation has funded the study of art history, in the United States and abroad, for some years, and in more recent times has also funded artistic restorations around the world, becoming among the

162

most substantial sponsors of its kind that exist. When the furore over the restoration of the Sistine Chapel ceiling reached its zenith, the Foundation funded a trip to the Chapel by a group of restorers, mainly from the United States, to see for themselves if anything out of the ordinary was unfolding there (as if those individuals had not seen the ceiling restoration before). The chief restorers from the Getty, the Washington National Gallery, and the Metropolitan Museum in New York were flown to Rome. The fact that these individuals specialized in paintings in oil or tempera rather than frescoes was never publicly explained. As can be expected, collectively they pronounced solidly in favour of the efforts of their fellow professionals, that is, they supported the restoration establishment. Their public appraisal was given wide coverage in the media, orchestrated by the omnipresent PR operators. Several of the restorers were already officially connected with the Vatican project, notably David Bull of the Washington National Gallery. Even though the Kress is a tax-exempt foundation it seems not to have attempted to act evenhandedly by including at least some painters and restorers who had expressed objections.

A more social than political aspect of the Restoration establishment is composed of well-intentioned individuals and organizations who band together 'Saving Our Past: A Race Against Time,' as the title of the World Monuments Fund's recent brochure has it. The director of the Kress Foundation is Chairman of the Board of Trustees while their Hadrian (not Nero) Award recipients include Carlo De Benedetti, Paul Mellon and the Prince of Wales, in recent years. No one in their right mind would fault the intentions of such enterprises, but the fact that there are no outside, independent controls, nor are the interventions subject to serious criticism and analysis by independent agencies or individuals, is another matter. It is here that concerns must be raised in the continuing crescendo of interventions which, in some cases, may have caused more physical as well as aesthetic harm than good, as in the case of the sculpture at St Tromphime at Arles, Jacopo della

163

Quercia's San Petronio sculpture in Bologna and Donatello's stuccoes in San Lorenzo in Florence.

Artists, art scholars and writers on art strongly influence the public's comprehension and evaluation of art. But in the case of the Sistine ceiling's restoration a split developed between contemporary artists on the one hand and the restoration establishment, with boundless support from historians of art and art critics, on the other. Of course, some perfectly respectable artists were satisfied with and even enthusiastic about what had taken place but, on the whole, artists harboured serious doubts while generally scholars were contented, in some instances even ecstatic. How is it possible that the two sides should see with such very different eyes?

Artists often have experience with restorations themselves, not all of it agreeable. More frequently than one would like to think, contemporary art objects are accidentally injured in transit to exhibitions or galleries. In some instances, necessary repairs are improvised in the galleries or museums on a makeshift basis without fanfare and even without the artist's knowledge, much less permission; in others, experts are called in, or the artist himself does his own repairs. But once damage occurs, inevitably some permanent loss has been incurred, as any artist can see is the case with all restorations. Contemporary artists often also have a keen attachment to the objects of the past which either by imitation, osmosis or rejection have contributed to their own artistic development. Previous art is professional heritage and artists have probably always helped preserve the work of their predecessors. Michelangelo, who lamented the destruction of Old St Peter's, probably saved Jacopo della Quercia's Bologna portal with its sculpture. Degas was an outspoken defender of the integrity of the Louvre's masterpieces from 'cleanings', and battled to save the *Mona Lisa* from beautification. Who today will stop the Louvre from cleaning Leonardo's *Madonna and Child with St Anne*, which has already been removed from the gallery? The background landscape has already seen treatment, and the figures are being readied for an attack. And

if the *St Anne* is allowed to be updated, will not the *Mona Lisa* be next?

On the other hand, like postwar restorers, art critics and art scholars may deal with art objects for a lifetime but still have little awareness of precisely how they came to be made, much less of the processes of form-making that every practising artist who picks up a pencil experiences daily. The separation between art scholar and artist seems to me to reflect a serious shortcoming in the current practice of art history (and perhaps the orientation of artists, as well). That reputable and powerful art historians in their untouchable bastions in the universities are literally unable to 'see' that an admitted modern forgery is not a Modigliani sculpture or that a figure in Veronese's *Marriage at Cana* needs to be one colour rather than another, or that modelling has been lifted from Michelangelo's figures on the Sistine Chapel ceiling, cannot be put down to mere lack of imagination. What a painter can spot in a blink of an eye has apparently entirely escaped the notice of many prestigious Renaissance art scholars. How is this possible?

A substantial number of art historians are concerned almost exclusively with antiquarian problems. As with other specialities, issues are researched for their own sakes, without any obligation to place findings within a larger context, or any desire to apply them to current cultural life. It is not surprising that the aesthetic effects of an intervention become less interesting and important than any 'discoveries' which may apply to research. A new detail, a previously unnoticed object, an unforeseen treatment, or even a technical device, especially one that may permit a 'new' interpretation or reinforce an old one, become the ultimate desideratum. The unexpected mode of application that Michelangelo is now being said to have employed, the luminous colour uncovered especially in the lunettes, or the flatness of the planes and the absence of modelling after the cleaning, have caused genuine excitement. For some, a theory that Michelangelo was the first Mannerist appears to have been confirmed: for them the 'discovery' is worth restoration. That what it reveals is only half the story, or that damage

165

or permanent loss may also have resulted does not mitigate enthusiasm for what are, superficially, new data.

On the opposite side of the art historical spectrum, archival studies have attracted a large following, and such research effectively immerses an art scholar in 'his' period. I have long advocated the value of first-hand research of the 'sources', having spent countless days leafing through musty manuscripts in Italian libraries and archives to confirm a lost date or incident in the life of an artist I study. For an historian, nothing quite compares with the satisfaction of finding a scrap of information or new reference which can shake up past beliefs. But such study must be undertaken with temperance, in clear recognition of what can be determined from such information and what cannot. When the activity becomes a mindless exercise in fact-gathering, like knowing Michelangelo's laundry list, the kind of bread he preferred (the saltless Florentine variety), his favourite wine (Trebbiano), or the mineral water he drank to break up his kidney stones (Fuggi), we gather only colourful biographic titbits.

The need to interpret material is imperative: herein lies the distinction between an historian and a mere accumulator of data. This is not to say that isolated gatherings of facts may not come in handy one day in illuminating larger issues, or that data should not be banked. I am not yet sure what we are to make of the fact that in old age Michelangelo went around Rome in one of his ragged fox coats and that he had hundreds of gold ducats tucked about his house when he died, but I am prepared to see that these details might form part of an interpretation of the master's life.

In the case of the Sistine Chapel ceiling a good deal of ink has been spilled in seeking to reconstruct the kind of scaffolding Michelangelo designed after that provided by Bramante proved inadequate, but no one has yet come up with a convincing chronology of his actual work on the ceiling: are the lunettes contemporary with the stories above them, are they earlier or are they later?

Enough has now been said to show that powerful and sophis-

ticated interests operate to ensure that restoration continues along its present furious track, and that it gathers speed, despite the fact that restorers and their advisers are now often divorced from the concerns of practising artists, have no experience of the creative process and possess little sympathy for aesthetic issues. How does the establishment protect itself from criticism or even awkward questions? A particularly crude skirmish was described in the prologue to this book. Obviously a gaoled, discredited or bankrupt critic will be a less effective one. Secrecy is also a key weapon. Belittling the credentials of critics, so that no answer need be given to the points they raise, is another. In defending the cleaning of the Sistine Chapel ceiling, the Vatican team demonstrated how this approach can be reduced to absurdity. First, the claim was put forward that no scholar not a Renaissance specialist was qualified to criticize the restoration, an exclusion that eliminated in one fell swoop the vast majority of art historians. Then, even Renaissance specialists were declared unqualified to comment unless they were conversant with all the scientific parameters of modern restoration; they must be knowledgeable about computer science, physics and chemistry. In fact that would disqualify virtually every art historian on both sides of the dispute. To muffle opposition further, another argument was used. Only scholars who had seen the restored frescoes in Rome, and not just photographs, could render judgement, although art historians habitually rely upon photographs, as have done connoisseurs past and present, from Berenson to Longhi, not forgetting Italy's most prominent, Federico Zeri. Next, it was not sufficient to have seen the restored frescoes from ground level, the way Michelangelo painted them to be seen; they had to have been observed from arm's length. About 4,000 visitors did get up on the scaffolding but if, for whatever reason, one never managed it, one was disqualified for life, or at least until a subsequent restoration. Even this stipulation was embellished. The Vatican experts established the requirement that to be really convincing, critics must have followed the progress of the restoration day by day from up close. Thus, in a final step towards the

167

elimination of all criticism, virtually everybody not actually part of the restoration team was deemed unqualified to comment.

In their own mansions, the art scholars who participate in the restoration establishment are quite restrictive in allowing opposition of any kind and can effectively block most criticism from their professional publications. Then, in another of those absurd twists of logic, they condemn their opponents for bringing criticism out in the open, outside the club, into the mass media. *The Burlington Magazine,* which is supported by the Kress Foundation, has to my knowledge never published a single negative appraisal of the restoration of the Sistine ceiling or of the Brancacci Chapel for that matter. I submitted a scholarly paper to them setting forth an argument which appears again in Chapter III of this book. I argued, within the parameters of accepted historical methodology, that *pentimenti* by Michelangelo must have been removed in the course of the cleaning. My evidence rested mainly on engravings and drawings made as early as 1534, in which the 'discoveries' claimed by the restorers were not shown. Since no one has claimed that changes were made between 1512 when Michelangelo finished painting the ceiling and 1534, I concluded that they must be *pentimenti* by Michelangelo himself. The *Burlington* rejected the paper on the grounds that one cannot count on the accuracy of the engravings and drawings. The editor did not let the scholarly community evaluate the proposal for itself. Much the same happened with *Art Bulletin,* the official publication of the art historians of America. What is evident is the consistent manner in which the establishment closes debate and marginalizes contrary opinions. I am not suggesting that arguments of mine and of those who share my views should not run the gauntlet of genuine scholarly counter-argument, only that they should not be suppressed. In fact, fair appraisal of criticisms, whether of what has been unfolding in the Vatican, or in the Brancacci Chapel, in the Louvre, in the National Galleries of Washington and London, in the Getty, or the Metropolitan, is virtually impossible in the official, scholarly journals. Professor Alessandro Conti's book on

the Sistine restoration, for instance, was virtually ignored by the press.[1]

The pattern among experts in any establishment is to limit criticism. My criticism of the restoration of the *Ilaria* was not appreciated in official circles. The Director of the Opificio delle Pietre Dure in Florence, Dr Giorgio Bonsanti, pointed out that the court had upheld my right to freedom of speech, but had not judged whether the criticism was correct or not, his implication being that the criticism was actually wrong.

What is almost unique, and also honourable, about this civil servant (who was also a member of an honorary committee of the Sistine restorations), is that he speaks out and is quite prepared to enter the fray, unlike many of his colleagues. His *de facto* defence of Caponi is consistent with his cordial praise of the cleaning of Benedetto Antelami's series of the *Months* in Parma, whose restoration has been severely attacked by several art historians. One of them, Mina Gregori, the professor who spoke in my defence at the trial in Florence, has been quoted as follows: 'Antelami's *Months* are now ruined: unsightly puppets robbed of their Romanesque contours.' In Bonsanti's article, which carries the title, 'A little knowledge of restoration is a dangerous thing', he lists five points. First, we learn that criticisms like those of Professors Gregori, Beck, Conti, Alessandra Meluccio Vaccaro, *et al,* tend to be expressed in inappropriate circumstances. What the appropriate circumstances are he does not say. Second, he objects to the tone of the criticism, which reveals 'bad manners' or 'uncivilized attitudes'. Furthermore, the criticism is unreasonable and unscientific. In a connected point, his fourth, Bonsanti claims that the critics have seen little or nothing of actual restoration in the making, and yet are prepared to make comments about the results. It is as if he is saying, to use the medical analogy which seems so appropriate to restoration, that one cannot say that the patient died unless one was present in the operating-room. Finally, he objects to the use by critics of certain terms like the 'skin' of a sculpture, or its 'patina', which he says are imprecise.

Dr Bonsanti then defends the cleaning of the Parma *Months* which was conducted by Bruno Zanardi, a vocal and powerful figure in the restoration field. Bonsanti writes: 'When I examined the statues . . . I had no sense that they had been cleaned excessively . . . I do not see why this aspect of the work should give rise to so much concern . . . judgements to the contrary are simply unfounded.' Thus, he has not relied on scientific data, on reports and testing, or on the definition of what the losses to the patina might have been, but used the same visual criteria as the unscientific critics, the very criteria he has found so inadequate. That the officials in charge of the Parma restoration had reservations of their own, to the extent that they closed down the workshop altogether, hardly gives credence to his evaluation. In a communiqué dated 28 July 1992, the Superintendency for Fine Art for the Provinces of Parma and Piacenza explained its position with regard to Zanardi and his activity at the Cathedral and Baptistery of Parma. It revoked Zanardi's contract, lamenting the fact that in the restorations he conducted in the Baptistery, he had created 'an irreversible situation which resulted in the total loss of the historic skin of the building, a profound alteration of the chromatic appearance, not to say an unjustifiable interpretation of the historical and architectonic elements'.

To hide behind the cover of expertise and 'science' may be superficially heartening. The long-awaited report on the intervention at the Brancacci Chapel, published by the sponsor in late 1992, has as its (translated) title, *The Brancacci Chapel: Science for Masaccio, Masolino and Filippino Lippi*. Science as a slogan in restoration has been co-opted for public relations purposes, but need we be reminded how many scientific certainties have been abandoned in the face of new data?

Are those most directly engaged in supervising the treatment of rare paintings and sculpture, and specifically those who make the crucial decisions, trained scientists anyway? The Superintendent of Pisa who oversaw the cleaning of the *Ilaria del Carretto*, the Directors of the major Italian restoration centres such as

Dr Bonsanti, Dr Mancinelli and Maestro Colalucci of the Vatican, Professor Umberto Baldini, an ex-Director of the Central Institute of Restoration in Rome, Dr Giovanni Urbani (likewise an ex-Director of the same institute and an admirer of the Sistine restorations and, apparently, of the solvent used there which was invented in his centre) – none are scientists as the word is commonly used. Let us be clear about it, these are the decision-makers, as are the curators and museum directors of the London National Gallery, the Metropolitan, the Louvre and the National Gallery in Washington.

If modern interventions are really scientific exercises, how is it possible to explain the various 'schools' and conflicting methodologies that exist? As it happens the Florentines at the Brancacci rejected the solvent used on the Sistine ceiling as particularly drastic and difficult to control, quite contrary to the view of their Roman counterparts. If disagreements can occur between Italian regions, they may appear to be slight in comparison to those between the Louvre and, say, London's National Gallery. Nor are the regional and national schools monolithic or homogeneous. The conservation restoration operations at the J. Paul Getty Museum are under the direction of an Italian who has brought his ideas to California, while those in Washington have grown out of methodology developed in London's National Gallery by a German. The Metropolitan Museum in New York, long under an English restorer who had been active at the Prado, is currently directed by a practitioner from Munich.

To characterize as anarchy the restoration establishment's rubric of the 'scientific restoration' is unhelpful. What must be understood is that so-called 'scientific restorations' are at a rudimentary stage. We may well discover all too soon that the treatments on those classics often referred to will turn out to be primitive in the extreme when subjected to critical criteria that are bound to develop in the future. Likewise, soaking the surfaces of marble statues with a heavy synthetic oil or layering Renaissance frescoes with transparent, impermeable acrylics may also prove to be unacceptable.

Is it not time to repudiate straightaway the misleading and silly notion that art restoration is scientific and begin to recognize that, of course, scientists must be called upon for analysis, tests, suggestions and advice, but their input does not constitute a 'scientific restoration'? Reflecting a point of view of the restoration establishment, Dr Bonsanti has written: 'I maintain that an intervention does not exclusively arise from conservational reasons; it is completely legitimate and even required . . . to reinvest the best legibility of a work of major importance, so as to permit a philological operation to be understood in its basic sense, for the purpose of correct valuation of the message of the work itself . . .' Not much science here. The principle espoused is worrying when one realizes that Dr Bonsanti's organization is currently using similar criteria for Jacopa della Quercia's Fonte Gaia statues which are coming back looking like objects from an antiquarian fair,[2] and for the superb *quattrocento* sculptures at Orsanmichele, including Nanni di Banco's *Quattro Santi Coronati*. I for one, shiver at the mere thought of the potential results.

It should be apparent, under any circumstances, that we are facing an emergency. We cannot allow ourselves to be seduced by apparent discoveries or approximate reconstructions or permit radical interventions because of a forthcoming exhibition. In the case of the five hundredth anniversary of Raphael's birth a decade ago, Dr Mancinelli produced some timely scrubbings which he announced in a 'scholarly' paper entitled (in translation): 'Restorations in the Vatican on the occasion of the Raphael centenary'.

We must admire Dr Bonsanti's call for complete openness and accountability. But his concept of accountability leaves much to be desired. He suggests the authorities in charge of a restoration should take steps to inform the public of what is being done and how, and should facilitate access to the site. This is *noblesse oblige* and little more. This is not an exchange of ideas, a discussion of objectives, a debate over methodologies, but rather another public relations device to stifle criticism before it starts.

The assumption underlying this position is that the restoration

172

establishment has the exclusive and direct line to truth, and all they need to do is present it. They are not prepared to countenance independent advice from art historians, artists, and other restorers, or to look in good faith at alternative approaches which might include non-intervention. Opposition therefore has to be forceful, merely to gain attention, to shake a society that has been lulled into thinking that clean is beautiful, and that it has been achieved without terrible cost.

Is it not time that we call an immediate moratorium on important sculptural and pictorial restorations, until a proper range of opinions and approaches can be evaluated? Dr Bonsanti gives the impression that all restorers and institutes of conservation and restoration operate using the same techniques and the same ideology. Nothing could be further from the truth. 'Complete openness' is essential, but openness is a two-way street. Centres of restoration should be open to other methodologies, to other tools and techniques, and to other philosophies that might refine the objectives of their intervention in the first place.

If I am one of the barking dogs in the subtitle of Bonsanti's article, so be it, though I do think it is a step up from being called a mutant. It may be necessary to bark to make the public understand the nature of the dangers, and the urgency of the matter. As things stand, the only controls are those self-imposed by a restoration establishment. That I find such a state of affairs intolerable goes without saying.

VII

Preventive Action

IT IS NOT enough to complain, to criticize, to cry wolf. In fact nothing is more demoralizing than to be obliged to respond negatively to the vast majority of interventions. Happily, there have been some notable successes.

The cleaning of Michelangelo's sculpture for the Medici tombs in the New Sacristy of San Lorenzo, in Florence, was completed in mid-1991, and it was done with noteworthy sensitivity. Since the work was executed more or less at the same time as the *Ilaria* and since both were of fine-quality marble, I am enormously relieved to be able to speak enthusiastically about it. What is extraordinary about the cleaning which, again like the *Ilaria*, involved sculpture that was housed indoors, was that no harsh chemicals were used, no mechanical means employed, no oil applied to the surface. The dust and dirt were gently removed with cotton wads and distilled water. What is more, the cleaning was conducted by an artistically oriented and enlightened young woman, Agnese Parronchi, who had trained a decade earlier at the Opificio. The money was supplied by a private sponsor, a foundation whose director showed the deepest respect for the works of art, while the Superintendent in charge was extremely well informed and

co-operative. In other words, this restoration, together with one by the same restorer conducted on Michelangelo's *Battle of the Lapiths and Centaurs* relief located in the Casa Buonarroti, has provided encouraging proof that sensitive cleanings are indeed possible.

Somewhat to my surprise and notwithstanding potentially serious risks, many restorers in the United States have approached me on a private basis and offered encouragement as well as valuable information. I also learned that, certainly in Italy if not elsewhere, restorers are strikingly vulnerable to the whims and theories of superintendents, directors, curators and their staff who 'direct' their activities in every instance. These individuals have usually been trained as art historians and are not completely comfortable with the intricacies of restoration. Some are, therefore, inclined to present the restorers with a general line or approach to be followed, indicating how the object should appear when the cleaning is finished and then checking once in a while to see that the work is turning out as desired. Others may be so unsure as to how the treatment should be conducted that they leave it entirely up to the restorer. In either case, the greatest responsibility falls on the shoulders of the restorer, although the institution tends to receive most of the public gratitude.

In any restoration there are myriad choices at almost every step of the way, especially with the more drastic approaches. Numerous conversations with the restorers strongly suggest that many of them would in fact welcome responsible collaboration. Indeed, the best circumstances are those in which the restorer, informed art historians, chemists and diagnosticians work closely together. How can such an optimum operational practice be achieved?

Behind the specific problems of individual restorations, I often found a conspicuous absence of any deliberated overview of objectives. In an effort to bring positive change to the general situation, to solidify my own thinking, and in the hope of sketching out principles that could be applied more widely, I gradually began to formulate a Bill of Rights for a Work of Art. These rights were

first elaborated early in 1991 in the *Giornale d'arte* and *The Times Higher Education Supplement*. I conceived them as points of discussion for art specialists, but also for the wider community. I imagined that they could be modified and that new ones might be added as debate ensued. But the need for a broadly based set of principles was clear to me, and I also realized that they could not come, at least at this stage of the cultural debate, from the restoration establishment itself.

A BILL OF RIGHTS FOR A WORK OF ART
Premise

Those men and women engaged in the study, conservation and maintenance of the art and cultural objects of the past – restorers and conservators, archaeologists, anthropologists, chemists, petrologists, photographers, critics, architects, art historians, superintendents, publishers, curators – perform a laudable activity that warrants the admiration and support of society. Their roles should be understood as vital components in the preservation of the integrity of the artists, named or anonymous, whose works they are seeking to preserve.

Preamble

Produced throughout the history of man, works of art represent an activity as natural and as necessary as eating, sleeping and reproduction. These objects – paintings, sculptures, textiles, pots, reliquaries, totems and edifices – executed in diverse forms and media often constitute the highest values of a society as a whole and of their individual creators. The preservation of the finest among them from every period and from every continent, culture and people is not merely desirable but essential for a world facing an uncertain future.

The Rights

1. *All works of art have the inalienable right to an honourable and dignified existence.*
2. *All works of art have the inalienable right to remain in their original abode whenever possible. They should be permitted to rest in their acquired homes without being moved to distant places: in galleries and museums, in private collections, in houses of worship, in public spaces, in a protected and controlled environment free, as far as is possible, from pollution, excessive variations of climate and all forms of degradation.*

Comment

In principle, they should not be bound and packaged, tied and crated, blanketed or wrapped and sent on risky voyages by train, ship or plane hundreds, sometimes thousands, of miles from their usual residence with all the risks implicit in travel: possible accidents and shifts in temperature, altitude, humidity and physical environment. Instead of the art being transferred to metropolitan centres for grand exhibitions it is deemed more desirable that interested individuals travel to the works. When that is impossible or prohibitive, high-quality reproductions, facsimiles or reconstructions should be provided, taking advantage of modern technology.

3. *Works of art recognized as of the highest order by consensus and by tradition should be regarded as belonging to the entire society of the world, as part of the 'global cultural patrimony', not to a single entity, either local, institutional, or national, although the 'owners' would continue to have full custodial responsibility.*
4. *The 'owners' of the paintings and sculptures, as well as other art objects, hold them under an enforceable constructive trust, for the benefit of the public.*
5. *In the process of conserving works of art, ample room must also be provided for the new as well as for the conservation of the old, for*

177

otherwise we risk fossilizing ourselves in the past. Decisions affecting art held in trust should be reviewable.

Comment

Unquestionably, decisions as to which works must have priority are particularly complex and have artistic, political and cultural overtones. In an effort to begin to devise a system for such decisions, special boards, at local, regional and national levels, and composed of practising artists, architects, art scholars, restorers, engineers and critics, as well as representatives from political, economic, scientific and educational components, should be established. They would be charged with drawing up lists of works under their jurisdiction.

Decisions should be made on the basis of flexible but rigorous criteria: in certain instances they may be exclusively artistic, in others social or political also. For example, the most beloved monument of a particular village, town or city, one that on purely aesthetic grounds might be deemed 'ugly', but is nonetheless locally treasured might qualify. Its case for preservation might be stronger than that for a work of higher artistic achievement. Broadly speaking, the objects under consideration might be placed into one of three categories:

Category A: Those buildings, monuments, works of art, archaeological finds and artefacts of the highest priority, historically, culturally or aesthetically; those that must be preserved at all costs.

Category B: Objects from the past which under optimum conditions should be preserved.

Category C: The rest. Care should be taken when putting works into this category to avoid relying too much on contemporary patterns of taste.

In all three categories, procedures for appeals should be readily available. If mistakes are made in the first instance, machinery

178

should be in place to correct them. Furthermore, flexibility tilted towards preservation rather than possible loss should be an operating principle in the decision-making process.

> 6. *The most distinguished art objects shall be specially designated 'world-class masterpieces', representing, perhaps, one object in a hundred (from Category A) among the finest cultural treasures (somewhat in the way that buildings are selected for 'landmark' status). Prior to treatment of any in this group of masterpieces, all proposed procedures would be subject to review by a court of competent jurisdiction after hearing testimony from specialists and representatives of the culture. Second opinions and sometimes third opinions should be sought.*

Comment

Experts in the field – art historians, architects, restorers, archaeologists and critics – should be excluded from membership of the commission to avoid any semblance of preconceived positions or vested interests. Rather, those parties who have special commitments would be asked to explain all aspects and issues that might be raised, presenting an articulate case for a given action or procedure. The commission, like a jury, should hear arguments from the proponents of particular courses of action as well as from individuals who may have objections or who may wish to present alternative approaches.

Membership of the commission, which would be formulated *ad hoc* for any given intervention, should be constituted from among the most distinguished minds of the culture – scientists, scholars, writers, poets, artists and statesmen. They may be selected from lists of Nobel prize winners, for example, or from amongst holders of honorary degrees at the world's leading universities, but in all cases the commissions should be small to allow for the most harmonious operation possible.

Once a course of action has been agreed upon by the commission and its recommendations accepted by the appropriate authorities, conservation plans can proceed. One member of the commission

179

should act as an official observer while work is undertaken, with access to all data as it becomes available. If necessary, the observer could reconvene the original commission.

In the event that the commission, which would not have legal authority, decides against a particular course of action, the authorities could still, in principle, go ahead. However, the prestige of the commission would be such as to discourage such action.

> 7. *Under no circumstances should preservation and conservation techniques be employed that are essentially experimental in nature, except where the work of art is in imminent danger. In all other cases carefully controlled, fully documented testing is a prerequisite; findings, including photographs, must be made publicly available in a timely manner and at reasonable cost. No restoration should be undertaken for the sake of curiosity or profit. If scholarly and scientific 'discoveries' result from conservation techniques, they should be regarded as fortuitous byproducts, not as the* raison d'être *of the intervention, as the work of art must not be considered an 'experimental laboratory'. Since every treatment, cleaning or restoration has potentially negative side effects, intervention should be undertaken sparingly, and with bland and reversible techniques if possible, recognizing that in the future more effective and less damaging procedures may be devised. Restoration techniques should be subject to review before any restoration is undertaken.*
>
> 8. *Masterpieces of the past should not be reproduced without a clear distinction being made between original and copy, so that the integrity of the original is preserved. Efforts should be made to protect artists and their estates from violations of their intentions. Furthermore, repaintings and integration of missing portions of original works should be clearly visible as such.*

Comment
For example, an original marble statue from the Renaissance reproduced in the original size, in bronze or terracotta, diminishes the intention of the artist. Efforts should also be made to protect living

artists, and international machinery should be put into place for such a purpose.

9. *Works of art should not be divided or dissected, altered or mutilated. For instance, predella panels should not be separated from their altarpiece nor should individual pages be removed from a book of drawings. In principle, later transformations, adjustments and reformations added to the original statement should be left intact as marks of its history.*

Comment

For example, a Romanesque church may have been remodelled by a Baroque architect, and a fourteenth-century painting 'modernized' by a fifteenth-century master. It is sometimes impossible to distinguish between the absolute original and later modifications. Or a generally recognized master may have intervened in the work of a less distinguished colleague. Rather than alter history, and run the risk of losing important marks of one or another epoch, the work should be left intact.

10. *The stewardship of works of art, especially masterpieces of noted historical significance, should be subject to free and open debate and appropriate judicial review.*
11. *The examination and maintenance of works of art must continue on a regular basis and be carried out by trained professionals, certified by national and international standards, when feasible, after any objector has been given the right to be heard.*

* * *

Excitement quickly subsided after the *Ilaria* trial: reality set in and my various accounts had to be paid. While court costs were charged to Caponi, I was personally responsible for my not insubstantial lawyers' fees. In fact, I had a shock: in the Italian system for penal cases, a defence lawyer is automatically appointed

181

by the court. If you already have your own, you must officially disengage the court-appointed lawyer. I did not think this would be much of a problem, because I assumed that the court-appointed lawyer would be compensated by the court, and to have a lawyer up in Piedmont did not seem like a bad idea. In fact, the local lawyer turned out to be useful because of his personal experience with the individuals in the court. My defence lawyer from Florence, Filastò, was, however, in charge of the case. Not long after our Turin triumph, I received an exaggerated bill from the lawyer there. I had to pay it because almost simultaneously he appealed to a local body of lawyers, who approved his claim for extra charges beyond those listed by their organization because of the 'importance of the case'. I had no inclination to go to court again, this time against one of my lawyers. An Italian saying advises that the best case is not the one that is won, but the one that never came to court.

My Florentine lawyers were quite sensitive, recognizing that I was an individual without the backing of a newspaper, or a university for that matter. I believe that a certain amount of Italian pride was involved, too, because they realized that my motivation was to protect Italian art.

I offer these details only because when the time came to pay, friends offered to collect the money by throwing a party and spreading the word. The question weighed upon me heavily because, while I was happy to have my bills paid, it seemed to me that the issues went beyond my person and my wallet. We postponed announcing a party for weeks. Finally I realized that any money that was to come in should be applied for a more long-lived purpose. Under these circumstances, I decided to found an organization. It is called ArtWatch International.

The Bill of Rights for a Work of Art was used as the foundation statement of the new watchdog organization, whose role is to alert the general public to illicit interventions, unreasonable threats to masterpieces, or situations connected with art that need action. ArtWatch's statement of intent was worked out in collaboration

with several founders, including Dr Donald M. Reynolds and Gordon Bloom, and offered the possibility of action in the face of a closed and often hostile restoration establishment. At the same time, flexible and relatively broad goals were laid down. We managed to raise 'seed' money, and had our not-for-profit tax status approved. But there was an early setback. Our application for associate membership of ICCROM, the International Centre for the Study of the Preservation and the Restoration of Cultural Property, which had been founded by UNESCO in 1959 as an autonomous scientific organization, was rejected and our $200 returned. The organization, which has its headquarters in Rome, refused our application without any explanation whatsoever. Since ICCROM's main activity is teaching restoration, did they consider our membership a threat? In any event, the rejection was additional proof of the absolute necessity to break the circle by bringing artists and members of the culture into the discussion. ICCROM, principally a hands-on organization, appears not to be concerned with the moral and ethical issues that we believe are an integral part of all preservation activities.

The Mission Statement of ArtWatch International

1. To serve as an international advocate for the conservation and stewardship of historically significant works of art and cultural monuments

2. To promote an open exchange of ideas and information on the full range of practices and policies in the field of conservation, restoration and international stewardship of important cultural artefacts.

3. To contribute to the development and codification of national and international cultural policies and practices as they bear upon historic and contemporary works of art, especially but not exclusively in the area of painting, sculpture, architecture and gardens.

183

4. To discuss, review, critique and amend those policies and prac-
 tices, and to promote educational programmes which will faci-
 litate this goal.

5. To develop manifestos such as 'A Bill of Rights for a Work
 of Art' which will facilitate the enlightened stewardship and
 protection of the global cultural patrimony by throwing into
 the spotlight moral and ethical factors.

6. To collaborate in the creation of position papers and policy
 documents with other nationally and internationally chartered
 organizations.

7. To act as a watchdog organization in the arena of cultural
 policy, protecting works of art and the general public from
 vested, private and institutional interests.

An important restoration issue involving the art establishment
in the United States arose during the late summer of 1992. Students
and alumni of the Barnes Foundation's art education programme
sought the assistance of ArtWatch – incidentally underlining the
need for such an organization. The Barnes Foundation was set up
to house the collection of Dr Albert C. Barnes, in Merion, Penn-
sylvania, and to use it as the basis of an illustrious if controversial
teaching programme – one in which the American theorist of
education John Dewey and the English philosopher Bertrand
Russell once played roles. The collection consists of about a thou-
sand items, among them outstanding works by Renoir, Matisse,
Picasso, Seurat and Modigliani. It has more Cézannes than are to
be found in the whole of Paris, and also an impressive collection
of African art.

The indenture of the Foundation specifically prohibits sale of
the works or their removal from the premises, but the Foundation's
administrators, on the basis of so far largely unsubstantiated claims
of financial difficulty, set out to break the indenture's terms to
raise funds to refurbish the building and the collection. At first
a multi-million dollar mass sale was contemplated but such was

184

public opposition that the administrators withdrew their legal application. In 1992, however, a court gave the go-ahead for a world tour of about eighty of the collection's finest paintings. This fund-raising device – which should act as a warning to would-be benefactors that any terms they set will readily be violated – was orchestrated by the National Gallery in Washington.

Friends of the Foundation point out that Barnes's prime intention, that the collection be used for teaching, will be undermined by this tour. The absence of 'core' pictures will seriously disrupt if not obliterate the programme of instruction. True, the techniques of teaching by art historians at the Barnes have been belittled in universities and colleges, but is that reason enough to destroy a successful programme? What about freedom of choice, and intellectual diversity? Who is to say that the Barnes methods are without merit? The alumni, many of whom have achieved recognized success in the art world, are extremely enthusiastic.

Superficially, it may appear attractive to make the collection available to a wider public, though in fact the collection is open three days a week during most of the year. Anyone who takes the trouble to get to Merion half an hour before opening time is assured of a visit for only a dollar – a fraction of what most museums would charge to see such works. Barnes made it clear that participation in the art appreciation course also should be open to all, so that claims of exclusivity are quite out of order. There are excellent collections, including some owned by universities, far less accessible than this one.

The world tour planned for the pictures and the inevitably rapid restoration in preparation for it have also been challenged. In preparation for the tour's opening in Washington in May 1993, all eighty or so pictures were sent for treatment that had to be completed in nine months. One would expect a restorative programme of this size – even if it were desirable, which is highly questionable – to take years. Accelerating treatment of such delicate objects would be contrary to normally recognized standards of good practice. The paintings chosen for the tour, mostly nineteenth- and

twentieth-century works with the most pulling power with the public, had for the most part so far escaped radical treatment and with a handful of exceptions were in fine condition. As a body of paintings in a relatively authentic state they were considered a shrine by contemporary artists.

Transporting works of art is also always risky. The frequent crating and re-crating required for stays in Washington and the Philadelphia Museum of Art, as well as stops in France and Japan, multiplies the possibility of injury.

ArtWatch has gone on record as advocating a moratorium on the projected tour and on restorations not already carried out. The only exception should be conservational interventions where there is present danger to a painting's physical integrity. No irreversible aesthetic 'improvements' should be permitted, certainly not without consultation with representatives of the culture who have no vested interest in the situation.

Once again the established powers in the art world have united to pursue their goals without revealing the slightest willingness to engage in open debate or to consider views about the trusteeship of artistic treasures that may be different from their own. We have found a similar situation at the Louvre over its treatment of Veronese's *Marriage at Cana* and Leonardo's *Madonna and Child with St Anne*, not to mention the classical sculpture housed there, at the London National Gallery, at the Getty Museum in California, and over Jacopo della Quercia's Fonte Gaia in Siena. The list is really endless. Our experience with all these has served to reinforce the conviction that disinterested opinions must be brought into the discourse and that an organization like ArtWatch, with its close ties with artists and restorers (yes, restorers) can make a positive contribution to the proper conservation of our cultural heritage.

The restorations discussed at length in this book and the network surrounding them are part of a wider pattern in society. In the West, wealth and waste defined the 1980s. While the United States saw something of an economic decline, for Western Europe, and East Asia, the decade was one of unprecedented prosperity.

The 1980s were characterized by a virtually uncontrolled expansion of organized crime and the unrelenting exploitation of natural resources. With wealth came the drug explosion and, at least partially related to it, the AIDS epidemic. Television sets became all-colour, and expanded in size, as did the average family car in Europe. Favoured colours became increasingly brilliant, ever more eye-catching.

Work on the Sistine ceiling was appropriately begun as the decade opened and completed with its end. Restoration of the Sistine Chapel, the Brancacci frescoes, the *Ilaria del Carretto* and *The Marriage at Cana* fitted neatly into an age when junk bonds were a route to vast wealth and Disneyland was the favoured family entertainment, when brash was best and the deal was king, when almost all of us had allowed ourselves to be talked into the idea that our surroundings, even ourselves, should be made better, cleaner and more beautiful, usually with chemical help. How could we resist the formula that if clean is beautiful, extra clean is very beautiful and super clean is most beautiful of all? For more than a generation we have been bombarded with jingles and ditties about 'whiter than white' laundry, sparkling pots and pans, glistening floors, glowing toilet bowls. It is the same with our bodies: our hair, shimmering, dyed a designer-selected colour, our teeth capped pearly white. We must be scrubbed and caressed with chemicals, and covered again with fragrances and Fomblin-like oils, our faces lifted and lumpy cellulite made to disappear with miraculous products.

The treatment of art was not immune to this obsession with perfection. For if clean is beautiful, dirty is ugly, dirty is poor and dirty is bad. Get it off, get it all off. Brush a chemical on, let it work, and wipe it away. That is how Easy-Off gets the grime from the stove, and that is how AB57 works. No ring around the collar, no telltale stains.

The manner in which we abuse our bodies and pollute our environment and the way in which we tamper with nature in the search for 'perfection' have been mirrored in the irresponsible

187

restoration of many of our art treasures. As I stand against pollution of our world so do I oppose the risky restoration of the Sistine ceiling and the *Last Judgement* undertaken in a mindless effort to 'improve' the rarest treasures of our culture. The issue of radical restorations should be understood as part of an ecological challenge, one that concerns our present, ever-changing attitudes toward past achievements and how we are prepared to treat our physical and cultural environment. A firm philosophical stand regarding the broader choices has to come first, before irreversible action is undertaken. Undoubtedly choices must be made and priorities established. In order to do so, we must have a clear formulation of the values that should be preserved. There are political, but also moral issues to be resolved. Most of all we must decide who we are, what we want to pass on and in what state. We must get our priorities in order.

Final Observations

The reader will have long since noticed that most of the examples discussed in this book, namely the art works as well as the restorations, are Italian. For this reason Italian restorers may appear to have been singled out for criticism, and the methodologies of modern Italian conservation and restoration especially found wanting. This impression is not intended nor is it correct. The grand museums of the rest of the world, from the Louvre or London's National Gallery (as Michael Daley has shown) to the Metropolitan Museum in New York or the National Gallery of Washington, have if anything a less impressive record than, say, the Uffizi or the Brera. Among the smaller collections, the Jarvis Collection of Italian pictures of the Yale University Museum seems to have been particularly severely censored. On the whole, operatives in Italy (they are not always Italians) appear relatively attuned to aesthetic issues.

The reasons Italy looms so large in this book are first that I am, after all, a student of Italian art, and second that Italy is still filled

with masterpieces, perhaps more than any other European country. The excesses lamented here represent not a national but a world problem, and one especially of the 1970s and 1980s. The reader will also recognize the heroes of our account are Italians. Toti Scialoja, Alessandro Conti, Venanzo Crocetti, but perhaps most of all Agnese Parronchi, who is pointing the way to a new excellence in stone conservation and cleaning, and Mirella Simonetti, who has put her career on the line in her unremitting search for the truth about the conditions that affect her beloved works of art. These two restorers, and hundreds of others I dare say, along with dedicated superintendents of fine art and their staffs, illustrate the fundamental justice of Cesare Brandi's penetrating observation that restoration is, after all, criticism. (How can we dare abdicate this function to scientists and technicians, who really belong to another métier?)

If we believe that there is some quality unique to works of art, whether pictures, statues or buildings, we have to try to identify that special quality. The question has challenged philosophers since Plato and answers do not come readily. Yet at the risk of sounding like an unreconstructed romantic, unscientific and untechnological to the core, I am deeply convinced art has indeed a quality, a component, an aspect, an ingredient, an aura that sets it apart from even the best illustration, design and construction. It must be there because most of us can single it out effortlessly. Van Gogh's paintings have it, so do Cézanne's, and keeping the discussion close to the text, so do the works of Masaccio, Jacopo della Quercia and Michelangelo, even if we cannot pin the element down, define it, or load it on to a hard disk. Yet if this crucial quality is there, it must be ethereal and elusive. I am prepared to call this special component the 'spirit', using a word that conjures up religious, moral and ethical considerations.

In the final analysis, what has been lost on the Sistine Ceiling, in the Brancacci frescoes, in the *Ilaria*, and in so many museum-cleaned pictures, is the spirit, the art of the art. To be sure, we have identified changes, specific losses or alterations: the glue paint-

ing, layers of modelling, shifts in outlining of the figures, atmospheric effects, *pentimenti*, the patina of time or the patina created by the originating artist, or a unity that seems especially often to be the victim. In perfectly good faith, one may respond that the images are still there; they can be read, they can be photographed, perhaps even more effectively than before the restorations. So need we make such a fuss?

But what has been disturbed, we contend, is the spirit which lifts the work from normal, material experience to a higher realm where beauty prevails. Without it Van Gogh would be what his early critics said he was, an untalented, struggling, provincial amateur. Masaccio would be a country bumpkin who misunderstood human anatomy and had a poor sense of proportions. Michelangelo might be thought merely an overblown Biblical illustrator whose conception of the human figure was an unpleasant exaggeration of reality. The spirit in art is immensely fragile, and I am not sure that even the best Van Gogh painting, for instance, could survive heavy-handed restorations. Nor do I believe it could survive media adulation, indecent prices and record praise. One thing is certain, Van Gogh himself could not have.

Can it possibly be appropriate to commercialize our artistic heritage as has happened? What becomes of the spirit inherent in those modest Cézannes while they are carted around the world like circus freaks, and medicine men sell tickets of admission and trinkets? Even when the money is used for ostensibly good purposes, can such activities be said to perpetuate the spirit inherent in art?

The bombing of the Uffizi Gallery which occurred on the night of 27 May 1993 is a further devastating reminder of the fragility and vulnerability of our world treasures. But it also reminds us of exactly how indispensable restorers and conservators are in the cultural drama of a modern society. Man-made disasters, usually the result of wars, terrorism and vandalism, together with natural catastrophes like floods, as well as accidents, are all too familiar. The authors of this book admire restorers' skills and their devotion

as much as anyone else. What we object to is the unnecessary campaign of beautification which seems to have taken hold in the museums and in other public places where art works are displayed. Frescoes and sculptures are covered over and receive their treatment, and are then ceremoniously unveiled, only to be subjected again after a few years to another round. Paintings in museums disappear for periods of time, only to reappear all spruced up, looking more like their neighbours than they did before and increasingly conforming to a bland museum look. An insistence upon this irreversible cultural post-modern happening by persons in power still continues, as if the pendulum were swung by inertia rather than reason. Whatever can be said to be left of the spirit of masterpieces, and usually there will have been serious and even devastating damage as a consequence of previous interventions, is further bruised. A firm stop should be put immediately to this haemorrhaging of our past.

Further information on the restoration issues discussed in this book may be obtained from:

> ArtWatch International
> 931 Schermerhorn Hall
> Columbia University
> New York, New York 10027
>
> Tel: (212) 854–4569

Notes

Preface

1. J. Beck, 'Reflections on Restorations: Jacopo della Quercia at San Petronio, Bologna', *Antichità viva, anno* xxiv, 1985, pp. 118–23.

Prologue

1. The Italian text ran as follows:

 Il sottoscritto dott. Luca Cianferoni, nato a Firenze il 26 maggio 1966, residente a Fiesole, Via Bolognese n. 38, dichiara quanto segue:

 'Quale praticante nello studio dell'avv. Antonino Filastò ho seguito il dibattimento del processo al professor James Beck, svoltosi in data 17 maggio 1991 davanti alla II sez. penale del Tribunale di Firenze. Alle ore 13 e 20 circa uscivo dal Tribunale essendo l'udienza terminata da pochi minuti. Mi precedevano di un paio di metri nel corridoio, e quindi in prossimità della vetrata di uscita, i signori avvocato Ermanno Ugolini, e dottor

Giovanni Bellagamba, presidente della II sezione del Tribunale. Camminando affiancati l'avvocato e il giudice discutevano del processo al prof. Beck di cui da poco si era esaurita l'udienza dibattimentale. Più precisamente era l'avv. Ugolini che parlava dicendo, più o meno testualmente, che gli avvocati della difesa intendevano alzare un polverone ma che si doveva discutere l'articolo di giornale. Il dott. Bellagamba annuiva, poi, aprendo la porta a vetri, ha pronunciato la frase che segue da me distintamente udita: '-Eh, ma io lo condanno'.

Chapter I: The Ilaria del Carretto

1. 'Studiorestauri di Gianni Caponi & C.', *Manufatti Lapidei– Schede Tenica–Dopo il Restauro*, Caponi's final report. Photocopy in the possession of the author. Also a photocopy of a report issued by the Superintendent herself is in the possession of the author, and was a press release obtained from a journalist.
2. K. Shulman, *Anatomy of a Restoration: The Brancacci Chapel* (New York, 1991), pp. 128 and 191–201.
3. A. Conti, *Restauro* (Milan, 1992), p. 19, says '. . . la reversibilità è stato sempre uno dei criteri fondamentali del restauro'. It is, of course, more a goal than a reality, as recognized by Conti (p. 18), given that absolute reversibility does not exist; hence the need for caution.

Chapter II: Masaccio, The Brancacci Chapel and the Trinity

1. K. Shulman, *Anatomy of a Restoration: The Brancacci Chapel* (New York, 1991), p. 128.

Chapter III: The Sistine Chapel

1. Patricia Corbett, 'After Centuries of Grime', *Connoisseur*, May 1982.

2. Alan Levy, 'Michelangelo Restudied', *Art News*, October 1981.
3. *The Sistine Chapel: Michelangelo Rediscovered* (London, 1986), p. 260. This book contains a foreword by Carlo Pietrangeli, and text by André Chastel, Gianluigi Colalucci, Pierluigi De Vecchi, Michael Hirst, Fabrizio Mancinelli, John O'Malley and John Shearman.
4. 'A shade of doubt dogs the Sistine Chapel restoration', *Christian Scientist Monitor*, 11 September 1986.
5. M. Kirby Talley, Jr, 'Michelangelo Rediscovered', *Art News*, Summer 1987.
6. The J. Paul Getty Trust, 'The Conservation of Wall Paintings' (Proceedings of a Symposium organized by the Courtauld Institute of Art and the Getty Conservation Institute, London, 13–16 July 1987).
7. *Bible Review*, August 1988, p. 16.
8. *National Geographic*, December 1989, p. 697.
9. Telephone conversation with Michael Daley, February 1990.
10. 'Michelangelo Restudied'.
11. F. Mancinelli in *Apollo*, May 1983.
12. *The Sistine Chapel: Michelangelo Rediscovered*, p. 242.
13. *The Sistine Chapel: Michelangelo Rediscovered*, p. 261.
14. 'The Conservation of Wall Paintings', p. 67.
15. K.W.G. Brandt, 'Twenty-five Questions about Michelangelo's Sistine Ceiling', *Apollo*, December 1987, p. 395.
16. Michael Daley, letter to Professor Kathleen Weil-Garris Brandt, 27 May 1990.
17. Gianluigi Colalucci, letter to Michael Daley, 17 July 1990.
18. 'Vatican Restorers are ready for Last Judgement', *The New York Times*, 19 June 1991.
19. Telephone conversation with Michael Daley, July 1991.
20. 'The Conservation of Wall Paintings', Plates 39, 40.

21. *The Sistine Chapel: Michelangelo Rediscovered*, p. 265.
22. 'Michelangelo Restudied'.
23. 'Sistine Chapel clean-up erases some beliefs on Michelangelo', *San Francisco Examiner*, 28 April 1985.
24. *The Sistine Chapel: Michelangelo Rediscovered*, p. 236.
25. 'A shade of doubt dogs the Sistine Chapel restoration'.
26. *The Sistine Chapel: Michelangelo Rediscovered*, p. 262.
27. *The Sistine Chapel: Michelangelo Rediscovered*, p. 262.
28. 'Michelangelo Rediscovered'.
29. *The Sistine Chapel: Michelangelo Rediscovered*, p. 262.
30. 'Michelangelo Rediscovered'.
31. Gianluigi Colalucci, letter to Michael Daley, 17 July 1990.
32. F. Mancinelli, F. Hartt and G. Colalucci, *The Sistine Chapel* (London, 1991, 2 vols.), Vol. I, p. 361.
33. Speaking at the Wethersfield Institute Conference, New York, 21 October 1985.
34. F. Mancinelli, *The Art of the Conservator* (London, 1992), p. 93.
35. *Art Bulletin*, September 1989.
36. 'Out of Grime, a Domain of Light', *Time*, 27 April 1987.
37. 'Twenty-five Questions about Michelangelo's Sistine Ceiling', p. 399.
38. *The Sistine Chapel: Michelangelo Rediscovered*, p. 218.
39. *Art Bulletin*, September 1989.
40. 'After Centuries of Grime'.
41. Alexander Eliot, 'Agony or Ecstasy', *Harvard Magazine*, March/April 1987.
42. 'Twenty-five Questions about Michelangelo's Sistine Ceiling', p. 399.
43. 'Twenty-five Questions about Michelangelo's Sistine Ceiling', p. 398.
44. 'Twenty-five Questions about Michelangelo's Sistine Ceiling', p. 395.

45. 'Michelangelo Rediscovered,' p. 170.
46. Editorial, *Burlington Magazine*, November 1987.
47. *The Art of the Conservator*, p. 92.
48. The oration was by Laura Battiferra degli Ammannati and appears in translation in Rudolf and Margot Wittkower, (eds.), *The Divine Michelangelo* (London, 1964), p. 86.
49. Robert J. Clements (ed.), *Michelangelo: A Self-Portrait* (New York and London, 1968), p. 34 [Armenini].
50. Clements, *Michelangelo: A Self-Portrait*, p. 34 [Vasari].
51. *The Independent*, 20 March 1991.
52. Joyce Plesters, 'The Materials and Technique', *Michelangelo Entombment of Christ*, National Gallery, 1970, p. 25.
53. Dr Nicholas Penny, telephone conversation with Michael Daley, 30 September 1991.
54. Dr Nicholas Penny, letter to Michael Daley, 31 October 1991.
55. Jill Dunkerton, letter to Michael Daley, 20 October 1992.
56. Dr Nicholas Penny, letter to Michael Daley, 13 November 1992.
57. *The Sistine Chapel: Michelangelo Rediscovered*, p. 218.
58. Frank Mason, letter to Dr Carlo Pietrangeli, 3 September 1985.
59. Telephone conversation with Michael Daley, February 1990.
60. *The Sistine Chapel: Michelangelo Rediscovered*, p. 7.
61. 'Michelangelo Rediscovered', p. 160.
62. R. Goldwater and M. Treves (eds.), *Artists on Art* (London, 1976), letter to Benedetto Varchi, 28 January 1547, pp. 87–8.
63. *Vasari on Technique* (New York, 1960), from Introduction to 1550 edition of *Lives of the Artists*, p. 216.
64. *Vasari on Technique*, p. 216.
65. 'Michelangelo Restudied', p. 120.
66. André Chastel, 'First Reaction to the Ceiling', *The Sistine Chapel: Michelangelo Rediscovered*, p. 160.

67. 'A Pristine Sistine: Michelangelo Unveiled', *Wall Street Journal*, 18 April 1987.
68. 'Michelangelo Rediscovered', p. 167.
69. *Art Bulletin*, September 1989.
70. Letters, *The Independent*, 25 March 1991.
71. 'Twenty-five Questions about Michelangelo's Sistine Ceiling', p. 394.
72. 'Twenty-five Questions about Michelangelo's Sistine Ceiling', p. 398.
73. *The Art of the Conservator*, p. 92.
74. Dr Reinhold von Liphart-Rathshoff, *Zeitschrift für Kunstoeschichte*, Vol. VII, 1938.

Chapter IV: The Physical Condition of the Sistine Ceiling

1. 'Conference Report', *Burlington Magazine*, November 1987, p. 754.
2. K.W.G. Brandt, 'Twenty-five Questions about Michelangelo's Sistine Ceiling', *Apollo*, December 1987.
3. Alan Levy, *Treasures of the Vatican Collections* (New York, 1983), p. 81.
4. F. Mancinelli, *The Art of the Conservator* (London 1992), p. 90.
5. *The Art of the Conservator*, p. 91.
6. M. Kirby Talley, Jr., 'Michelangelo Rediscovered', *Art News*, Summer 1987, p. 164.
7. Levy, *Treasures of the Vatican Collections*, p. 150.
8. *The Sistine Chapel: Michelangelo Rediscovered* (London, 1986), pp. 264–5. The book contains a foreword by Carlo Pietrangeli and text by André Chastel, Gianluigi Colalucci, Pierluigi De Vecchi, Michael Hirst, Fabrizio Mancinelli, John O'Malley and John Shearman.
9. *The Art of the Conservator*, p. 92.

10. The J. Paul Getty Trust, 'The Conservation of Wall Paintings' (Proceedings of a Symposium organized by the Courtauld Institute of Art and the Getty Conservation Institute, London, 13–16 July 1987).

11. F. Mancinelli, F. Hartt and G. Colalucci, *The Sistine Chapel* (London, 1991, 2 vols.), Vol. I, p. 365.

12. *Art News*, October 1981, pp. 117–18.

13. General Report of the Restoration of the Sistine Chapel Lunettes, *The Sistine Chapel: Michelangelo Rediscovered* (London, 1986), p. 265.

14. Paolo Mora, Laura Mora and Paul Philippot, *Conservation of Wall Paintings* (London, 1984), pp. 284–5.

15. *The Art of the Conservator*, p. 103.

16. Mora, Mora and Philippot, *Conservation of Wall Paintings*, p. 297.

17. 'Michelangelo Rediscovered', p. 164.

18. 'Michelangelo Rediscovered', p. 164.

19. *Christian Scientist Monitor*, 11 September 1986. See also Alessandro Conti, *Michelangelo e la pittura a fresco* (Florence, 1986).

20. Mora, Mora and Philippot, *Conservation of Wall Paintings*, p. 342.

21. Mora, Mora and Philippot, *Conservation of Wall Paintings*, p. 342.

22. Mora, Mora and Philippot, *Conservation of Wall Paintings*, p. 342.

23. 'Twenty-five Questions about Michelangelo's Sistine Ceiling', p. 398.

24. *The Sistine Chapel: Michelangelo Rediscovered*, p. 265.

25. 'Metodo per la rimozione di incrostazioni su pietre calcree e su dipinti murali', in G. Urbani (ed.), *Problemi di Conservazione* (Bologna, 1974), pp. 339–44. (In their account of AB57 in

Conservation of Wall Paintings, the Moras make no references to EDTA.)

26. Unpublished paper, July 1992.
27. Unpublished paper, July 1992.
28. J.A. Lauffenburger, C.A. Grisson and A.E. Charola, 'Changes in gloss of marble surfaces as a result of methy/cellulose poulticing', *Studies in Conservation*, August 1992.
29. Simonetti, unpublished paper, July 1992.
30. Mora, Mora and Philippot, *Conservation of Wall Paintings*, p. 292.
31. Richard C. Wolbers, 'A radio-isotropic assay for the direct measurement of residual cleaning materials on a paint film' (London, 1990), preprint of the contributions to the Brussels Congress, 3–7 September 1990.
32. Mora, Mora and Philippot, *Conservation of Wall Paintings*, p. 297.
33. *The Sistine Chapel: Michelangelo Rediscovered*, p. 265.
34. 'The Conservation of Wall Paintings', p. 72.
35. *The Sistine Chapel*, Vol. I, p. 365.
36. *The Art of the Conservator*, p. 103.
37. Simonetti, unpublished paper, July 1992.
38. F. Hamilton Jackson, *Mural Painting* (London, 1904), p. 48.
39. *Art News*, October 1981, p. 117.
40. *The Sistine Chapel: Michelangelo Rediscovered*, p. 265.
41. Simonetti, unpublished paper, July 1992.
42. 'Michelangelo Rediscovered', p. 168.
43. 'Michelangelo Rediscovered', p. 168.
44. 'Michelangelo Rediscovered', p. 168.
45. 'The Conservation of Wall Paintings', p. 74.
46. 'The Conservation of Wall Paintings', p. 74.
47. Letter to Michael Daley, 17 July 1990.
48. *The Art of the Conservator*, p. 107.

49. Telephone conversation, July 1991.
50. *National Gallery Technical Bulletin*, Vol. 9, 1985, pp. 52–3.
51. *Burlington Magazine*, November 1987, p. 754.

Chapter VI: The Restoration Establishment

1. A. Conti, *Michelangelo e la pittura a fresco: technica e conservazione della Volta Sistina* (Florence, 1986).
2. As A. Conti (*Restauro*, Milan, 1992, p. 40) raised a fascinating observation with regard to a small *Coronation of the Virgin* in the Museo dell'Opera del Duomo in Orvieto. An unfinished work, which was cleaned recently, the original now appears as if false.

Index

AB57 solvent, 72, 94, 104–5, 110–18, 187; chemical composition, 111–12, 113–14; method of use, 106–9, 116–17
ABC television, 92–3
abrasives, 27, 125, 156
acetone, 126, 133, 135, 137, 141–2
acrylics, 171; Paraloid B72 resin, 72, 119, 142
air-conditioning, 120–2
alcohols, 126, 137, 141–2
Amendola, Aurelio, xiii, 10, 24
ammonia, 111
ammonium bicarbonate, 112, 113
Annigoni, Pietro, xv, 144–6
Antelami, Benedetto: *Months*, 169–70
architecture, restoration of, 155–6
archival research, 76–7, 166
Arezzo: Piero della Francesca's True Cross cycle, x
Arles: St Tromphime, 163
Armenino, Giovanni Battista, 80, 90, 98–9

arricio (plaster base of fresco), 39
artists, 163–6
ArtWatch International, 182–4, 186
atmosphere, 40, 70, 110, 118–22, 125
attributions of works, 157
Auerbach, Frank, 133

Bacon, Francis, 133
Baldini, Professor Umberto, 55, 170; and Brancacci Chapel frescoes, 35, 37, 42, 45, 50, 51, 52
banks, Italian, 3, 21–2, 161
barium hydroxide, 119
Barnes Foundation, 184–6
Barni, Roberto, xiii
Barsotti, Contessa Stefania, 9
beeswax, 27
Bellagamba, Dr, 9, 19, 14–16
Bellini: *Feast of the Gods*, 99–100
Bensi, Dr Paolo, 111
benzene, 126
Berenson, Bernard, x, 152, 167

201

stuccoes: San Lorenzo, Florence, by
 Donatello, 163
sulphur, air-borne, 118, 122
Sylvester, David, 133
Syremont company, 25, 54–5, 56

Talley, M. Kirby, Jr., 69, 74, 75–6,
 87
taste, modern, 56, 148, 149
tempera, 124
Tintoretto, 79
Tintori, Leonetto, 60, 61, 111
Titian, 124, 129; *Feast of the Gods*,
 99–100
toluene, 126, 137
Torraca, Professor Giorgio, 119
training of restorers, 126, 153
turpentine, 125, 126
twentieth-century art, 155, 164,
 186

Uccello, Paolo: *Battle of San
 Romano*, 121, 150–1
Uffizi Gallery, Florence, xiv, 154,
 188
Ugolini, Dr Ermanno, 7, 10, 11,
 14, 16, 18, 19, 21
ultramarine, 71, 72
ultra-violet light, 100, 125
underpaintings: fresco, see *sinopie*;
 panel paintings, 124
UNESCO, 183
Urbani, Dr Giovanni, 81, 170
Uwins, Thomas, 130, 131

Vaga, Perino del, 80
Van Gogh, Vincent, 140, 189
varnish: on frescoes, 73; on oil and
 tempera paintings, 125; test for
 originality, 99–100
Vasari, Giorgio, 79, 88–9, 91, 97, 98

Vatican: archives, 76–7; Raphael
 frescoes, 77, 83, 104, 122, 172;
 see also Sistine Chapel
Velazquez, 129, 131; *Rokeby
 Venus*, 142
Venice, 28, 158
vermilion, 141–2
Veronese, Paolo Caliari, 130; *Mar-
 riage at Cana*, x, 55, 121, 186
Victoria and Albert Museum, Lon-
 don, 28

Walden, Sarah, 144
Warburg Institute, 133
water: as solvent, 111; de-ionized,
 with plastic pellets, 27; distilled,
 116–17, 174; for removing sol-
 vents, 116–17
wax, 27, 31
wax resin, 142–3
Weaver, J. R., 132
White, John, 133
whitewash, 60–1
Wilson, Charles Heath, 67, 96,
 100, 112
Windsor Castle, Berks., 91
wine as solvent, 92
wooden supports for paintings,
 124, 125
World Monuments Fund, 163

X-ray techniques, 100
xylene, 142

Yale University Museum: Jarvis
 Collection, 188

Zanardi, Bruno, 169–70
Zeri, Federico, 167
Ziegler, Laura, xiii, 2–3, 9
zinc oxide, 124

210